Artists at Curwen

PAT GILMOUR

ARTISTS AT CURWEN

a celebration of the gift of artists' prints from the Curwen Studio

TATE GALLERY

ACKNOWLEDGEMENTS

The challenge of mounting and cataloguing *Artists at Curwen* in just over two months, to take advantage of a gap in the Tate exhibition programme occasioned by building delays, reminded the Print Department of the old saying, 'The difficult we do at once, the impossible may take a little longer'.

It might, of course, really have proved beyond us but for the tremendous and heartwarming co-operation from private lenders and public collections alike (individually acknowledged in the catalogue listing) and the support of Exhibitions and Publications department staff.

The bulk of the work, however, fell to the Print Department. Jill Howorth and Christine Ives researched, stamped, numbered and catalogued the magnificent Curwen Gift of 750 Studio prints; Les Prince mounted and/or framed both Press and Studio exhibits; Liz Kay gave secretarial support, including an entire weekend. I have never before encountered such even-tempered willingness, precision and dedication.

Pat Gilmour

Exclusively distributed in France and Italy by Idea Books
46–48 rue de Montreuil, 75011 Paris and Via Cappuccio 21, 20123 Milan

ISBN 0 905005 75 9 paper 0 905005 80 5 cloth
Published by order of the Trustees 1977
for the exhibition of 23 February–11 April 1977
Copyright © 1977 The Tate Gallery
Published by the Tate Gallery Publications Department,
Millbank, London SW1P 4RG
Designed by Pauline Key
Cover/jacket designed by Lynn Lewis
Originated and printed at The Curwen Press Ltd, Plaistow, London E13

Contents

Cover/jacket
E. McKnight Kauffer
Curwen Press Unicorn, 1929–30
(see catalogue No.161)

Title Page
Edward Bawden
Curwen Press Unicorn

Foreword

This exhibition is part of the public celebration of the formation of the twentieth-century Print Collection at the Tate based on the gift of about 2,600 prints from the Institute of Contemporary Prints in 1975; its genesis is recorded in the Tate Gallery Report for 1974–76. It is in fact the second of these special celebratory exhibitions; the first was devoted to the work of Henry Moore which marked a major gift of prints from the great sculptor and also his commitment to give one copy of each future print he makes to the collection. At a later date it is intended to devote a special exhibition to the Rose and Christopher Prater gift of some 1,400 screenprints.

The list of those who have worked with the Curwen Studio reads as a rollcall of the most distinguished British artists of their time. The quality of the work they produced in conjunction with the Curwen Press is a tribute to the sympathetic understanding which has always been the distinguishing mark of the directors and staff of the Press in their dealings with artists.

Those who have helped the exhibition either with information or by loans are too numerous to mention individually but I should like to make a special acknowledgement to Basil Harley, managing director of the Curwen Press and to his infinitely helpful staff. Also to the Curwen Studio, its manager Stephen Reiss and the master printer Stanley Jones.

We are specially indebted also to the families of Harold Curwen and of Herbert and Oliver Simon. The affection and admiration inspired by these three early directors of the Press, as indeed by their successors, has been amply demonstrated by all those who were their friends or did business with them, and who have volunteered information and helped to make the account as accurate and full as possible. We acknowledge their generous help gratefully.

I should like to pay tribute to all the staff of the Print Collection at the Tate who worked more than usually long and concentratedly

to prepare the prints and the catalogue in time. Particularly warm thanks are due to Pat Gilmour who has written what amounts to a brief history of the Curwen Press and guided all the preparatory work with that energy and dedication which we have come to expect from her.

After two years as the first Curator of the Print Collection Mrs Gilmour is returning to teaching but we hope she will continue her association with the Tate in work on future exhibitions.

Norman Reid *Director*

The Curwen Press

Eric Gill, Press Unicorn, 1926

flatter

Victoria

FLATTER

Edina

FLATTᴇ

Gresham

Institutions are not abstract entities, but are composed of individuals, and while the principals themselves would both have insisted that the Curwen Press comprised the whole band of exceptionally loyal and skilful workers who served them in the heroic period of typographic progress following the First World War, for the majority of people the Curwen Press meant two men – Harold Curwen and Oliver Simon.

As a child, I only associated the name with *Mrs Curwen's Pianoforte Method* and that spry unicorn trademark, crisply cut on wood by Eric Gill in 1926, alertly prancing across the front cover in perpetual eagerness. Of course, music, and, in particular, joy to the world through the ease of singing Tonic Sol-fa rather than reading standard musical notation, was the rock on which the Curwen Press was founded. For the Reverend John Curwen, who began popularizing Tonic Sol-fa as an offshoot of his Nonconformist Ministry in the 1840s, it was eventually his whole life. The first chapel he built became, when his congregation outgrew it, a printer's chapel (parts of which are still in use to this day) because he needed his own printing press to help him spread the word.

Thus the Curwen Press began, but between 1863 and 1916 only the content of what was published at Plaistow was considered; visual qualities were apparently of little consequence. When the founder's grandson, Harold Spedding Curwen, took over management of the Press shortly before the First World War, he inherited action songs with a plethora of excruciating typefaces – the droopy blobs of Victoria, the elongated Edina, the peg-leg Gresham – often jumbled higgledy-piggledy into one job; not to mention advertising accounts for a certain sanitary fluid which had been devised with all the vulgarity of fifteen-colour chromolithography. It was this visual wilderness that Harold Curwen transformed, and no small part of that transformation sprang from his happy introduction of independent artists to design for the Press.

Harold Curwen

Many of the qualities that made Harold Curwen an outstanding printer can be seen to have sprung from a somewhat unconventional education. Being Nonconformist, his parents had no desire for an Establishment education and he was therefore not sent to a public school, but to the progressive school–Abbotsholme. There the founder Dr Cecil Reddie, though rigidly autocratic, even believing there was a 'right' sleeping posture, was willing to explain and patiently reason out his theories at length. He also believed in social fairness, and that education of the hand was at least as important as academic learning. Craft work was a compulsory part of his curriculum, and cooperation and leadership were emphasized, rather than competition. As well as beginning his career in printing at school, Harold worked in wood and metal; all his days he delighted in hand-made objects and fashioned them himself, so that his leadership of the craftsmen in his firm was solidly based on his own practical experience. He was also receptive to new ways of doing things, ready to experiment, and although there were inevitable paternalistic overtones in his relationships with his workers, his mind was exceptionally open. In 1916 we find him writing his *Diary of Odd Matters* in a way to delight feminists, that because war has claimed the men, women are now preparing zinc plates: 'which work was done by a man before and the change is most satisfactory'. He held ballots before making changes in working hours, his was among the first printing firms to introduce the five-day week and two weeks holiday a year, and the young Oliver Simon was impressed when, upon the proposal that he should join the firm as a pupil, Curwen consulted with the Combined Chapel at his works and wrote: 'We couldn't possibly wish for a more intelligent committee. You see I've great faith in *real* Democracy and want to carry this through properly. If so, you'll find it much easier and pleasanter than if I bring you in over their heads. . . .'[1]

This may seem, at first sight, peripheral to his relationship with artists, but it is not. His openness to new things in a period of enormous change was the crux of his technical expertise. His patience in explaining change to his men matched his teacher's interest in expounding the results of his experiments to all-comers, but particularly to artists. Above all, the rather special cooperative spirit which was to be found among his craftsmen, created the kind of sympathetic atmosphere in which artists can work.

Noel Carrington, both friend of Harold and customer of the Press, relates that there was not a job Curwen could not do as well or better than his workmen. Yet at the same time he shared problems with them, making of them, in Christian Barman's words 'a common adventure'.[2] George Truscott, compositor at the firm from 1925 to 1976, recalls that unlike today's designers, who leave a compositor no room in which to exercise his skill but tie him down to the last em, Curwen (and later Simon) would make a rough layout, indicate a face, but leave the sizing and spacing to the man on the shop floor and then, only if necessary, refine the proof. In this way full participation, of the kind envisaged by William Morris, was extended, for Harold Curwen cared deeply about job satisfaction. That is why so many employees stayed so long. He cared about relating directly to his employees himself, as well. Truscott still remembers, wonderingly, that if Curwen was in the firm on pay-day he would personally take over the handing out of the wage packets from the cashier, saying thank you to each man as he left at the end of the week.[3]

At the same time, Bert Marsh, former sales manager, remembers almost equating Harold Curwen with God; he seemed to know the answer to everything! Significantly, the hand-made grey and vermilion box on his desk—an example of his own cabinet making in which he kept the tools of his trade—was known at the Press as the Ark of the Covenant.

Curwen as Designer

Another of Curwen's formative influences following apprenticeship at his father's Press and a study year at Leipzig, was his spell in Edward Johnston's class at the Central School of Arts and Crafts towards the end of the first decade of this century. Johnston was a calligrapher who had studied classical, medieval and Renaissance texts and believed the instrument used to form letters should

condition their shape – an aspect of the philosophy of truth to materials. He designed the sans serif lettering used by the London Underground from 1918, but Harold Curwen designed his own sans serif typeface earlier while he was studying under Johnston, and he too based his forms on Roman models tracing them with a round lettering nib. The capitals were first printed from line blocks, then finally cast in 1927. Not everybody thinks the lower case, added at this time, works too well. It has an astonishing Greek 'e' and a somewhat idiosyncratic staccato 'g', but when it appeared in the *Curwen Press Miscellany* in 1931 Edward Bawden was enthusiastic enough about its nonconformism to write:

> Your typeface seems to me to be one of the most inspired and youthful pieces of work in the whole book. How dare you at your age – ripe, merry and secure – to be so provocative with your lower case. I threw up my hands, so to speak, with amazement at such naughtiness. Admiration followed.[4]

Curwen, helped by H. K. Wolfenden, had also produced a sturdy poster face and in the *Miscellany* of 1931 it was clear that he had turned his attention to the design of music punches, enlisting the help of Paul Woodroffe (who designed the Press's first Unicorn) and setting about a 'conservative reform' by altering the note-heads to damson shape and carefully proportioning the lines, tails and slurs so as to allow room for increasingly complex notation to breathe upon the stave.

Christian Barman has stressed that Curwen did not start a new press, 'he inherited an old one and it was necessary that this inheritance should be transformed at his hands'. It was by no means as simple as it sounds. His compositors felt they were losing old friends when he took advantage of a Government munitions drive to sell off as scrap 20 old-fashioned typefaces and they had to be converted to his decision to concentrate on the remaining four, plus the new Imprint and Kennerley. Despite the mildness and diffidence which every commentator has noted in his demeanour, Barman recalls that he also possessed the necessary 'core of extreme toughness' and 'a streak of the heroic' to fit him for this task.

Abbotsholme had introduced Curwen to Arts and Crafts ideas of integrated work, of good design permeating to everyday things and these aims remained in part the aims of the Design and Industries Association of which Curwen was a founder member in 1915. Here 'fitness for purpose' became the watchword, and Curwen spoke and

the progress of

Harold Curwen, sans serif type, 1927

Paul Woodroffe, Press Unicorn

wrote not only about that, but of his evangelical belief that the aim of work should not be personal gain, but the good of the community.

Through the Design and Industries Association Curwen met a number of other design enthusiasts who became valued customers, as well as Joseph Thorp, whom he employed as a printing consultant for three years from 1918, and who put the fillip of his extrovert personality at his service.

A quite hilarious and self-confessedly flamboyant little booklet called *Apropos the Unicorn*, after the trademark he had encouraged Curwen to adopt, sang Thorp's praises of the Press in lively button-holing style, and was embellished with a string of artists' unicorns. Macdonald Gill's unicorn in a printer's shop, like a bull in a china shop, impales bad typefaces and worse printers on his horn. The Knight-in-Armour Curwen raised aloft on a Cosomati shire unicorn is unwilling to be dragged forward by Thorp (complete with megaphone) because he baulks at riding out and sounding his own trumpet. A frisky bucking unicorn by Phoebe Stabler is similarly leashed by a chain of roses. Unabashed, Thorp now a medieval squire in motley with a feathered cap, insists on being the 'Champion of Frankness' curvetting out all a-jingle on a gaily caparisoned and wickedly glinting unicorn steed drawn by Dorothy Mulloch, the Curwen shield raised aloft. The Curwen Press, says Thorp, produces the best business printing in England–'simple, direct, distinguished, intelligent, individual and adventurous'. Artists, he said, had commented on Curwen's skill with colour. Curwen was an expert and transparently honest when it came to costing, and what he printed was good because appropriate: a corset catalogue would not be printed in the same way as an invitation to dine with the Guild of Fishmongers. He had found the right formula, which was to make printing so excel that none could possibly find its way into a waste-paper basket.

The booklet was almost bursting at the seams with unicorns, because in the same tiny format were two more, not unrelated to rocking horses, designed by Claud Lovat Fraser who was probably introduced to Harold Curwen by Thorp. He was the first independent artist (already famous for his theatre designs) to work for the Press and he flooded Curwen with little vignettes and headpieces appropriate for a multiplicity of purposes, as well as giving him the idea of the Curwen Press papers. In the years following the First World War, clearly benefiting from the example of these two friends,

Lovat Fraser, Press Unicorn

[13]

Harold Curwen went on to design a number of publicity shots to whet the appetite of his customers for his work.

He advertised his unicorn again as an intelligent and adventurous beast always trying new strokes. He headed another bill 'Printing with a Spirit' and beneath a boy and rising sun by Doyle Jones avowed: 'It's a great pleasure to arrange fine type and still finer artistry to convey the spirit of your message. And work that is a pleasure is usually a success.'

He had the artist 'D.M.B.' design a tiny scent bottle label as the kind of thing to be aimed at in commercial printing – decorative, interesting, virile, with lettering 'built in' to the design, yet not spoilt with overcrowded detail.

These 'fresh' things are not normally possible to the regular trade 'Artist' who has his nose on the commercial grindstone 8–9 hours every day. I get help in this matter wherever I can find it. Let me in turn help you!

said his text.

In 1921 his grander brochure *Business Printing* told customers that 'a well balanced and orderly form makes for orderly work and conveys an impression of efficiency' – a kind of expressionism in accounts statements that was accompanied by a lesson in house style.

But the most famous of all his publicity shots was that with Lovat Fraser's boy and girl skipping across the fields with a great swag of ribbon between them above the message: 'Get the spirit of joy into your printed things.'

By the time of the second Double Crown Club Dinner in 1924 this marvellous invitation to adventure in jobbing printing had settled into history and Gerard Meynell in the menu was able to send up not only the 'Spirit of Joy Cheerily Era' but Oliver Simon's new style with printers' flowers.

As Holbrook Jackson was to comment over ten years later, Harold Curwen had abolished class distinctions between books and jobbing printing.

Under this generous influence the Cinderella of the Printing Arts was fitted with the missing glass slipper. Leaflets and booklets, invitation and menu cards, folders and stationery and press settings, developed style and charm. It was as though a company of drabs had been transferred from squalor to opulence.[5]

The designer, Ashley Havinden, on hearing of the death of Harold Curwen in 1949 revealed that he had collected examples of Curwen's

D.M.B., *La Mariposa* (Cat.5b)

Lovat Fraser, publicity shot, 1920 (Cat.18c)

jobbing printing and would occasionally 'refresh my jaded feelings about contemporary problems of design by taking heart from their simple and forceful charm'.[6]

Curwen's Approach to the Artist

The printing of illustration is perhaps best understood as a form of transfer in which one matrix (in the case of monochrome) or a set of matrices (in the case of colour) can repeatedly impart an image to successive sheets of paper. In the days when Curwen was operating, if the artist was directly concerned in hand-making the matrix– by engraving on wood or copper, or by drawing in special crayon or ink upon a lithographic stone–the printed result was called an original. The printer's role was then confined to printing the edition, and if the artist also supervised this, his control was absolute.

If, however, the artist, rather than become involved in the print process himself, made a picture or design in oil or watercolour, the printer's role was then either manually or photographically to convert that image into a printerly interpretation. Although it grows more sophisticated with each successive year and new techniques are constantly being tried, the photo-mechanical copying of work in other media almost always results in an approximation, for economy invariably decrees that the myriad hues of the artist's palette must be confined to the range of the four-colour process, while except in collotype, now very nearly extinct, the nuances of wash and tonal variation are usually interpreted by the mechanical half-tone screen. Within one colour, this artificial fragmentation of the image, into a subliminal patterning of dots, suggests paleness by scattering tiny specks and intensity by accumulating larger blobs until the point where they run into each other as solids. Even today, in the most careful hands, distortion of the original is more likely than not, and at the time when Curwen began his printing revolution photo-mechanical results were quite often a travesty of the artist's intention.

All his biographers recall that Harold Curwen loved artists about the place and was never happier than discovering men of talent and giving them commissions. Although she was at boarding school during the most rapid period of growth at the Press, Curwen's eldest

daughter, Isabel Cameron, remembers the excitement her father felt about the work he commissioned in the 1920s and that artists frequently came to the house. She particularly remembers Edward Bawden, who painted her a Red Indian outfit on hessian. Noel Carrington writes that Curwen 'had an unfailing admiration for the creative artist, whether draughtsman or photographer' and that it was common to meet such men and women at his home any weekend.

Curwen also had unusual perception and Christian Barman has written of its almost tactile quality: 'there were moments when his eyes resting on the print he seemed to be feeling it with his eyes rather than looking at it, using his eyes as a blind person uses his fingers.' When they didn't want to make original prints, this gift allowed Curwen to help artists to design with a particular and appropriate process in mind.

In the early 1920s Curwen's exploratory use of the 'colour line block' admirably suited the work of Lovat Fraser and Albert Rutherston. Lovat designed in bold black line solidly infilled with coloured inks of vivid hue. His friend Albert Rutherston also learnt to make a pen and ink outline and then, on a printed proof, to judiciously fill in areas of colour in keeping with the capabilities of the zinc block. The tiny *Four Seasons* – a calendar the Curwen Press circulated in 1922 – drew lavish praise from all quarters for its intense little illustrations. 'I am filled with a desire to possess two copies . . .' wrote E. C. Gregory of Lund Humphries[7] and the formidable Henry Tonks of the Slade had this to say:

At this time when men's minds seem turned only to machinery and when they treat art and the artist with contempt, there is some satisfaction in finding a firm who knows how to make use of so fine and delicate an artist as Mr. Albert Rutherston and can produce so charming a little book.[8]

And the artist himself requested Curwen to thank the craftsmen who had carried out the work:

I have never had any designs of mine more beautifully reproduced than these and I do realise the very great amount of care that has been taken not only by yourself and Simon, but by those who control the presses.

It seems to me always that here is where the wonder of the machine comes in – when it is controlled – and takes its proper place as the servant of man.

Too often we become its servant. Then away fly all the

PLATE 1

Eric Ravilious, illustration from *High Street*, 1938 (Cat.178)

PLATE 2

THE LUCK OF
THE BEAN-ROWS
A FAIRY TALE TRANSLATED FROM
THE FRENCH OF
CHARLES NODIER
ILLUSTRATED BY
CLAUD LOVAT FRASER

LONDON
DANIEL O'CONNOR
90 GREAT RUSSELL ST., W.C.1

Lovat Fraser, title page from *The Luck of the Bean-Rows*, 1921 (Cat.30)

PLATE 3

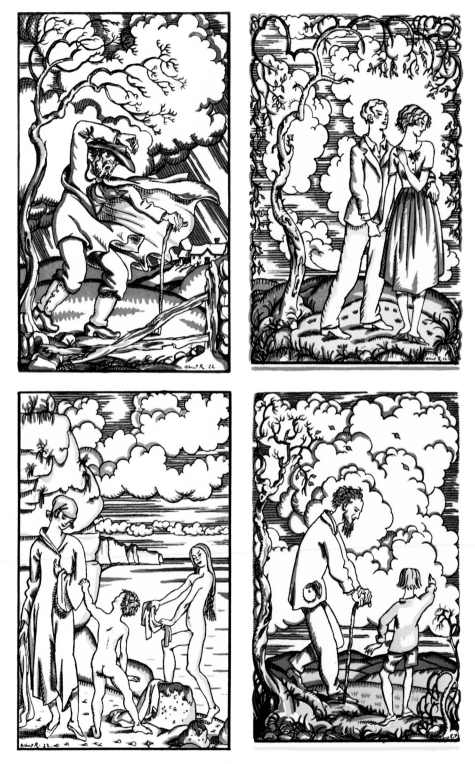

Albert Rutherston. *The Four Seasons*, 1922 (Cat.44)

PLATE 4

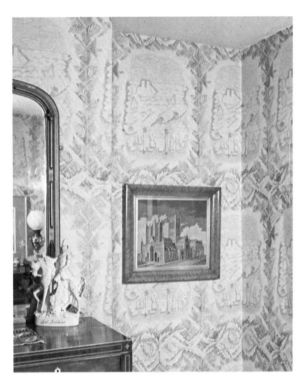

Edward Bawden, Wallpapers (Cat.116)

left, *Riviera*
below left, *Pigeon*
below, *Conservatory*

Opposite page:

Curwen Press pattern papers,
reproduced actual size

top left, Paul Nash
top right, Lovat Fraser
bottom left, Enid Marx
bottom right, Barnett Freedman

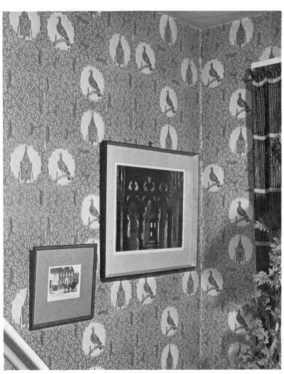

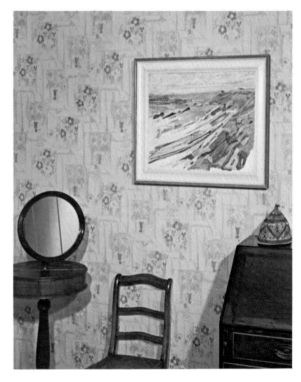

PLATE 5

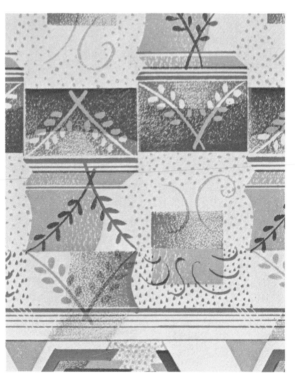

PLATE 6

Barnett Freedman, illustration from *Lavengro*, 1936 (Cat. 140)

PLATE 7

John Nash, illustration from *Men and the Fields*, 1939 (Cat.211)

PLATE 8

E. McKnight Kauffer, illustration from *Elsie and the Child*, 1929 (Cat. 153)

qualities we love.

> In your works always you control the machine, hence the
> excellent results you get, making it a great pleasure for people
> like myself to work with you or for you.[9]

'Controlling the machine' was a great factor at this time when
hand process was still equated with fine art, and industrial process
with commerce; but of course it was the possibility of designing well
for the machine that both Curwen and Oliver Simon in their
different ways were exploring.

The mechanical method was all very well, wrote Harold Curwen,
but it must not 'cut out control by the imaginative author of the
design reproduced'.[10] He always encouraged artists to supervise the
proofing of their work and to deal direct with the press rather than
only through the intermediary of a third party such as the pub-
lisher. For example, the Press printed the imaginative series of
Ariel poems for Faber begun in 1927. These were alternatives to
Christmas cards comprising an unpublished work by a distinguished
poet illustrated by a sympathetic artist. To keep the price reason-
able, Faber tried to devise a colour range which would control the
total number of printings on a set of eight poems printed at one
time. Some artists, notably Paul Nash, felt consternation at being
restricted or having colours predetermined. When the matter of a
'virulent azure' he objected to on one of the poems had to be taken
up with the Press, Curwen replied: 'I think it becomes obvious that
one cannot get two artists to agree on the same shade and it is
inevitable that each one should be dealt with individually.'[11] Curwen
wanted to consult the artist at all stages, and to try to incorporate his
ideas, which he realized would act as a stimulus to good work.

Another unusually effective reproductive process Curwen took up
and improved was stencilling. Around 1925, he came across Jean
Saudé's *Traité d'enluminure d'art au pochoir* and started his own
experiments, introducing something already quite common in
France to England. His chief development was the use of a celluloid
rather than an oiled board or copper stencil, which allowed the
users to see the key design beneath as they brushed the colour
through the open areas. Usually the key was printed by letterpress,
lithography, or rarer processes such as photogravure and collotype,
then colour, exactly as that used on the original by the artist, was
applied by hand. The most brilliant adaptation of the process seems to
have been made by E. McKnight Kauffer who designed two Arnold

Bennett books. In *Elsie and the Child* he used opaque gouache stippled in places by a sponge-like brush; in the later *Venus Rising from the Sea* the lucidly drawn subtle grey lithographic line is coloured by passages of swiftly brushed watercolour. Kauffer enthused about the method and Curwen's ingenious and inventive understanding of it when writing the introduction of a 1930 catalogue of work stencilled at the Curwen Press. Equally Paul Nash, whose book *Urne Buriall* was stencilled at the Press in 1932 and was said by Herbert Read to be 'one of the loveliest achievements of contemporary English art',[12] wrote that the Press practised stencilling 'with so much intelligence and with so much sympathy for the artist's requirements that books decorated in this manner have a definitely new aesthetic value'. He also thought the girls showed not only considerable skill, but fine sensibility. 'How many printers would be so thorough?' he asked in relating the way a brush identical to that Kauffer used on *Elsie and the Child* originals had also been used by the stencillers.

Curwen, of course, trained the girls taken from his Bindery to operate the process. The key worker was the stencil-cutter who, as Nash put it, had to divide up the picture as a bird might be carved at table. Oliver Simon has poetically described two of the girls involved. One, Gertrude Temkin – 'intelligent, ironical and graceful . . . straight out of a painting by Mark Gertler', the other, Elizabeth Henderson 'a beautiful gentle Botticelli-like creature' who worked on the Nash book. For nine books listed by Simon, Curwen did both text and illustration, but the Press stencilled other books as well in which another printer had prepared the text, and they also used the process on ephemera. Bawden did some of the loveliest of his decorations using intertwined ribbons of stencilling on a line block fantasy, as well as a leaflet publicizing a tailor. The most incredible trouble was taken over the slightest productions.

Gertrude Temkin has related how Curwen taught her to 'read' the illustration then cut the necessary holes in the celluloid. Her hands would ache from gripping the stencil knife, but Curwen would come along and cut it like cheese. Alas, the depression of the early 1930s put paid to the production of the kind of limited edition suitable for such a process and an outbreak of marriage among the girls, plus stiff competition from France, all contributed to its cessation after 1932. In his biography Simon said the epitaph of the defunct department might well be:

Quality before quantity

Noble struggle before mere achievement

Honour before opulence.

Another of Curwen's technical specialities was printing from wood, which usually meant working with blocks the artist had cut.

The great torrent of wood engravings produced during the growth of the mass media throughout the nineteenth century and ideally compatible with letterpress was largely based on the concept of drawn, particularly pen and ink, line. During the 1920s and following Seymour Haden's campaign for original rather than reproductive engraving, the idea became prevalent, furthered by Rooke and Gibbings, that design on the wood should be produced by whatever the graver could naturally create rather than what it could artificially imitate from an alien medium. 'White-line' engraving became the characteristic mode, with bold areas of uncut black illuminated by skeins of fine lines, flicks of dotting, or shoals of scorper marks. While it was one thing to print such a block by hand onto a sympathetic Chine or Japon paper, the same block machine printed at speed on hard-sized paper was a different matter. If the solids were inked sufficiently to create a living black, then the hair-lines might choke up robbing the work of its light. To get the balance exactly right, to dampen the paper so it could receive a perfect impression, was a skill hard won. Eric Gill was complimentary about the printing of the *Ariel* poem he illustrated in 1927, and Curwen held up the way he made his blocks as an example of good cutting. Between 1927 and 1930 Oliver Simon at the Fleuron annually published *The Woodcut* including work of most of the famous British engravers of the day and many foreigners as well. The fine press-work stands as testimony to Curwen's skill at printing this particular kind of illustration. In 1931 in the *Miscellany* he wrote of the difficulties entailed and of the need for printer and artist to understand each other's intention at the outset; then he dedicated the piece to engravers who did not 'tickle' their blocks and publishers who allowed the printer to choose the paper. Nash, writing of the second volume of *The Woodcut* in 1928, although disappointed in the Continental contribution was warmly congratulatory about the appearance of the book which, he said, was 'as good as ever'.[13]

Harold Curwen left a fascinating series of scrap books which show the care and experimentation he brought to his craft. He pasted in examples of his own and of other people's printing that had pleased

[19]

him. He listed papers and their various uses, and he did light tests on the fastness of coloured inks and annotated the results. Although the way the experiments came about is purely conjectural, there is also a file of autographic illustration by several of the famous artists who worked at the Press in which they appear to be trying out alternative methods of illustrating the books for which they have been commissioned. Nash, for example, ended up illustrating *St Hercules and other stories* by the use of the line block, plus stencilled watercolour. But he also tried out his frontispiece of a frond-shaded lamp as an autolithograph, which Curwen printed direct and offset from his drawing on stone.

McKnight Kauffer, in a style which resembles the *Don Quixote* frontispieces for the Nonesuch Press volumes, also made a stone lithograph which Curwen printed for him in four ways: in black; in the same colour with the drawn values reversed; in terra-cotta; and upon black paper with the lithographic print glittering with aluminium powder. There is also an illustration very similar to the earlier drawings for *Venus Rising from the Sea* in which Kauffer has made his original in drypoint on zinc, and then Curwen has taken an intaglio transfer to be printed lithographically from it. None of these methods was in fact proceeded with; quite different techniques were finally chosen. It is however evidence that before deciding upon any one plan of action, the artists were introduced to many possibilities.

The procedure of taking a lithographic transfer from an intaglio master is one that Harold Curwen borrowed from music. Music, as will be readily appreciated, is very difficult to typeset, and the customary way for Curwen to produce it was to make an intaglio plate by driving punches into relatively soft pewter, take a print in special ink on transfer paper, and put it down on to a lithographic surface. Exactly the same could be done from an artist's intaglio plate. Many of the pattern papers by Bawden were first etched by him, then lithographically transferred, and the artist also did an abstract engraving to illustrate an article that Graham Sutherland wrote in 1937 in Oliver Simon's magazine of the graphic arts—*Signature*. Sutherland told how Curwen had revived the old practice of lithographic transfer from an intaglio print, and compared Bawden's actual inset engraving with the lithographic transfer of an engraving by Jock Kinneir which, Sutherland held: 'Apart from the fact that the lines are not raised above the surface of the paper, is

scarcely distinguishable from one printed direct from the copper.'

Those who love engraving may reflect that it is precisely the fact that its line amounts to a raised deposit of ink on a cast of dampened paper, that gives the process its inimitable crispness. Nevertheless, the lithographic interpretation was a very good one, and since lithographic printing is considerably cheaper for shorter runs than photogravure and easier to mass produce than the complex inking and handwiping of an engraving, it had considerable possibilities in which Sutherland was trying to interest imaginative publishers on Curwen's behalf.

One may also ask oneself whether, if the artist made his block or plate with lithographic transfer in mind, one is to call the result a reproduction or whether it is an original. With Bawden in particular, some wonderful productions—both for wallpaper and posters—came from the artist's lino-cut designs which the Press printed from lithographic plate by pulling a print on the intermediate transfer paper of just the 'starved' quality that Bawden liked. Although Pennell, Whistler and Sickert once waged war in court to decide whether transferred lithographs ought properly to be described as 'original' or not (and made a number of experts look ridiculous through their inability to distinguish one from t'other) lithographs made by the artist on transfer paper are usually held to be the artist's original work. For the printer can almost magically transfer to stone or plate everything that has been drawn on a particular kind of paper in a particular kind of crayon or liquid, simply by treating the result and applying pressure to it in the press. The additional beauty of the device is that the artist does not have to drag an awkward block or plate with him, nor need he draw back-to-front on the stone, which is necessary if he wants a direct print.

The principle of traditional lithography is that a greasy image drawn or painted onto the fine-grained surface of a stone (or metal plate) will accept ink, while the chemically treated and dampened areas of the surrounding stone will not. The technique has won the unlovely categorization of 'planographic' because the design is neither incised below the surface, nor does it stand proud in relief. You can polish the stone and use the finest of pens, you can prepare various degrees of 'tooth' to take beautiful chalk work, and you can apply liquid with brush, spray, or thumb!

You can also prepare the drawing liquid, known as tusche, with various diluents from distilled water to petrol, which make it dry

as a wash in fascinating flow patterns that suggest everything from the eddying of an ebb tide, to the globular drift of rain on a wind-screen. You can also apply the grease and then partly scratch back with various knives or scrapers in a kind of mezzotint technique. These more painterly techniques, and later the use of frottages cut out of transfer paper and collaged, have on the whole been used by the great lithographers of the Modern Movement (Redon, Lautrec, through Chagall to Picasso); they were scarcely the norm in the England of the 1930s.

For when Harold Curwen began encouraging lithography for artists in England, despite the Senefelder Club it was very little practised here. Etchings were the approved way for an artist to edition pictures, and wood engravings were for the autographic illus-tration of books. There were however various firms who employed wonderfully clever lithographic craftsmen, in the days before photo-lithography ousted them, in particular to hand-copy originals painted by artists for poster work. The most famous of them all was Thomas Griffits who worked for Vincent Brooks Day, then for Curwen's friendly rival Fred Phillips of the Baynard Press. Although the Curwen Press also provided lithographic craftsmen, and as late as 1941 were brilliantly hand-copying a Paul Nash watercolour, Harold Curwen's whole approach to the technique was to encourage artists to make the lithographs themselves. In 1929, Kauffer's girl-friend Marion Dorn autolithographed *Vathek* at the Press for Nonesuch and throughout the 1930s tremendous work in posters, in book illustration—even in book jackets by that arch-autolitho-grapher Barnett Freedman—was supervised by Harold Curwen. Baynard were similarly busy. In fact, Griffits was Barnett's first teacher. But both Robert Wellington and John Piper, who from 1936 to 1938 commissioned twenty-five artists in a most imagina-tive two part programme of lithographs for schools, favoured the Curwen Press because of Harold's understanding of artists. By the time their second group was to be made, Harold Curwen was with-drawing from the Press because of a nervous breakdown that even-tually robbed printing of his capabilities for good. So half of that group of prints were done at the Baynard Press. Here Griffits was certainly helpful, but he was a forceful character, who, because he was grounded in the days of chromolithographic copying, liked to take over the job and dictate the moves. Wellington and Piper both report that the atmosphere at the Curwen Press was quite different

[22]

because with Harold Curwen an artist's intentions were paramount.

Curwen recovered his health sufficiently to become a country grocer during the war, and though he retired after the war from all business activity, he was still in touch with his artist friends. Edward Bawden was still writing to him in 1945 for advice about the best order of printing his lithographic colours–possibly with *The Arabs* in mind–and Curwen, who was revising his *Processes of Graphic Reproduction in Printing*[14] (dedicated to 'those users of printing who allow good work to be done') welcomed the query because it helped him shape his revision.

The Arabs was itself an indirect outcome of Curwen's enthusiasm for autolithography for he had managed to infect Noel Carrington with the idea by showing him Barnett Freedman's work and Carrington in turn suggested Puffin Picture books to Allen Lane. The first were published in 1940, and out of 108 titles sixty-three were autolithographed at various firms. This meant that artists' originals were being widely circulated in inexpensive books. 'For several artists', writes Carrington, 'it was their first use of the medium. Not all printers would accept artists doing their own plates through trade union prejudices. Curwen were always ready to help artists.'

The other area in which Harold Curwen's contribution showed originality and understanding was in his use of photography, for while he welcomed autographic illustration he also seems to have been early in his appreciation of the photographer as artist. He was a very good amateur photographer himself. In fact, one of his own photographs–of a child nestling in fluffiness–was used in a Witney blanket advertisement. But the industrial photographer he commissioned most was the brilliant Francis Bruguière who worked on striking booklets for Gestetner and Bryant and May. In them Curwen's frank, plain, open concept of typography is teamed with the timeless photographs which he allowed to bleed at the edges rather than confining them within a framework. In *Match Making* for Bryant and May, they perfectly complement the text pages set in a large fount of Baskerville which itself has very little margin. What is even more remarkable about the photographs is the way Paul Nash's cover, making patterns of logs and matches which recall the 1929 painting of stylized logs in his garden at Iden, is picked up in Bruguière's endpapers showing serried ranks of untipped wooden spills. In the yet more amazing almost abstract

photographs of the weird wheel and scaffold structures of the match packing machines, one imagines, prefigured, the works of Nash to come such as *Voyages of the Moon* or *The Mansions of the Dead*.

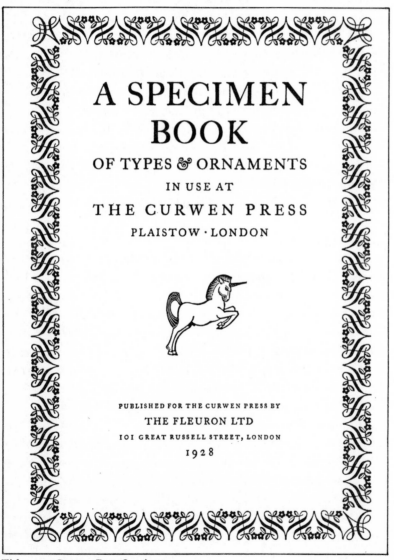

Title page, Curwen Press Specimen Book, 1928 (Cat.7)

Oliver Simon

Christian Barman in an article about Harold Curwen mentioned 'the breadth and catholicity of a mind that could accept and absorb not only the incandescent novelty of artists like Lovat Fraser and the young McKnight Kauffer, but a typographic genius like Oliver Simon with an outlook almost diametrically opposed to his own'.[1]

Simon himself was 'amazed' at the freedom Curwen gave him in his own sphere when after his period as a pupil he was employed by the Press to try and introduce more book printing. Because of that freedom, and long before the job of typographer was a recognized profession, Simon became an internationally famous book designer.

Like Curwen, Simon's youth had been rooted in the Arts and Crafts movement. Although he doesn't mention it in his biography, his parents were members of the Ancoats Brotherhood which provided a platform whence men such as William Morris and Ford Madox Brown carried art and beauty to the meaner streets of Manchester. The Simon home was full of good design and, in addition, his mother was born a Rothenstein, sister to William, later to become Principal of the Royal College of Art, and to Albert (who changed his name before the First World War to Rutherston).

The story is well known how Simon, befriended in London by his two artistic uncles and looking for a job, saw a display of Kelmscott Press books in a bookshop in Piccadilly, and on the spot decided he *must* become a printer. Before long he turned away from his uncritical view of the private presses, rejecting their subservience to illustration on wood, and above all, their preaching of legibility and accessibility while failing to achieve either. He did, however, retain an admiration for Lucien Pissarro's Eragny Press and the exquisite feeling of his coloured wood engravings and he visited him and later featured his prints in a postwar issue of *Signature*.

In company with Francis Meynell and Stanley Morison, Simon, while admiring the presswork and standards of craftsmanship of much private press work, was against their backward-looking archaism, their elitism and prejudices about hand setting, and was in favour of modern methods of production to achieve good design and wider distribution. Although it is true to say that many of the loveliest books Simon created were also in rather small editions, by using twentieth-century methods he at least demonstrated a potential fusion of mass production and fine printing. His ideal, which he expressed in a privately printed conversation with Hamish Miles, was not the self-conscious book 'but to see all that is good, beautiful and magnificent in printing arise spontaneously from everyday work'.[2]

Where artists were concerned, Simon was against redrawing Renaissance ornament and for seeking out the work of original artists of his own time. When he did establish book printing as an important area of Curwen Press activity he commissioned many of the most notable artists of the day to design ornaments, initials and printers' flowers. 'Surely each generation ought to leave its characteristic imprint?' he asked in Curwen publicity in 1922.[3] Partly influenced by Poeschel and E. R. Weiss in Germany, the use of the fleuron, or printers' flower, which Meynell started at the Pelican Press, was to become his own hallmark.

When he took an advertisement in the first issue of *Imprint* in January 1913, Harold Curwen had not only claimed to print 'artistic and forceful' showcards, pamphlets, etc. but also 'the printing and binding of beautiful books of every description'. In fact, he did very few books until Oliver, installed in a West End office, started to pull in the orders.

The first Lovat Fraser book in colour line block to be printed by the Press appeared in 1921 and bore the marks of Harold's style. With *The Four Seasons* of 1922–the very successful Curwen publicity calendar and declaration of beliefs already mentioned–the book is already reeking of Oliver's influence. Earlier the same year with Stanley Morison, Francis Meynell and others, he had suggested a publishing society to collaborate in demonstrating to collectors that books set by machines could also be beautiful. The group met once, but failed to agree on a corporate policy, or to produce more than a sheet of headed notepaper. Francis Meynell believed this was largely because Oliver Simon could never adjust

to a committee of more than one. Only their name–The Fleuron–
survived. In a different context, this became a new journal of typo-
graphy which Oliver Simon and Morison planned over tea at Lyons'.
Simon edited the first four issues and Morison the remainder, and it
was a model journal, the name of which Simon subsequently bor-
rowed for his personal publishing activities.

Simon shared his London office with Morison and was first to
admit that the influx of visitors who came there, plus the encyclo-
paedic knowledge Morison generously shared, meant that for nearly
three years he enjoyed a private university of printing. It helps
account for his meteoric rise to eminence. In 1923, the year after
The Fleuron was first mooted and in which Oliver brought out the
first issue of his journal, Francis Meynell began the Nonesuch Press
(dedicated to the production of fine and very varied books by
machine) and Morison began his revolution of the Monotype faces–
in which, without losing the subtlety of hand work, the setting of
type could be mechanized avoiding assembling a multiplicity of sorts
by hand in a composing stick. By 1924, after he had published his
catalogue of books printed at the Curwen Press from 1920 to 1923,
Simon's style had already become a legend, and he went on to
establish its clarity, rectilinearity, restrained use of ornament, and
exquisite choice of fount to express the subject through physical form.

While Harold, the craft-based printer with his main interest in
the raising of standards for business printing operated in the East
End, the cosmopolitan and sophisticated Oliver, who had now moved
to Great Russell Street, 'made his empire in Bloomsbury'.[4] Accord-
ing to his brother, he never mastered the manufacturing side and
did not, like Harold, identify with the works' team, although
when he was later awarded the O.B.E. he did make a point of telling
the men that the honour belonged to them all.

Although he sometimes handled business printing (some Council
for the Encouragement of Music and the Arts and Arts Council
catalogues bear his unmistakable stamp and are models of their kind)
he never liked jobbing printing because of the degree of customer
control. He always wanted full authority. Holbrook Jackson has
written that:

Artists did commercial work without losing their integrity as
artists. Claud Lovat Fraser with his Regency mind and twentieth
century technique did any job of work that came to his hand, from
trade circulars and booklets to editions de luxe and stage décors.

McKnight Kauffer's mechanistic emblems began to crackle on the hoardings. Paul Nash made a brief excursion into typography bringing a new abstraction to the decoration of books. Albert Rutherston made form and colour dance to a new measure that was refreshingly old, and Thomas Lowinsky wedded a modern ornamentation to the printed page.[5]

But where this activity embraced the ephemera of advertising it was left largely to Harold, and, in the club that he founded, Oliver always resisted the incursion of advertising men, because to him they represented compromise.

The first catalogue raisonné that he produced states that the items listed were not a complete record of the Press's work but only those books 'where the design and choice of materials has been freely committed to the printer'.

This means that Harold Curwen may well have slaved over the extremely tricky illustrations for a book the text of which was printed elsewhere, without it being credited among Curwen Press titles. The *Mask of Comus*, a Nonesuch production of 1937 illustrated by Mildred Farrar (owing perhaps a debt to Bawden), was a case in point. Even when a printer has set the text, he does not normally appear in concise catalogue details since it is considered more relevant to name the publisher who put up the money.

It is often very difficult, so much being conducted verbally by telephone, so many publishers having no archive of past correspondence, to discover exactly who did what towards the publication of a book, but one of the well-documented books of the 1920s is the *Chatto and Windus Almanack* of 1927, the only book ever illustrated by Stanley Spencer. Letters reveal the artist was clearly commissioned directly by the publisher who had the blocks made and corrected at his office, and then forwarded them to the Press with paper specification and some kind of design. But since Oliver claimed credit for the work in his catalogue he must have felt he had materially affected it. Whatever the case, Spencer writing to Chatto and Windus late in 1926 expressed a great delight at the result: 'I was much taken with the proportion; the "de luxe" lids and especially the type, small but clear . . .' and 'the whole get-up is so in keeping with the drawings.'[6] The Tate Archive has two fascinatingly annotated copies of the book that Spencer purchased at the time, in which he has squared up and clearly developed the drawings, some of which were to become major paintings.

Stanley Spencer, illustration for *Chatto and Windus Almanack*, 1927 (Cat.240)

This sensitive matching of the typeface to the illustration, both of which are chosen for their compatibility with the content, is nowhere more dramatically seen than in the Nonesuch *Genesis* of 1924. The book, designed by Francis Meynell, is based on Paul Nash's woodcuts which proceed from an all black void through various irradiations as God creates the world. The solidity and weight of the blocks are perfectly matched by Rudolph Koch's Neuland typeface, specially imported. Oliver claimed to have had a hand in this book too, since it is one he lists in his catalogue raisonné, but just what interaction there was between printer and publisher either on this, or on Wadsworth's *Sailing Ships and Barges*, where the light elegance of Koch Kursiv is set against spare and graceful line engravings, it is impossible now to discover.

One book design which did largely spring from Oliver was *Urne Buriall*. Although there would have been no book had Dr Desmond Flower of Cassells not been adventurous and knowing enough to give Oliver his head, the idea for a magnificent work to be illustrated by Paul Nash was initially put to him by Oliver. Dr Flower has related in Herbert Simon's history of the Press[7] that he always gave Oliver a completely free hand with the design of his books, regarding him as 'the master'. So after John Carter had been approached to edit the text Nash chose, Oliver set to work. The paper was made to his satisfaction, the typography was of course his and Nash communicated about his stencilled illustrations directly with the Press. Indeed, only the collotypes and the binding were handled elsewhere. Dr Flower generously credited all concerned in his publisher's note, but the customary catalogue entry would reveal none of these facts about one of the most vital protagonists.

One could quote countless letters of appreciation at about this period from those whose opinion Simon respected. Nash, always perceptive and difficult to please, thanked him for a copy of the *Specimen Book* in 1928 saying: 'I am very proud to possess it . . . it should establish you in a very distinct position among men of taste and you know the old saying about it being so much easier to find men of genius than men of taste.'[8]

Three years later when the *Miscellany* came out, even Harold Curwen was moved to write of his 'quite unbounded admiration'[9] and of how proud he was to be associated with the achievement. Both these books were created to demonstrate the typographic possibilities at the Press. They are exquisite testimony to Simon's already

Of this Edition, printed in England, on Zanders hand-made paper, at the Curwen Press, 450 numbered copies have been issued

This is number *83*

Edward Wadsworth, engraving for
Sailing Ships and Barges, 1926
(Cat.236)

mature style. The border of each page is perfectly matched to the fount, and the actual excerpts used to display type are also a revelation, for they reflect many of the current ideas in printing with which Oliver presumably agreed.

Dr Flower has talked of Oliver's spirituality–that his sights had been raised to a point at which he could no longer see this sordid world. His daughter Jill remembers him as a very affectionate and interesting father, but recalls that because of his shyness and a Puritan streak, he apparently seemed formidable to many 'despite his lovely smile and small stature'.[10] Even his brother George, she writes, was in awe of him. At Sunday lunches at Downshire Hill, in which both his children were always included, Oliver would gather groups of people together that he felt would find each other interesting, but he rarely mixed the three distinct categories of artists, writers, and printers or typographers. Most of the contributors to *The Fleuron, Signature* and *Horizon* came to the house, and during the war many Hampstead intellectuals–such as Stephen Spender, Anthony Burgess and Roland Penrose, distinguished members of the Air Raid Precautions unit–sheltered under a large table in his kitchen, indulging in utopian conversation.

> He was a habitudinarian . . . [writes Jill]. He caught the same train to Plaistow every day, walking along the same streets to get to the station, sitting in the same carriage and wearing the same coat or mackintosh year in and year out. He was the most un-vain man I have ever known, but being a man of habit he liked his ties in an old tie box and his things were to be found in the same place for all the years he lived in Downshire Hill. If a book was put back in the wrong place he noticed immediately. . . . Books were his source of life. He loved the feel of books and would sit in his armchair by the sitting room fire turning one over in his hands and tasting it, so to speak, as anyone else would taste good wine. He loved the touch and feel of paper and this was when his sweet and affectionate smile would light up his face.

Oliver's brother Herbert writes that 'he revelled in being a patron and his own sensibilities guided these enterprises with wisdom'. His patronage of course was mainly that which he could offer through his contacts with the Press. Sometimes the Press commissioned and paid for work direct, but since the commissioning firm was often simply using the Press to realize work for which it footed the bill, it was a case of putting in a good word at the right time and suggesting

a suitable artist for a particular job. Robert Wellington, who got his job at Zwemmer's Gallery through Oliver Simon's recommendation, remembers how very good he was at putting in a word.

Although Lovat Fraser and Rutherston were already famous in the theatre, a great many artists that Oliver Simon introduced to the Press were virtually unknown when their work was first sought. Even those who were relatively well established could do with a helping hand, and on at least one recorded occasion Simon sold some of Paul Nash's woodcuts to an American buyer. Graham Sutherland remembers the help Oliver gave him with real warmth. 'Oliver was of immeasurable help to me in every possible way', he wrote, 'encouraging me to write and reproduce my work in *Signature*. He was also the first person to bodily take my work around to various collectors, physically carrying the work himself. . . . He was not only a great typographer but also one among very few patrons of great intelligence.'[11]

Oliver owned paintings by most of the artists who worked with the Press and obviously went to their exhibitions. 'Alas not all my friends show the same dogged affection for my work'[12] wrote Bawden in 1939. Michael Ayrton, who wrote on Chagall for *Signature* after the war, was equally appreciative. A letter of 1947 suggests: 'If you know of anyone likely to employ me on anything, let me know in your usual invaluable way. I have nothing much before me except one book and some lectures, so I shall be quietly painting until I am removed to the poorhouse. . . .'[13]

All these friendships are described in Oliver's autobiography and after reading that part of it describing her late husband, Margaret Nash wrote to Simon:

> I realise how well you write and how perfect is the description you have put down of him both physically and mentally. You are indeed an artist in your assembly of facts and recollection and in the lively way in which you present the artists and writers who had the good fortune to meet you and to work with you.[14]

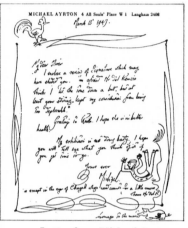

Letter from Michael Ayrton to Oliver Simon, 13 March 1947

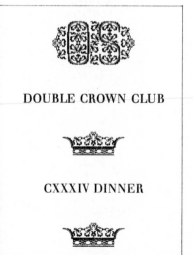

Hans Schmoller, Double Crown Club Menu No.134, 1956 (Cat.3c)

Artists and the Double Crown Club

Undaunted by his failure to get The Fleuron publishing society off the ground, Oliver Simon nonetheless suggested a dining club in 1924 for those interested in good printing. As a founder member, he got together a small committee to direct things. The name of the

club referred to a particular paper size but also to an intention to 'crown' two books per year, a practice abandoned in 1927 because in effect it meant members sitting in judgement upon one another's productions.

In reading James Moran's account of club proceedings one wonders sometimes if the combination of bibulous conviviality with post-prandial addresses and discussion was the wisest of recipes for a serious exchange of views, for frequently the talks, or certainly the contributions following them, seem to have had a touch of Grand Guignol about them. Moran reveals this with such wry comments as: 'the members betrayed their penchant for running off in chase of their private serifs in all directions'.[15] Edward Bawden's witty drawings of 1935 for dinner No.48 show the transformation of the dining room from its pre-aperitif tranquillity to its post-brandy serif-chasing in the chandeliers.

If the talks varied in quality, however, the perennial wit, imagination and invention in the design of menus, which usually announced the discussion topic, is a lasting delight. The range of subjects covered in the last fifty years is a potted history of the changes in printing and the graphic arts which have taken place. Menus have masqueraded as book jackets, book spines, prelims, stamp books, American periodicals, newspapers, paperbacks, packages, and even as a timetable, the latter cunningly devised by Noel Carrington and printed by Harold Curwen who had clarified the design of Imperial Airways and Green Line timetables. The already mentioned typographic spoof by Gerard Meynell lampooned Harold Curwen by printing the menu headed by a boy on a rocking horse blowing a trumpet à la Lovat Fraser. Meynell similarly teased Oliver Simon by printing it submerged under a positive herbaceous border of typographic flowers. Meynell preserved a space for the next phase – the 'beauty born of simplicity era' – and said the compositor was doing as well as could be expected.

The artists most frequently associated with the Curwen Press in pre-war days nearly all designed menus. Indeed, Bawden, Sutherland, Ardizzone, Paul Nash, John Piper, John Farleigh, Barnett Freedman, Eric Ravilious, Albert Rutherston and Lynton Lamb were all members at one time or another and several gave after dinner papers, as did the calligrapher Reynolds Stone and the typographic designer Dr Berthold Wolpe, also associated with the Press.

They also joined a few cricket outings, for Simon was a great

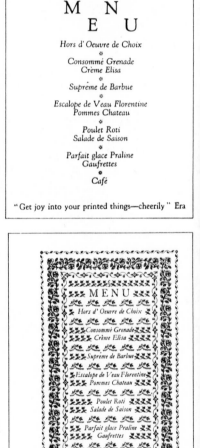

Gerard Meynell, Double Crown Club Menu No.2, 1924 (Cat.3a)

Reynolds Stone, Press Unicorn

cricket enthusiast, and along with Curwen employees, publishers, and typographers, artists would also get roped in to take the field. George Truscott remembers both Sutherland and Freedman coming along to watch matches, and Eric Ravilious, who played for a Double Crown Club side captained by Francis Meynell on an occasion when Oliver was out for a duck, wrote to a friend: 'I enjoyed it all very much and shall hope to play again, as Meynell kindly said that my bowling was of erratic length but promising. . . .'[16]

When it came to menus, Nash, oh-so-characteristically refused to accept the first printing of one he designed in 1925 because he disapproved its quality, although he made good the deficiency later. Sutherland did an appropriately surreal collage for a dinner at which Nash talked on *Surrealism and the Illustrated Book*. Lynton Lamb has suggested that artists 'helped the club . . . to counteract the slight tendency towards gentlemanly philistinism that seasons the salt at high tables' and cites Nash's talk in particular as a timely corrective in this respect.

One could never have called Oliver philistine (though Marcus Brumwell, who directed an advertising agency, recalls he was dubbed 'The Archbishop' once by Ben Nicholson for his slightly rigid and symmetrical rectilinearity). Nevertheless there was a certain amount of friction between artists, who felt they were not understood, and the rest of the members. John Farleigh, Albert Rutherston and Barnett Freedman were heard to mutter more than once that the artist never got a look-in when it came to papers and the discussion. Certainly the great majority of speakers talked on topics from printing or typography. However, Farleigh spoke twice on illustration (which was also dealt with by William Rothenstein, Eric Gill, Roger Fry and Ardizzone) and Barnett Freedman and Berthold Wolpe tackled lithography. When Francis Meynell spoke on 'Art Jargon' in 1952, Freedman designed the most exquisitely tender lithograph of a nude about to be scrutinized and dissected by a queue of critics and connoisseurs doubtless thinking of significant form. The Plastocowell process, which introduced plastic overlays as a means of lithographically transferring artists' colour separations, was also featured, with a delicate use of it in the menu by John Buckland Wright. Various aspects of the artist and the printer were dwelt upon by Noel Rooke, Barnett Freedman and John Piper, the first mentioned coinciding with a Farleigh menu design in which the artist is shown squelching ink all over everything as he is nipped in the printing press,

clearly symbolizing his intuitive role in the clinical typographic scheme of things.

A curious rule, made by Foss and Simon the founders (and eventually rewritten in 1974), proclaimed as eligible for the club artists who had 'illustrated a book typographically' and nobody ever really knew what this meant.

Frank Sidgwick in an article on the Double Crown Club in *Signature* No.2 claimed it was 'intended to allow the election of illustrators who were sufficiently artists to realize that type was not merely an arabesque pattern surrounding their drawings',[17] but in 1946 when the rule was queried by James Shand, Oliver's brother Herbert explained that it meant 'not Rackhamishly'.[18]

Now Arthur Rackham was an illustrator who sprang to fame as the half-tone process was developing, and in the presence of one of his spookily Gothic fantasies, the veils of subtle colour somewhat muddily translated, one is always aware, despite the potency of his imagination, how much lovelier the original watercolour must be. This is quite contrary to the illustrative style of an artist like Aubrey Beardsley who, with his running blacks and intricately stippled textures, was consciously designing for the line block in a way which is ultimately realized rather than debased by its passage through the printing press. Moran has also suggested that possibly, since letter-press was the most common text process when the club was founded, the rule meant to design for relief.

Even Harold Curwen, eventually chief champion of full-blooded autolithography which had in those days to be separately run from the text, spoke to the Design and Industries Association in 1918 saying that the purpose of print was to be read, and that decoration should be subservient to the wording and related to it in character.

In the privately printed conversation already quoted, Oliver Simon agreed with Hamish Miles when he stated he was typographically a puritan and interested in the actual printed presentation of text rather than trimmings. One is always aware that in his own chosen publications, nothing obtrudes. An artist providing embellishments will do it with reticence which blends rather than competing with the typography. Of Meynell's Nonesuch *John Donne* with florid Italian endpapers, Oliver commented that he had 'dressed the Dean in a tart's drawers'.[19] Much later, writing of his own *Introduction to Typography* in 1945, Oliver showed himself aware of the dichotomy between artists and typographers when he told Nash:

I am glad you like my book, although I feel it is a little austere and logical for the enjoyment of artists. It was written much more for the legion of wax-moustached gentlemen who grace the printing trade.[20]

However, in the books which were primarily vehicles for artists, just as in *Signature*, where full-page illustrations in all techniques demonstrated the capacities of their creators, it was difficult to find a rationale for Double Crown Club rule 4c.

Signature

Oliver Simon also styled a number of periodicals, among them *Life and Letters*, the *Book Collector's Quarterly*, a Southern Railway quarterly *Over the Points*, *Wine and Food*, and the influential *Horizon*; but *Signature* was his own magazine. He meant to call it 'Impressions' but later changed the name and issued it three times a year as a quadrimestrial of typography and the graphic arts. It was obviously to appeal to printers and typographers but also to the artist by 'speaking his own language' and introducing him to the work of his contemporaries. In its early days it cost a mere 10/- yearly despite the fact that one might find in it inset collotypes, etchings or engravings, pull-out lithographs and stencilled illustrations. Many of the artists most frequently to be found at the Curwen Press had their work featured, sometimes with several pages of autographic illustration, and many of them also wrote articles. Sutherland and Piper both made more than one contribution, as did Paul Nash who selected material from the early chapters of an unpublished autobiography and called it 'Openings'.

In 1938 Edward Gordon Craig wrote congratulating Oliver and suggesting that for the use of a monoprint (gratis) he might get *Signature* sent (gratis) in return.

'I have made such a design,' he wrote. 'It needs the most careful reproduction and printing so I suppose you are the only one who could tackle it. It's entitled "The King's dead—long live the King" and it's a bit wierd [*sic*]. It represents the gentleman wafting himself out of the window into the Evigkeit.'[21] However, the design, which he wanted Oliver to obtain from Max Beerbohm, does not seem to have appeared.

In the early days, Oliver's artistic outlook tended to concentrate on the homegrown. Meeting Sutherland helped to broaden his

horizon as did attending the intriguing spectacle of the *International Surrealists Exhibition* in 1936 when he inhaled the perfume of a kipper collaged to one of the works and witnessed a sylph seeking publicity for the movement by a mysterious appearance all in white with a fencing mask covered in fresh red roses. Oliver printed the *International Surrealist Bulletin* No.4 about the exhibition, as well as the first issue of the *London Bulletin* for the Surrealists on April Fools' Day 1938.

He had had earlier European publishing contracts through J. E. Pouterman in Paris, and through him had met the artist René Ben Sussan. After 1937, when he visited the Paris *International Exhibition*, there was a strong flavour of the Ecole de Paris in *Signature* as well. Seeing the books Vollard had published was 'like a flash of lightning' and an article by Lynton Lamb which came out in No.8 with Pouterman's help was the first that ever appeared on the subject. Two years later the first handlist of Picasso's book illustrations appeared in No.14 and Oliver Simon became the proud possessor of several Picasso prints. After the war there was Michael Ayrton on Chagall, John Berger on Marino Marini and Denys Sutton on de Stael.

Signature stopped publication during wartime. Not only was the last issue of the old series produced under an open sky because of bomb damage (there were bombs at the Press on 15 September and 13 October 1940 and 19 March 1941) but all Oliver's artists had gone to war.

The sufferings of this gifted band of souls at the hands of the bureaucratic machine at its most deadly has to be read in the Imperial War Museum correspondence to be believed. The problem of whether he should travel first class (as the honorary rank of captain required) or third class (as the rather low pay of £325 for six months suggested was seemly to the official concerned) was visited on poor Eric Ravilious. The artist's widow, after he had been lost off Iceland, waited a year for them to decide who paid her pension in view of the War Artist's ambiguous status. John Piper, relatively happy to be concerned with his beloved churches, if not with their bombing, was not an official artist, it was decided at one point, but a civil servant of the professional and technical grades. Barnett Freedman was ready to give up the unequal struggle when, having fought for a permit to sketch, he was not actually allowed to go anywhere to do so. 'It is really more important to keep out the

Germans than to take in Mr Barnett Freedman', wrote Colin Coote from the War Office, who was all for giving this unruly character, who had dared question an official, his marching orders. John Nash was desperate for work. His brother Paul was desperate for photos. Sutherland was desperate for petrol permits and permits to buy painting materials. Of them all, perhaps Edward Bawden was most in his element. Farthest flung, he travelled the desert finding that without exception natives had better manners, and when eventually recalled he wrote to E. M. O'Rourke Dickey: 'Why do you wish to recall me when at the present moment I have not had the opportunity to contract dysentery, bilharzia, or hook worm? How unsympathetic of the committee!'

Throughout these vicissitudes, the artists missed nothing so much as cultural contacts and Oliver often wrote with news or copies of the journal. When it ceased publication, and Barnett Freedman realized he had to do without it, he wrote that what was needed was a special tiny edition of *Signature* to 'carry all of us on through the dark days of the war'.[22]

In 1942, sending five back numbers of the journal to his uncle, Sir William Rothenstein, Oliver told him: 'It is perhaps remarkable that after five years of such a specialised publication I have a balance in the bank which I am holding in case of restarting after the war.'[23]

That moment came in 1946 and when, after the years of austerity and shortage, Beatrice Warde of the Monotype Corporation received the first copy of the new series she was moved to write:

This *Signature* is like the patch of blue sky that tells us the
storm is nearly over. Nothing your contributors can say in words
can be more powerful in lifting our critical faculties back to
peacetime level than what you and your colleagues have 'said in
deeds' by this combination of good design and craftsmanly
production.[24]

In 1954, after decelerating to two and then one issue per year, *Signature* was wound up with a valedictory poem from Edmund Blunden to Oliver, part of which read:

Learning and life, art and invention were
This work's proud element and character
And now the fabric's seen in its extent
At once simplicity and ornament.

Oliver Simon died, two years after completing *Signature*, in the same year that his autobiography was published.

The Press Postwar and Herbert Simon

After his breakdown, Curwen never again returned to work at the Press, although it was often planned that he should. Oliver and his brother Herbert, who had both become directors in 1933 when the Press broke away from the music publishing side, steered it through first financial depression then war to a secure position afterwards. But much had changed. Although it was still famous for its craft skills, such as the beautiful borders of typographic flowers set by Bert Smith and particularly patronized by Charles Mayo at the British Transport Commission, photolithographic procedures and four-colour offset now rivalled letterpress and changed the nature of the work entirely.

When Oliver Simon died in 1956, Herbert took over management. One often wonders if he ever regretted leaving the Kynoch Press in 1933 to work somewhat in the shadow of his famous brother. For although he was interested in design as well, he was always thought of as the practical man, the business man. Oliver related how, when he and Harold were forced to talk about finance or administration, Curwen would close the discussion with 'Now let's get back to work'. But Herbert Simon was one who realized that finance and administration, which included the restoration of machinery in the plant, were also work. He made possible what the others did by recommending automatic feed, by buying presses that could cope with longer runs and had greater capacity. In fact he replaced the now worn-out machinery installed with music in mind by up-to-date presses more suited to the new roles Harold and Oliver were playing.

Like Harold, for whom the architect Sir Edward Maufe designed the house called Mansard, Herbert had a house specially designed by Christian Barman and he filled it with Edward Barnsley and Gordon Russell furniture. He too loved pictures, hanging works by Bawden, George Chapman and John Piper, whose painting 'Cresswell Mill'

Opposite: Bert Smith, letterpress typographical borders (Cat.13)

was specially commissioned by the Press when he retired in 1970, in deference to his special interest in industrial archaeology. He collected prints about the Industrial Revolution, and loved railways, and his interests brought a number of books to be printed at the Press. He was also a collector of sculpture, owning small works by Elizabeth Frink, Henry Moore and Barbara Hepworth, and when he was associated with the Studio – which took over artist's lithography from 1959 – he commissioned several sets of lithographs from Barbara Hepworth.

He was also the faithful historian of the Press, charting its development from the earliest days of music publishing, but characteristically scarcely mentioning himself. The work joined his book on the craft of letterpress printing.[1] *The Times* obituary of 16 November 1974 spoke of his simplicity, modesty and lack of ostentation, and of his paternalistic but scrupulously fair attitude to the employees, in which he certainly carried on the Curwen tradition.

In an article on his brother, Herbert asked which has been more important – Oliver Simon or Harold Curwen, but came to the conclusion, as did Noel Carrington,[2] that they complemented each other. 'Certain it is that without the technical skill and real pioneering of Harold Curwen, Oliver Simon would have floundered; but the latter's achievements in book printing and editing have left an enduring memorial which Curwen's commercial work, splendid as it was, could never have conjured forth.'[3]

Artists at Curwen

Claud Lovat Fraser

Lovat Fraser, who didn't much like groups and movements, was nevertheless persuaded by Joseph Thorp to join the Design and Industries Association in 1917 and it was through this that he met Harold Curwen.

Herbert Simon says the Plaistow works were immediately transformed by an era of puce, primrose, viridian, and sky blue, which in 1919 seemed 'daring to the point of recklessness'. The artist was certainly a great influence in infusing Curwen's work with 'The Spirit of Joy'.

Lovat, who was in conscious revolt against pomposity and academism and charmed by the simplicity of such things as the woodcuts of Joseph Crawhall, found a modern equivalent for them in a proliferation of broad line reed pen drawings enriched with coloured inks. These were translated into modern street ballad sheets and chapbooks which he published himself from 1913. 'With corrupt and outmoded types and printer's ornaments and packing papers so crude in colour as to be almost obscene', said Holbrook Jackson, 'he called forth booklets which have entranced the fastidious bibliophile.'[1]

He also produced similar designs for Harold Monro at the Poetry Bookshop, some of the later examples of which Curwen printed.

Lovat was a great tosser-off of thumbnail sketches and small drawings with which he would embellish anything within reach. These tiny flowers and fronds and personalities teemed from him, and were so enchanting that Curwen bought a sketchbook containing 250 such drawings. He found them of use not only in his own lively publicity, but in jobs he produced for his customers. Among those Lovat designed for were Heals, Enos, who published a memorial painting book when he died, and MacFisheries who asked for gay gummed poster pointer labels. The *Diary of 1745* (right up

The **CURWEN UNICORN is** an intelligent and adventurous beast. He is always trying new strokes.

Your interest helps quite as much, or say nearly as much, as your orders.

It's good fun to do good work, and it also happens to be good business. Remember the UNICORN of The **CURWEN PRESS**

HAROLD CURWEN
Plaistow, E.13

Lovat Fraser, Curwen publicity shot, 1920 (Cat.18b)

A Short Cut, a Quick End.

Lovat Fraser, illustration from
Safety First Calendar, 1921–22
(Cat.21)

Lovat's eighteenth-century street) was Joseph Thorp's paean for Fripp's Olive Oil Soap, while *The Great Step Forward* booklet was lively publicity for the New Comptometer. There was also a colourful *Safety First Calendar* in which cautionary illustrations pithily preach the pitfalls of short cuts and the need to save lives rather than minutes.

'With care and sympathetic skill', writes Haldane Macfall two years after Lovat's death, 'Curwen found and developed a technique to fit Lovat's charming fancy; and instead of dragging Lovat down to commercial standards, he brought commercial tracts up to Lovat, who adapted his picturesque and gay art to it all.'[2]

Lovat's own stationery was always beautifully fresh and interesting and Curwen got him to design some for the Press. A solitary undated letter survives, apparently written by Harold Curwen on a sheet as yet bearing no printed address and with only a black line block outline of two dancing figures of Lovat's which presumably the artist has hand-coloured. The letter, written between the opening of Lovat's wildly successful *Beggar's Opera* (which Curwen mentions) and the artist's death almost exactly a year later begins: 'I'm simply aching to use some of these things.'

Between 1919 and 1921 Lovat designed several covers for the action songs which Curwen had rescued from Victorian clutter. Both these song sheets and a Witney Blanket advertisement, simply lettered by a calligrapher, are distinguished by their simplicity, gaiety and clarity in a way difficult to appreciate now.

The work which made Lovat most famous, and in which he was encouraged by Edward Gordon Craig, lay in the theatre, but the run of his celebrated *Beggar's Opera* which opened in the Lyric Theatre Hammersmith in June 1920 was to outlast him. Whilst resting at his cottage near his friend Paul Nash in Dymchurch, Lovat was taken ill and a successful operation was performed. His heart, however, weakened by rheumatic fever and war service, could not stand the strain.

The Press printed *The Lute of Love*, with its tiny black-and-white illustrations, before he died but *The Luck of the Bean Rows* was an historic coup for Oliver Simon, who, just starting as Curwen's representative, got an order for 30,000 copies of the second edition just before Christmas 1921 when Lovat was already dead. It was the first book the Press handled with coloured line block illustrations and was a model of its kind. The other books—the *Nursery Rhymes*,

the Poetry Bookshop's *Poems from the Works of Charles Cotton* and *The Woodcutter's Dog* were all reprints of earlier books, published posthumously but restyled by the Press, usually with beneficial effects.

One of the disappointments for the artist followed a commission from Curwen to illustrate A. E. Housman's lyric-sequence *A Shropshire Lad*. Inexplicably the poet rejected the sixty-three drawings of tiny figures and countryside motifs, and Lovat's widow, Grace, records that the artist, who was ill and tired out at the time, felt the rejection very deeply.[3] But Curwen bought the copyright to the drawings and went on using them, together with an earlier sketchbook he had purchased. The posies of harebells, small formal urns with flowers, strutting peacocks and engaging people continued for many a year after Lovat's death, wishing people a happy Christmas, announcing funerals, advising of the birth of babies, and in 1923 inviting guests to Harold Curwen's own wedding.

Lovat Fraser, stock block

Lovat Fraser's other legacy lay in the collection of pattern papers which were inspired by a notebook given him by Gordon Craig with a cover of Italian patterned paper. He filled the book with twenty-two patterns of his own which became the basis of the Curwen Press collection. With his work in the theatre and commercial design, Lovat may be said to have been a specialist in the ephemeral. Yet some of the pattern papers he inspired are still being produced today.

Albert Rutherston

Rutherston was Oliver's uncle, and he and his brother William Rothenstein helped Oliver considerably when he first came to London, inviting him home and introducing him to people. As a matter of fact, Rutherston introduced Oliver to Lovat, who in turn introduced him to Thorp, who made the most significant introduction of all to Harold Curwen, so that Oliver, in a way, owed his uncle his distinguished career.

Among the pictures Oliver left is one of his uncle's watercolours on a silk panel showing Harlequin and Columbine figures under a plumed tree. It was work of this charmingly decorative nature, to which he turned around 1910, that Rutherston did for the Press, rather than the solid dependable painting of his earlier career that he had learnt at the Slade.

Between 1919 and 1926 Rutherston designed fifteen vignettes reproduced in the 1928 Specimen Book using the line block for vases or cornucopia of sprigged flowers, or brittle stylized trees fingering the sky in convenient arabesques. The pattern papers he designed in pen and watercolour to be lithographically reproduced, were similarly floral.

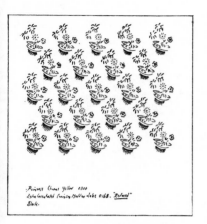

Albert Rutherston, pattern paper, 1925–27 (Cat.37)

Like Lovat, whose friend he was, Rutherston designed for the stage and between them both they devised an ingenious London Underground poster intended to be cut up and made into a toy theatre. Lovat had drawn a rough for it in 1921, but, when he died so unexpectedly, Albert Rutherston took over where he left off, incorporating many of Lovat's ideas, and carrying the thing through to completion. With John Drinkwater he also wrote the memorial biography of his friend that Curwen printed in 1923, in which the kind of colour line block that Lovat had popularized provided the lavish illustrations.

Rutherston too was associated with Harold Monro's Poetry Bookshop and illustrated *Forgetfulness* by Harold Monro himself. Indeed, like McKnight Kauffer who also illustrated a rhymesheet, Rutherston bought five £1 shares in the Bookshop when it became a limited company,[1] for the shop was a real force in London's cultural life at the time. The artist similarly worked on several extremely beautiful signed limited edition Christmas cards published by Oliver Simon personally and under The Fleuron imprint. There were two by John Drinkwater, and one by Edith Sitwell, the text appearing on the left inside the folded sheet, and the full-page illustration facing it. These poems, published between 1922 and 1926, seem to have been forerunners of the *Ariel* series broached by Faber in 1927, so small wonder that they asked Rutherston, upon the Curwen Press's suggestion of his name, to illustrate four *Ariel* poems in the years between 1927 and 1931.

Rutherston's success with *The Four Seasons* already spoken of was his first emulation of the colour line block used by Lovat. On the black-and-white print of his elegantly artificial outline drawing in pen and ink, which he would loosely lattice with cross-hatching in the larger formats, he would add three or four colours, articulating the drawing by shafts of edging colour rather than by filling in with solid blocks. *The Four Seasons* depicts young love in springtime, mother and children at the summer beach, red-haired autumn under a confetti of scattered leaves, and old age in the stormy blast of

winter. The technique reaches its apogee in *A Box of Paints* where, with four printed colours over the black key, the artist rings a remarkable variety of changes.

Poor Young People suffers a bit, as does the 1926 *Chatto and Windus Almanack*, from trying to crowd rather too much into a small space, but with Aldous Huxley's collection of essays in 1929, Rutherston moved to bolder treatment and colour applied by stencil. Although the concept is still that of line drawing with added colour (unlike Kauffer who valued the medium for its ability to convey mass) the book was a success, and it paved the way for the luxury *Haggadah* of 1930, the Jewish classic in which the story of Exodus is combined with the Passover celebration.

Oliver Simon had become a director of the Soncino Press, who published *Haggadah*, and the idea was to make a new critical English edition of this historic text, as well as setting it in Hebrew composed by Enschedé en Zonen of Holland. The aim, said the publicity, was to make a production 'inspired by the modern spirit' to carry on the tradition of pictorial *Haggadahs* starting in the fifteenth century. Rutherston supplied fourteen full-page illustrations plus seventy small ornaments. It was not cheap: there were 100 copies at £36.15s and ten on Roman Vellum costing over £200. So faithfully was the pen and watercolour translated into stencil over line block that, seeing both together, it is almost impossible to discern one from the other. Rutherston, working in much the same way as with colour zinc blocks, began with a very rough sketch, refining it until a black-and-white drawing could be made into a line block proof for him to hand-colour for the stencillers.

Some drawings were reworked several times. The original Moses stood before a bush bearing the face of God which might equally have done duty as a classical west wind. As it appeared in the book, the features have been abandoned for an arch of Hebrew characters filling the still centre of a corona of flame.

The full-width page headings are delightful, not least where the Pharaoh's daughter swims to the baby in the basket among the bulrushes. Many colour variants were tried, and the experimental proofs are covered with small dabs of transparent watercolour with which the artist tried to find the right colour balance for the stencillers.

When he filled in a Tate Gallery questionnaire in 1932 which asked him to list the important events in his life, among items such

as friendships and parenthood, and other professional jobs, Rutherston also singled out 'Designing for the Printing Press' and 'Making drawings for The Haggadah'.

Paul Nash

The third dinner of the Double Crown Club at the Holborn Restaurant on Tuesday February 17th at 7.30 p.m.

Chairman Albert Rutherston
Guest William Rothenstein
Subject Book Illustration
Designer Paul Nash

MENU
Huîtres Natives ou Hors D'Œuvres Variés
Petite Marmite Crème Madrilene
Filet de Barbue Bonne-femme
Poulet Poêlé Belle-meuniere
Feuilles de Laitues Vinaigrette
Bombe Plombiere
Gaufrettes
Café

Paul Nash, Double Crown Club menu
No.3, 1925 (Cat.56)

Nash is a linking figure among those artists who worked at the Press. He was a friend to Lovat whom he met in the years when that artist was helping to revolutionize Harold's style and admired his fresh approach to the poetry rhymesheets to which Nash and his brother both contributed. As a prolific writer of articles, often at the behest of the Press, he championed Kauffer and Sutherland and Bawden in print. He exchanged ideas with John Piper and was featured in the avant-garde magazine *Axis*, that Mr and Mrs Piper produced in the late 1930s, and when he lived at Oxford and started his Arts Bureau, Albert Rutherston with whom Nash had earlier taught at the Ruskin School was on the committee. He also taught alongside Albert's brother William at the Royal College. Here, Eric Ravilious and Edward Bawden, who were his pupils in the Design School, became what the Double Crown Club register called 'his spiritual heirs' in the art of the book.[1] He certainly helped them both in their careers generously steering them towards commissions.

Indeed, Edward Bawden feels not nearly enough has been spoken of Nash's powers as a teacher. He wrote to Bertram:

... the fact that he did not make the usual remarks common to teachers which have an air of being profound and yet are evasive, but instead tried only to give his own reaction plainly and clearly, gave a real personal value to his teaching. But though his teaching was personal it was always related to what he conceived was individual to each student; in other words he did not hand out propaganda for his own point of view but endeavoured to bring out instead whatever–slight though it might be–seemed unique in the student.[2]

Nash worked in an age making the transition from the artist as craftsman to the artist as industrial designer. Though he professed to be and to a large extent was of the latter persuasion, he could not help but be craft-rooted. Whatever else he might have said, this meant that his ethic was to make industry and business match his high standard of hand production, rather than to base what he designed on the limitations he had studied in the machine. There are

shades or densities of colour that, even now, industrially applied inks or dyes cannot achieve–with Nash they certainly had to try.

Oliver, writing in his autobiography, described his meeting with Nash at a party in the early 1920s where, with his unerring homing instinct for quality, he was drawn to a circle enthralled by one talker 'a natural dandy' with a 'slow, slightly halting, melodious voice, deep sympathetic eyes and a fine curving profile'. From this encounter, Simon and Nash became lifelong friends. Simon wrote:

> His qualities and position as an artist on the one hand, and his attitude towards the printed book and the world of business on the other, were unique. He was himself a good man of business and he had a most persuasive, almost feminine way of getting what he wanted. But his own way was, in the end, a realising of his poetic vision, untrammelled by commercial expediency. It was always an exciting and unpredictable adventure to work with him and sometimes exhausting, for he was wonderfully particular.

This wonderful particularity runs like a leitmotiv throughout Nash's printed work. Writing to Oliver in 1940,[3] he recounted that the printer for the Oxford University Press had misprinted a thousand sheets of headed notepaper for his Arts Bureau and had had the temerity to tell him there was a war on. 'I expect I made an enemy for life, but I made him do them again' wrote Nash, who had much the same battle with Miss Little of Modern Textiles. Nash always made everybody do it again–even Oliver if necessary– although his letters and writings show that he had faith in the Curwen Press, who gave him satisfaction more often than not.

The Nonesuch *Genesis* was the first book he did at the Press and he followed it the next year with *Welchman's Hose* which was the first book printed at Plaistow to be issued by Oliver under the imprint of The Fleuron. The book is usually written off as slight, and is certainly not another *Genesis*. Nevertheless, it employs five thought-provoking small wood engravings: a lark-encircled woman's head; a tiny abstract endpiece; a curiously compounded design suggesting hearts, birds and books (and appearing opposite a spirited appeal from the poet Robert Graves for his publisher to pay him); a composition of abstract forms which seem to be reflected; and the most attractive title page design of a strongly patterned black-and-white bird, perhaps a magpie. The Curwen Press paid Nash for the use of the bird as a stock block, and it crops up again and again on commercial ephemera as well as on the 1943

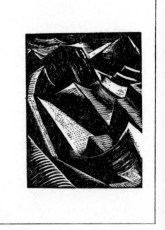

AND GOD SAID LET THE WATERS UNDER THE HEAVEN BE GATH— ERED TOGETHER UNTO ONE PLACE AND LET THE DRY LAND APPEAR AND IT WAS SO + AND GOD CALLED THE DRY LAND EARTH AND THE GATHERING TOGETHER OF THE WATERS CALLED HE SEAS AND GOD SAW THAT IT WAS GOOD

Rudolph Koch's 'Neuland' typeface (top) with a Paul Nash illustration (bottom) from *Genesis*, 1924 (Cat.61)

Paul Nash, stock block, originally for
the title page of *Welchman's Hose*,
1925 (Cat.55c and 62)

Council for the Encouragement of Music and the Arts catalogue of
his own exhibition of applied design. The Press also paid him for the
right to use a slim upright decoration from the invitation to his
Leicester Galleries exhibition in 1924, in which forking tree boles
are echoed in the branching leaves of a smaller plant.

Something of Nash's gamesmanship in being particular is revealed
in *Room and Book* which Oliver, by now a Director of the Soncino
Press which had absorbed The Fleuron, published in 1932. Nash
was offering advice to budding illustrators on the need for awareness
of different inks, papers and processes used in printing.

The usual proceeding, he writes, is for him [an illustrator] to
deliver up his designs at the appointed date and forget about them
until the proofs are sent in. . . . The better way is for an artist to
cajole the publisher and printer into a friendly conspiracy. If he is
able to show a knowledge of inks, papers and types, this will gain
the printers respect (?) and slightly frighten the publisher. The
artist should then have the situation in hand. To be just, artists
often have only themselves to thank if their work is not
satisfactorily produced – but not always.[4]

We see Nash gloriously in action 'slightly frightening' the publisher
in the matter of the *Ariel* poems.

He illustrated two of these poems for Faber, the first, 'Nativity' by
Siegfried Sassoon which was in the batch of eight begun in 1927.
When Richard de la Mare approached him again in 1929 to tackle the
difficult poem 'Dark Weeping' by A. E. [George Russell], Nash harked
back to the earlier poem saying that to his mind it had been ruined by
colours he 'was not interested in'.[5] Certainly at the time he had corre-
sponded directly with Oliver about the 'howling vulgarity'[6] of a yellow
cover he had been allotted and made a plea for it to be altered,
preferably to white, or failing that to grey, since: 'I object very much
being saddled with such a monstrosity entirely opposed to my
design.' In the event he managed to swop covers with McKnight
Kauffer, taking his mauve while Kauffer took the dreaded yellow for
Eliot's 'Journey of the Magi'. But Nash was never satisfied with the
inside arched chamber and blossom design in fawn and green either.

The story was to be partly repeated with 'Dark Weeping'. After
elaborating the former disaster, he opened negotiations by de-
manding a completely free hand with colour this time, plus an
increase of two guineas on the fee offered (which was that recom-
mended by the Press when they first put forward a list of artists for

the project). In a subsequent letter after Richard de la Mare had assented, Nash, who continually educated the world to the idea that the artist is worthy of his hire, explained that 'as an artist making my living by my art I am obliged to be practical'.

I am primarily a painter, [he went on] Painting is really a whole time job: my paintings are: a) twice as difficult, b) take twice as long to paint, c) (incidentally not because of a & b) sell at twice the price as two years ago.

On the other hand making designs such as you want may easily take as much thought and time as a small painting requires. Why does one make designs such as you require – for the fun of the thing really. . . . Then why a fee at all you might say. . . . Well you see, it's like this – but I have already bored you.[7]

When he produced the design in June, he pointed out that his illustration depended upon colour. 'If there is no objection', he said, 'I should like the Curwen Press to do the colour work as I am used to working with them. The three colours are pink, brown and blue, with blue for the cover.'[8]

When the proof came through, the blue was 'bright repulsive delphinium' and 'virulent azure' and the colour on the cover, did not, as he had asked, harmonize with the one inside. Eventually honour seems to have been partly satisfied by muting the cover to a grey a few shades deeper than the eggshell grey-green that has replaced the blue on the design.

'AE' was pleased; Nash's symbolic figure, he said, showed that the artist had understood the meaning of the poem.[9] And Nash explained: 'It seemed to me the most effective way to treat such a dose of mysticism was to double the dose.'[10]

It is the black-and-white title page with the cast shadows of its ladders and the double door and window opening onto slivers of star, sea and darkness which is often reproduced, but the inside design is at least as interesting. Nash created a figure almost surfing through space in a downward plunge between sky and sea to a point from which his recurring white convolvulus spirals upwards to the light; a symbol that he used again in *Urne Buriall* and in the foreground of the print for school-children, 'Landscape of the Megaliths', which he autolithographed eight years later.

St Hercules and other stories of 1927 was the first book Nash had coloured by stencil and he was quite pleased with the result and enthusiastic about the stencil process, as already adumbrated. The

PLATE 9

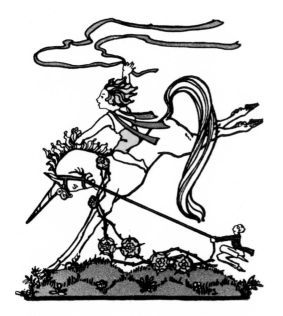

'UNICORN—RAMPANT
SANS REGARDANT'

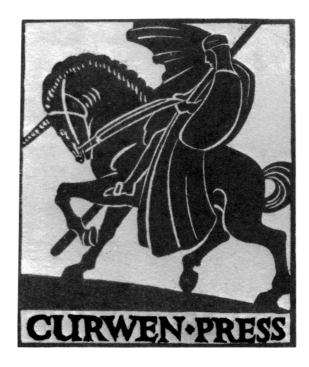

Curwen Press Unicorns: top left, Phoebe Stabler; top right, Dorothy Mulloch;
bottom left, Macdonald Gill; bottom right, C. Dixon

PLATE 10

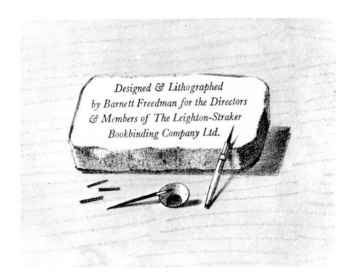

top and bottom, Barnett Freedman: Double Crown Club menu No.115, 1952 (Cat.130)
and motif from Christmas card (Cat.131)

PLATE 11

THE NEW BROADSIDE

Forgetfulness

A flower is looking through the ground,
Blinking at the April weather;
Now a child has seen the flower:
Now they go and play together.

Now it seems the flower will speak,
And will call the child its brother.
But, oh strange forgetfulness!—
They don't recognise each other.

BLANKETS
from the Original
WITNEY
MAKERS

Chas. Early & Co. Ltd.
Established 1650

THE POETRY BOOKSHOP, 35 DEVONSHIRE STREET, THEOBALDS ROAD
LONDON, W.C.1
New Address:
31, Russell St., W.C.1,
Designs by Albert Rutherston
Poem by Harold Monro

Made and printed in Great Britain at the Curwen Press, Plaistow, E.13

left, Albert Rutherston, *Forgetfulness*, c.1920 (Cat.39)
top and bottom right, Lovat Fraser: poster (Cat.22) and illustration, 1921 (Cat.24)

PLATE 12

top and bottom, Edward Ardizzone: *The Fattest Woman in the World*, 1956 (Cat.230)
and menu for Overton's, *c*.1953 (Cat.222)

PLATE 13

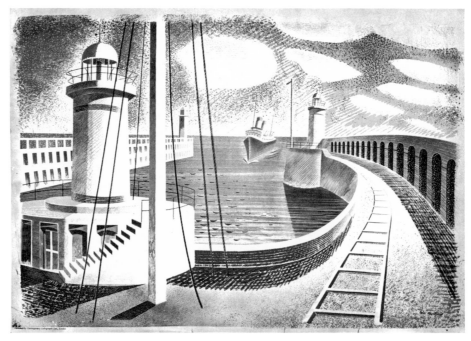

top left, Paul Nash, cover for *Shell Mex House*, 1933 (Cat.59)
top right and bottom, Eric Ravilious: *The Grapehouse*, 1936 (Cat.174) and *Newhaven Harbour*, 1937 (Cat.182)

PLATE 14

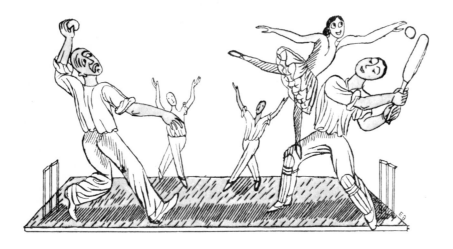

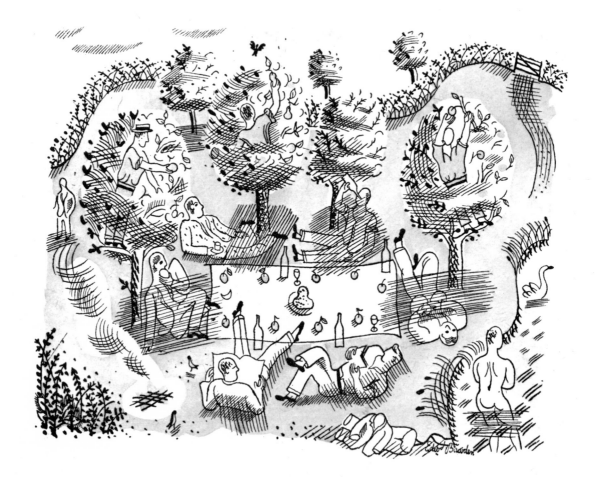

top and bottom, Edward Bawden: calendar illustration, 1950 (Cat.109)
and *The Bibliolaters Relaxed*, 1928 (Cat.80)

PLATE 15

Edward Bawden, *That's What We Want! Dried Beet Pulp*, 1930 (Cat.95)

PLATE 16

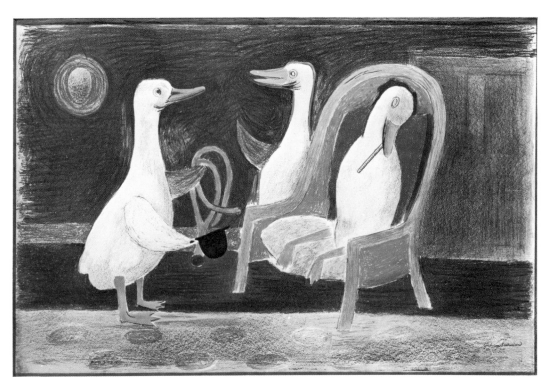

top, Graham Sutherland, *The Sick Duck*, 1937 (Cat.193)
bottom, John Piper, illustration from *Brighton Aquatints*, 1939 (Cat.204)

article he wrote about it in the *Curwen Press Miscellany*, which was reprinted in *Room and Book* a year later, is among several articles he wrote at Oliver's request, for he also publicized the pattern papers sparked off by Lovat when the Press produced a specimen book in 1928.

Paul Nash, pattern paper (Cat.54)

He made four himself: a stylized woodcut crocus; an illusory three-dimensional structure with a band of lithographic colour added; a stepped wood engraving which faintly suggests the sea wall at Dymchurch; and eclipsed golden moons lightly tangling with lattice work on a grey-blue ground. He wrote of the papers:

> This notable output by an English printer, is another sign of the steadily growing conviction that distinction of design is not only aesthetically, but commercially important.[11]

But in both cases he reveals for an industrial designer a surprising resistance to the machine by declaring, in its favour, that lithography (by which the pattern papers were printed) was not 'truly mechanical' and by rounding off his article on the stencil process in this way:

> The colour for each picture is applied separately by hand, not impressed by a mechanical device. The colours used are pure and permanent—the colours used in the originals—instead of being anything but pure and any distance you like from the originals. Furthermore, the drawings admit of two qualities that no flat printing can give: texture and variety. In short, they are alive instead of being dead. It is a curious instance, in these days, of the triumph of the hand over the machine.[12]

In *Room and Book* Nash tells the illustrator that there is no way to prepare a painting for three-colour process; the best procedure is 'to induce the publisher to use some other method—it will spare the artist disappointment'.

In the *Penrose Annual* of 1936 some printers were brave enough to stick their necks out and reproduce several of Nash's paintings experimentally and submit to his observations on them. He then revealed the crux of his customary problem with reproduction.

> He [the artist] does not expect, if he is wise, to find his picture matched colour for colour; but he does require, for instance if his painting is cool, that he will be given the same temperature in the reproduction. . . . The most usual difference which the engraver's proof reveals is in this matter of temperature. Being a 'cold' painter I am particularly sensitive in this respect and I must confess that in all my experience I have never been spared the necessity of pointing out to the engraver that his print is too hot.

[49]

The problems of accuracy in reproduction continually exercised him as they did Oliver Simon, and when the monograph on Nash in the Penguin Modern Painters series came out, in 1944, Oliver commented:

> It would not be appropriate for me to be writing on Curwen Press notepaper without raising a query. Surely the excellently printed colour plates are not facsimiles but interpretations. Should this not be stated in the introduction or imprint? Poor isolated virgins in Burton on Trent who hardly ever see a C E M A exhibition might be misled.[13]

Paul often sent Oliver reproductions of his paintings, for there are a number of them annotated by the artist in a small portfolio still kept by the Simon family and known as 'Oliver's Box'. Here, too, Oliver treasured not only these professional exchanges with Paul, but also the lovely hand-made Christmas cards that Nash sent to him or his wife Ruth in the pre-war years.

Nash did several other commercial jobs for the Press: several simple geometric borders in 1927; the *Match Making* cover in 1931; a tiny booklet with a three-colour lithographic cover for Jack Beddington called *Shell Mex House* in 1933; and a cover of moons floating in a sea of blue for the Press's own Newsletter in 1935.

The major work of the 1930s, however, was Cassell's beautiful production of *Urne Buriall* which Nash's biographer has called 'the crisis of his artistic life', where 'the essentially symbolic character of his work finally emerges and all his symbols are present or foreshadowed'.[14]

The book, comprising twin texts by the seventeenth-century writer Sir Thomas Browne, was a superb choice for Nash's talents and demonstrated that half the secret of good illustration is to team the right artist with the right text. *Urne Buriall* was a learned discourse on sepulchral urns found in Norfolk, while *The Garden of Cyrus* explored the incidence of the lozenge pattern known as the quincunx both as made by man, and as found in nature. With their absorption in metaphysical speculation about life's mysteries as imaged in the world, and on the geometry underlying nature, both texts might have been written with Nash in mind.

Nash first drew out rough designs in pencil and crayon, then refined and re-drew them using chalk so they would make good collotypes. The 'Phoenix and Snake' drawing, which Oliver owned, is considerably altered by the time it finds its way to the printer, for

the bird that earlier flew unhesitatingly towards the sun now turns to face the reader. The snake, coiling as the convolvulus coils, again prefigures the foreground motif found in 'The Landscape of the Megaliths'. The tokens of the dead—bones, combs, and bird; the ghosts like weird sea creatures or disembodied heads; the beautiful shapes of the urns themselves trailed about with vegetation or by worms; the logs of the funeral pyre; the receding broken columns and the floating figure in the rose and lilac sky of 'Sorrow' were all evocatively and sensitively drawn and coloured with the cool pastel shades of Nash's delicate palette.

The second part of the book delights in the sheathed forms of plants—the laurel, the teazle, the acorn, the pineapple, and the whirling sunflower with its quincuncial spiralling. The scales of fish and snake, even the diamond-patterned wavelets in the sea, no less than the man-made fishing nets, paving stones, and basketry, conform to this all-encompassing pattern.

Several of the book's designs recur again as paintings. 'The Snake and Phoenix' developed into an oil. 'The Mansions of the Dead' in which the soul, like a bird, effortlessly glides about the bleached structures forming an aerial corridor into the blue depths of the sky, was remade several times, and the mystery suggested by the design became increasingly important to Nash as the expected end of his life approached. 'The Quincunx Mystically Considered', with its pale cones and prisms became a water-colour called 'Poised Objects'. John Piper, in consultation with Nash, reproduced it in *Axis* five years after *Urne Buriall* had appeared, to illustrate a poetic article on Nash that had been written by his wife. Piper felt it was important for their art magazine to have colour-plates, and he frequently hand-cut rubber Paramat blocks, and added a black half-tone made after his own photograph of a picture when it was necessary, as it was in Nash's case. It will have been a new reproductive experience for Nash.

The extent to which Nash was difficult to please made his congratulation for work well done all the more satisfying when it came. He wrote personally to Harold Curwen about the stencilling on *Urne Buriall*. The letter would not have been true Nash had it not also had a quibble. He was displeased with the Shell Mex booklet lettering (which the Press altered) but, he continued, he had only just had a chance to compare the plates of the Cassell book with his original proofs and he had found them very good.

Mostly it is quite astonishing for its accuracy of interpretation. Considering how insensitive the collotypes are and that you were obliged to slightly strengthen my colours (which alarmed me to contemplate) I must say I think your people surpassed themselves in their understanding of the problem.[15]

The only plate that went wrong, he said, was 'The Vegetable Creation' where the colours were too hot. Otherwise he passed on his warmest congratulations, adding that he was glad neither of them entirely depended on royalties for financial reward.

Except for the rather splendid 1937 Contemporary Lithograph he drew at the Press for John Piper and Robert Wellington based on his 1933 experience of the avenue of Avebury stones, Nash did no more direct work at the Press although his talk to the Double Crown Club on 'Surrealism and the printed book' appeared in *Signature* in 1937.

One wonders how Oliver, who is on record as having 'no patience with freak type', responded to Nash's delight in Max Ernst and the découpages of George Hugnet in which 'an extensive use has been made of type stock. Now, at last', continues Nash, 'really repulsive "faces" come into their own. Dignity and Decorum are heaved to the winds and the utmost impertinences intrude with what I must admit seems to me an engaging irrelevance. But a careful study will discover a pretty consummate art directing these convulsive pages. There is a lovely affair of a blue eye poached in a blot of ink. . . .'

Nash's autobiographical excerpt 'Openings' appeared in *Signature* one year before war broke out. Then he was enmeshed in the tasks of being a war artist once more.

One of his successes in 1940 surrounded the six watercolours of crashed German bombers which he wanted to reproduce in book form. The nurses in the home he had been in had 'fairly gurgled' about them he told Dickey, trying to persuade the Ministry of Information of their popularity as reproductive subjects.

. . . the Treasury say it is 'luxury printing' [he wrote to Oliver in August 1940] Dickey murmured about getting it done *outside*, outside the M of I would that be? If you get a chance and like the idea do give a shove. I would add a few more designs and do a good cover. I believe it could be quite useful propaganda.[16]

Although the book did not eventuate, ever-helpful, Oliver Simon suggested that the National Gallery might publish two of Nash's

watercolours as they had recently done with Ardizzone drawings. He promised a 'subtle result', to be done by lithographic craftsmen by hand, not involving any work for Nash.

Olive Cook (now widow of Edwin Smith) who handled the production of Nash's reproductions at the National Gallery, wrote to Nash in April 1941 that the workmen had found the facsimile prints of two of his watercolours 'extraordinarily difficult and needed a lot of encouragement', which she provided. In particular 'The Raider on the Moors' involved protracted sensitivity, and was worked with the airbrush, with a coarse-ground stone to provide a texture similar to that found when watercolour floats onto a good paper, and with petrol leaching the design on parts of the stone to provide the fluid quality of the original.

Nash, who made a great impression on Olive Cook and came to the Gallery the first day the prints were put on sale, was absolutely delighted with the reproductions. 'This calls for a little celebration', he said, and invited her to lunch with him at Gatti's. 'What fixed the occasion in my memory', writes Mrs Smith, 'was that after a gorgeous repast Paul confessed that he had no money with him. He had left his purse "on the piano". So the celebration was on me! But there was no doubt about his pleasure in the prints. And he liked the idea of his work reaching a wide public.'[17]

The remaining letters between Nash and Oliver Simon exchange pleasantries and mention book publishing proposals Oliver was unable to undertake, but about which he offered advice. The last letter in the Tate archive seems to have been written when Oliver heard of Nash's final pneumonia. He wrote commiserating and enclosing a small booklet the Press had printed on *Design and Mass Production*, closing with the injunction Nash should not reply.[18] A few months later, Nash died.

Edward Bawden

'Ten years ago I was teaching design at the Royal College of Art. I was fortunate in being there during an outbreak of talent', wrote Paul Nash in the first issue of *Signature*. Amongst that talent was Edward Bawden, who, even whilst he was still a 'fresher', was already contacting possible patrons, among them the Curwen Press.

He, Ravilious, and Douglas Percy Bliss were inseparable friends at College. Bliss has written how advanced Bawden was, even as a

student, and how on a tour of Bawden's Essex one day all three sat down to draw Audley End. While he and Ravilious 'fumbled away', their friend professionally produced ink, water, brushes and 'pencils sharpened like daggers' and coolly produced an exquisite miniature. They decided from that moment that Bawden was 'different'.[1]

Certainly Bawden, of all the artists gathered here, was the one most frequently commissioned to work for the Press. He remembers Harold Curwen as a 'boy scout of a man' with thin legs sprouting from shorts. Full of good humour, but with little real sense of humour, Curwen was evangelistic for good craftsmanship, he says, and loved teaching.

One of Bawden's chosen media was the humble linocut, which he describes as a poor man's woodcut. He would stipple oil colour into the block and print it by foot pressure in his bedsitter in Redcliffe Gardens. 'This seemed to me to be carrying private printing rather too far . . .' quipped Nash. Curwen taught him about letterpress inks, but was also intrigued to see if he could get the same starved speckled quality as in the deliberately imperfect impression by means of which the artist felt he enlivened the printed areas. Curwen achieved this by printing from Bawden's block in litho ink onto transfer paper and committing it to plate, which made the speedier printing of the design possible without losing its attractive characteristic relief qualities.

It was while he was researching a poster for the Wembley exhibition in 1924 that Bawden came across a William Morris wallpaper –'an innocent daisy'–in one of the period rooms. Approving of innocence he fell in love with it, and began, in conscious revolt against the drop repeat of the floral cretonnes of his day which he despised, to create his own patterns, ingeniously building them up by the repetition of a multiplicity of small units.[2] In his turn, Curwen produced the designs as lithographic sheets which were stocked by the shop 'Modern Textiles'. From 1926, Bawden created the most enchantingly personal and offbeat 'cottage' designs, with waves, mermaids, leaves and fruit, deer and trees. 'The Large Seaweed', with its curly veined leaf and tiny anemone, graced Curwen's own bathroom at Mansard. An intricate hedged patchwork was punctuated with blossoming trees alternating with five peacefully munching cows. A diagonal brown design of stylized oak branches was broken up by rectangles with stags and riders in the grounds of Knole. In another, an overall pattern glorious in its leaf-green

Brick House, Gt Bardfield, Braintree, Essex

Edward Bawden, Christmas card (Cat.118)

boskiness, the vegetation is cleared in circles of discs in which appear a church tower with the clock forever at twenty to twelve and a ruby-eyed pigeon with soft grey folded wings. A letter of 1931 from 'Modern Textiles' reveals that the royalties on the sale of 507 sheets amounted to a princely £2 0s. 10d!

In 1933 Oliver Simon commissioned four designs which the Press was to publish. These were not created piecemeal, but by a complete block, and the designs were much more sophisticated – columns of telescoped starry cones on a speckled ground in 'Salver', the splendid columns and swagged drapes of the classical 'Façade', and ornamental gardens with a prickly stem which appears to pierce the paper in 'Node'.

Later use of the lino/litho technique included a ravishing series of posters for London Transport. One, not used on the hoardings, was devised as a collage, and looks past exotic cacti to the improbable Chinese pagoda at Kew. The design that was used features a marvellously observed mallard duck, the rhythms of whose curving breast and neck is echoed in an adjacent urn beyond which a red-faced gentleman surveys the scene near the pagoda. In the poster advertising the dahlias in Regent's Park a magnificent pelican looks aghast at a warlike sculpture, while the little bill for 'Chestnut Sunday' (the date of all these is 1936) with its cheeky wasp and close-up of a stylized deep red chestnut candle, brings all the freshness of an apparently hand-made print right before the public in the windows of a thousand transport vehicles.

As well as interpreting more lino designs, which found their way onto the covers of Ambrose Heath's *Good Food* series, Bawden recalls that Curwen taught him how to draw for the line block. His charming booklet *Pottery Making at Poole*, with its cover design of fishes and mermaids, and endpiece of a sailor putting a Poole pot to proper use, was the first commercial job he did for the Press, and included one of his pictorial maps. It heads a formidable list of payments at least twice as long as for any other artist regularly working at Plaistow. Among many other jobs, he made the Press a calendar, created some wonderfully wry press settings for the Westminster Bank, and a set of menu cards for Barrow's Stores. In one of these a dog throws himself into a frenzy at some unmoved cows, while in another a displeased bee bodes ill for his veiled keeper.

Two little masterpieces of the 1930s are equally notable for their quiet but 'impish humour' Hamish Miles remarked in an article

Edward Bawden, calendar, 1925
(Cat.74)

about Bawden's work in *Signature*. There was the 1931 booklet for a shipping agent, and *East Coasting* the previous year, in which the London and North Eastern Railway sought to convert holidaymakers to travel to the east coast.

The editing of the booklet was done by Harold Curwen whom Bawden later complimented for his masterly snip of the scissors and discreet use of the paste-pot.[3]

When Ravilious, with whom Bawden exchanged work, received a copy, he awarded Bawden 'full marks' writing:

A frame has been prepared in the manner of those of Seurat, for *East Coasting*, and a place of honour reserved for it in the upstairs room. It is a stimulating picture–one to look at when I feel as I do at present i.e. limp and dead beat (mentally and physically).[4]

For Bawden to have got away with his title page is a feat comparable to Goya's sly achievement at combining the role of court painter and character assassinator. The Life Guard, somewhat tentatively turned out in a coracle, are rocked by a glum conger eel challenging the length of the Loch Ness Monster. A nubile lady with a bright smile rides a distinctly pensive donkey. A lobster makes a pincer movement in the direction of an invalid lady whose husband in any case has already been seduced by a mermaid, while in a shaft of uncomfortable realism amidst all this fantasy, the same gust of wind that has billowed her tent blows the drawers from the lady who, we guess, was about to step into them.

Bawden, says Bliss, 'saw life like a foreigner at a cricket match marvelling at its madness'. Whether indulging in fantasy or understatement, a sharp eye, wickedly detached in its observation of human foible and absurdity, makes Bawden perennially amusing.

Like most of the other artists associated regularly with the Press, Bawden provided intriguing pattern papers, usually made from delicately etched units which were then repeated by intaglio transfer to litho plate. In the mid-1930s he made a London Transport Appointments Diary cover paper from an exquisite repetition of tiny seated travellers in boxed compartments above wheels which seem optically to whirr. There are charming page decorations too, the most beautiful perhaps those combining line block with stencil in which floral ribbons weave their two-colour lacings back and forth amidst leafy festoons, some of which seem to spring from the arms of tiny Schlemmer figures pirouetting on a framework beneath four

Edward Bawden, title page from *East Coasting*, 1930 (Cat.82)

Edward Bawden, cover paper for London Transport Board, 1935 (Cat.85)

chirruping birds (one knows instinctively without Tonic Sol-fa whether Bawden birds are chirruping or not).

Stencilling was also used on the earlier of the two Double Crown Club menus the artist designed–'The Bibliolaters Relaxed'–at which time Francis Meynell had become President. Bawden poked harmless fun at the Pelican and Nonesuch devices by allowing the Phoenix (that had become a Pelican) to roast on the fire (for dinner no doubt) and by converting the man and woman in front of None-such Palace into beer drinkers toasting each other in front of a pub. The endpiece either sent up Chatto & Windus or was his own version of the 'Déjeuner sur l'Herbe' in which a nude lady and clothed gentleman gently touch fingers surveyed by a libidinous cow and a bashful horse.

Edward Bawden, endpiece from Double Crown Club menu No.16, 1928 (Cat.80)

Another of Bawden's stencilled decorations was the full page for the *Curwen Press Miscellany* 'Homage to Dicky Doyle'. Doyle, together with Lear, has been among Bawden's heroes.

Perhaps the most astonishing work Bawden did for the Press, however, lay in the realm of typographic ornament. His first offerings are frankly timid–a collection of humps, slight zig-zags, and dotted brackets. A few years later, in 1928, he had devised not only an interlacing of serpentine curves, like brackets and base clefs, subtle in their suggestion of black and grey from one printing, but the most consummately skilful variations of calligraphic ogees, loops and arabesques ingeniously woven with tiny flowers. With one of these masterpieces Oliver graced the title page of the Curwen Press *Specimen Book* in 1928.

Moving from strength to strength Bawden drew in 1932 the tremendously bold three-dimensional rectangles based on the cast shadow of inspired bricking. After these he sought delicacy again with various groupings of tiny geometric elements, moving on in 1938 to two more powerful designs that the Press dubbed 'Boiled Sweets' and 'Window Boxes'. The first featured a kind of barley sugar twist in abutting ovals, the second an adaptation of the Greek key registered full face and obliquely. It looked simply splendid in red between black borders on the cream Imperial Airways Empire Air Mail programme. Robert Harling wrote in 1948 that Bawden's borders were among 'the most impressive contributions made to the decorative side of printing during this century'.[5]

The years are spanned by numerous book illustrations ranging from the humorous blocks for the *Review of Revues* calendar, to the

[57]

comparatively serious studies for *Life in an English Village*, auto-lithographed as a King Penguin in 1949. A notable success at the very beginning of this run was the 1928 *Ariel* poem by Edith Sitwell in which the fol-de-rol parasol lilt of the song, the frisky fillies and red setter dog are superbly captured in the full-page illustration into which a stag from the Knole wallpaper has strayed.

'I am enchanted with the way this poem has been produced. Why is it I have never seen any of Mr Bawden's work before?' asked the poetess of Faber in 1928.[6]

Bawden had an eventful war which transplanted him from his home county, Essex, to a variety of exotic places. After France and Dunkirk, he travelled in Egypt, Libya, the Sudan, Ethiopia, Syria, Iraq and Saudi Arabia. His adventures included following a camel cavalcade to Addis Ababa and circumnavigating Africa on his return, only to be shipwrecked off Lagos, taken to Morocco by a French Vichy warship and interned in Casablanca. Rescued by the Americans, he eventually arrived back in England via America. This travelling gave an authentic dimension to his illustration of *Travellers' Verse* in which his unerring and lightly satiric eye selects just those poems that mix his own blend of the prosaic and the exotic – such as Belloc's 'Oh Africa mysterious land' (surrounded by a lot of sand).

His sojourn in the desert equipped him ideally for the task of *The Arabs*, one of the Puffin Picture Books that brought artists' originals directly to children.

Bawden worked out the whole design minutely page by page in pen, crayon and watercolour and stuck to it so closely that in a double-page spread teeming with hundreds of tiny embattled figures, little more has happened between one version and the next, than that one or two men have raised their sabres a fraction higher, the better to decapitate their opponents. The transparent litho inks are especially subtle, a pale sand, cobalt and vermilion, creating secondaries of green, browns and orange beneath the black pen and crayon skeleton.

Bawden always had a fascination for the desert, on the theme of which one of the early wallpapers was based. In a landscape of primrose and ochre sand dunes, an arc of four silhouetted camels are led by a solitary red-clad native whose brother also appears, isolated, in the middle of the desert apparently miles from human habitation. Bawden says many people find this particular paper jokey (and nobody

would find it humourless) but it was seriously done by him as a private commission for an Egyptologist at the British Museum. He regarded it as prophetic, since during the war he found his imaginary landscape in Saudi Arabia and even more exactly on a journey to the Siwah Oasis.

As a war artist Bawden revelled in the exotic, writing marvellous letters to Dickey at the Ministry of Information. He had, he said, turned down an invitation to accompany Shaikh Wabdan el Barrak across Arabia to Yemen since he did not know whether the War Artists' Advisory Committee would take steps to retrieve a temporary officer but, he said:

> It would have been a magnificent sight to have seen Shaikh Wabdan riding at the head of his eight-hundred men and multitude of camels, singing in a sad nasal wail a song of his sweetheart. The Shaikh with his hair in long Sadun plaits, wearing pale puce-coloured robes and a great black abba with gold embroidery, armed with a curved sword, dagger, and silver-chased rifle as the eight-hundred men – a cavalcade of white and black figures and gorgeous scarlet saddle finery – and all of them armed to the teeth. Even Bloomsbury's heart might kick a little faster, mine did, at the thought of such an adventure. But the walls of the National Gallery might have stared in vain for embellishment. I should have returned a polygamous Muslim with a smattering of Arabic and a liking for a whole boiled sheep for lunch and dinner, and few – very few – drawings.[7]

Throughout his years of work for the Press, Bawden was on terms of personal friendship with Harold Curwen, visiting him and inviting him to his home at Great Bardfield. A delightful series of illustrated letters survives from the 1930s showing the warmth between them. Under a headpiece of a blue bird swooping upon flies Bawden promises a periodic visit to the Press.[8] Or he jokes with a valedictory Moo-o-o-o about a commission for a happy cow poster in which the whole sheet is taken up by a brown-and-white cow smiling.[9] 'By a Promethean labour' Bawden later announced, he had created a whole herd of them for the Empire Marketing Board poster 'What we want is dried beet pulp!'[10] Happy cows may be thought of as a Bawden speciality, for his splendid Contemporary Lithograph of 1937 encapsules the scene at Braintree cattle-market, incorporating grass-chewing yokels and the bland faces or angular haunches of serried ranks of the livestock waiting to be sold.

In 1939, when he had been a village grocer for only a month, Curwen, who found it 'far harder work than ever I went through in my youth at Plaistow' was longing for Edward to come and paint a blanked out window on the premises 'with a Victorian ghost and a tame parrot'.[11] After the war, by which time Curwen had given up the shop and moved to Dorset, Bawden was still writing to him for lithographic advice.

'Oliver's box' also contained Bawden mementoes. A Christmas card based on Brick House was used to illustrate the autobiographical *Printer's Playground*. Another treasure was that with a heel-ball frottage of an owl in the moonlight and full-page calligraphic greeting reminding us Bawden had been a royal exhibitioner in writing and illuminating. At yet another Christmas, Charlotte and Edward sent a 'Heads Bodies and Legs' drawing which has now improbably found its way into the Simon collection at Cambridge University Library. It was the product of a popular game of the thirties and Bawden wrote recently that he still possesses a collection of the drawings: 'a somewhat pornographic harvest, but timid compared to what can be done today'.[12]

The letter to Herbert Simon from Bawden in answer to questions he posed when writing the history of the Press revealed that Bawden did his first job for the Press in 1924–now over fifty years ago.

Eric Ravilious

Another of the artists listed by Nash in the 'outbreak of talent' at the Royal College was Eric Ravilious,[1] whose career was closely linked with that of Edward Bawden. Indeed, they worked together on an outstanding mural at Morley College in 1929. It, like Ravilious, perished during the war.

Just as he helped Bawden, Nash was helpful to Ravilious, among other things introducing him to the Society of Wood Engravers in 1925. The Society had been started in 1920 by Robert Gibbings and Noel Rooke, and included among its members Lucien Pissarro, Edward Gordon Craig, Eric Gill and the Nash brothers. Gibbings ran the Golden Cockerel Press where he produced over forty books illustrated with wood engravings. The most famous of them had been done by Eric Gill but he welcomed the new and younger talent that Ravilious represented.

It has already been demonstrated that Harold Curwen was an

expert at coping with the printing problems created by the white-line wood engravers. As Ravilious was one of the best artists of the wood engraving revival, it was inevitable that he should have made contact with the Curwen Press, and indeed he was represented in three out of the four annual issues of *The Woodcut* published by Oliver at The Fleuron. In 1927 he supplied a 'Flower Sprite', in 1928 his 'Proserpina' served as an illustration of scorper work for an article by D. P. Bliss. Her skin is lightly grazed, the skirt falls in shoals of scorper marks that follow the limbs beneath, the grass glitters with spitstickered dew or daisies, and her feet are lost amidst tufts of shaggy pinks. The work reminds one that Ravilious had looked at Gothic tapestries, at Persian miniatures, at wood engravers like Bewick, and at those fascinating manière criblée prints of the late fifteenth century with their punched patterns, which he re-invents in modern terms. With 'The Boxroom' for the luxury fourth edition, a signed copy of which he presented to Oliver, the scene is of a finely observed candle-lit room with a girl lying in bed under a line hung with her own stockings.

By now he had also provided an illustration of 'The Three Holy Children' for the majestic undertaking of the Cresset *Apocrypha* which the Curwen Press printed, and 'Dr Faustus conjuring Mephostophilis' about which the artist wrote to Bawden in 1929:

> In fact I am anxious to begin again at Morley but can't do this because of an enormous block 5 × 7 in of Faustus I hope to begin today. It is merely an adaptation of my wall design – it will keep me going until the end of the week.

Faustus was for the British Legion Book edited by Captain H. Cotton Minchin which the Press printed in 1929 and of which the Prince of Wales took several copies, presenting one to the King and Queen.

In 1930 Ravilious illustrated 'Elm Angel', one of the *Ariel* poems with engravings of a 'white temple glowing through the green' and a youth sitting by a river. The poem was yet another by Harold Monro of the Poetry Bookshop, whose rhymesheets, illustrated by both Nashes and Lovat Fraser, Bawden and Ravilious had studied in the Victoria and Albert Museum Library. Ravilious had quite a collection himself, but never illustrated any.

In 1932, the same year that he illustrated the magnificent Golden Cockerel Press *Twelfth Night*, Ravilious provided exquisite small illustrations based on Great Bardfield (where he and Bawden shared Brick House) for Herbert Simon's *Kynoch Press Notebook and*

Diary. By 1933 when the diary came out, however, Herbert Simon had become a Director of the Curwen Press and Ravilious, who had turned increasingly towards the watercolour painting he loved, was planning an exhibition at the Zwemmer Gallery. The magnificent device he designed for his card – a serpentine curve encompassing starry spheres – was printed by the Press in November 1933. Among buyers of his paintings were Charles Laughton the actor and his brother Tom, the enlightened owner of the Pavilion Hotel in Scarborough. A whole series of Curwen artists designed publicity booklets for the hotel, including Ravilious who had worked for them in the uncharacteristic medium of line block in 1930.

Eric Ravilious, invitation card, 1933 (Cat. 167a)

The Press were attracted by the abstract devices Ravilious cut and frequently, when he had designed one for a specific purpose, they bought the rights to it afterwards, as well as commissioning some. Possessed of an internal fire, the small blocks whirl or radiate light. Oliver called them 'Attention Getters' and the Press paid Ravilious six guineas for two in 1936.[2] One – a kind of dotted flower of coiled ribbon – appeared in a Westminster Bank advertisement. The Press also rescued a three-dimensional star from a Cassell book cover for *The Shining Scabbard* and allowed it to shine in other firmaments. An exquisite 1935 vignette of loaf, bottle, wheat-ear and grape may have been a label for the Kemp Town Brewery that the payments book lists as unused: but the Press bought it and used it. Another late acquisition was a threefold formation of pointed elipses emitting sparks – a design that appears in its unfinished state in the Royal College catalogue raisonné of Ravilious's wood engravings,[3] but completed with central circles is described by the Press as Stock block 1008. All these joined the attractive range of designs that the Press kept on hand for customers of general printing who unhesitatingly accepted as expressively powerful, forms they might have questioned in a painting.

The *Curwen Press Newsletter* No.6 of 1934 – another of the Press's well-designed and elegant productions which kept customers in touch with developments – rejoiced in an oval cover design by Ravilious radiating fishbone patterns and stars.

The year 1935 was Jubilee year and Ravilious wrote to a friend in February that 'Curwen now wants a jubilee advertisement for the S. Railway "to strike a Rural and Royal note, maximum joyousness without colour printing".'[4] This was for a tiny but exquisite booklet called *Thrice Welcome* which the Railways Board published.

Eric Ravilious, stock blocks

Eric Ravilious, illustrations from
Thrice Welcome, 1935 (Cat.171)

Ravilious provided three concentrated headpieces, one suggesting rural tranquillity with a country house amidst lawns and trees reflected in a glacial pond; the second depicting history with a cannon beside a ruined arch; while the third stood for joyous recreation with a dark rider against whose galloping form a tennis player is seen gracefully sprinting to maintain a rally.

The fineness of the cutting contrasts interestingly with the comparative coarseness with which Ravilious adapted his cuts for Green Line and Country Walks booklets—still in production today—which had to be printed on less luxurious paper.

Thrice Welcome was covered with a jubilee pattern paper commissioned by Heals which Ravilious designed with a very formal diamond-checkered pattern alternating ornate crowns with crossed sceptres. He had created one of the Curwen Press pattern papers in 1927—a two-colour wood engraving using an arc behind a double pyramid and printed in blue and green. Although it was not produced in sheet form, another all-over pattern provided the cover of the Austin Reed booklet also produced in Jubilee year. Wood engraved, but lithographically reproduced, the repeated motif, like coiled rope illuminated with the inevitable star, lends dignity to yet another commercial Curwen Press production.

Like Bawden, Ravilious was a member of the Double Crown Club and like him he designed a menu—for the forty-ninth dinner at the Café Royal. He featured the salient lettering on the dark spotted body of a large sole and set it about with items from the menu—hors d'œuvres variés, melon, trussed fowl, asparagus, and pear, topped by the bravura of an intricately folded serviette.

Both Bawden and Ravilious designed unicorns for the Press. But while Bawden's, like an Arab steed, trips the light fantastic with flowing mane and tail, Ravilious's, on the other hand, looks as if he has just lost the Royal arms and wonders what has happened to the lion.

During the 1930s with his growing interest in painting and in colour, Ravilious turned away from wood engraving more and more, mentioning in one letter that he is 'crawling like a fly over all these finicky bits of wood'. His last major statement in the medium was the Nonesuch *Natural History of Selborne* (not printed by the Press). In his next and last book, *High Street*, he turned to lithography.

High Street began life as an 'Alphabet of Shops'—an idea Ravilious had in 1935 which he offered to the Golden Cockerel Press to replace

a book on gardening they had asked for which he didn't relish. Shops were in his blood, for his father had kept first a drapers, then an antique shop in which the artist encountered the English water-colour school he so much admired. He was always on the lookout for quaint and unusual places – he and Bawden had spotted the premises of a submarine engineer which lay on their way to Morley College at the time of the mural – and it too found its way into *High Street*.

His first lithograph, for the Contemporary Lithograph series, was made in 1936. A note to him from Harold Curwen mentions a 'summer school' as being 'a figment of Oliver's imagination' and asks him to come in mid-September and to let Curwen know whether he wants a grained or polished stone.[5]

When he eventually started the print, he was immediately enthusiastic about the medium and hopeful of good results. The subject he chose for the schoolchildren was a clear cool view of the harbour at Newhaven which he had visited with Edward Bawden. He subtitled the work 'Homage to Seurat' recalling the northern Channel ports by that artist, and his work shares their calm.

A preliminary watercolour shows that he kept extremely closely to his initial idea, in which the cool blues are slightly warmed by a powdering of pink and yellow, although the watercolour washes are, in the lithograph, translated into a system of dots and cross-hatchings.

Later that year, he tried out a design for the book of shops loosely connected with the Tate's pellucid watercolour 'The Greenhouse' of 1935. He first encountered the greenhouse the previous year while staying with Peggy Angus at Furlongs, a cottage on the South Downs. Nearby at Firle there was an old nurseryman who had plant-hunted up the Amazon and Ravilious would visit him. The premises were to provide the subject for both works. The tiny lithograph he called 'The Grapehouse', and it shows a man with watering can stepping into the cool clarity of the glasshouse which is festooned with an entrancing framework of vines.

'G for Grapehouse' never got into the book, because by this time the 'Alphabet of Shops' had been dropped. So it became instead a Christmas card for Sir Stephen and Lady Tallents in 1936. The book was by now *High Street*.

Somewhat inexplicably, Ravilious retained a woodcut of chefs slicing a huge fish for the title page, but the rest of the book is richly illustrated with twenty-four lithographs, with three basic colour changes. Under Curwen's tuition Ravilious had absorbed,

with tremendous speed, not only the basic drawing techniques of lithography, but also the tremendous possibilities of a limited colour range when transparent colours are used.

Herbert Simon remembers Ravilious 'delighting in an easy contact with the skilled men who actually did the lithographic plate preparation and printing. He liked the works atmosphere, and as he had no feelings of being a superior person, he was offered friendship from all unreservedly.'

It is clear he was also able to draw on a good deal of their expertise concerning overprinting.

The drawings that survive show he made detailed annotated studies on the spot which were later distilled and edited into an incisively simple pencil line.

The colour combinations Ravilious used show extraordinary sensitivity and allow him, with only four printings, to suggest a tremendous range. The most obvious of his three combinations—of mustard, red-orange, black and grey—is manipulated so that it conveys the sober 'Oyster Bar' where only the lobsters provide a dash of red, to the junk yard where its brilliance both bricks the wall and covers a central swag of vivid cloth.

The pages in rose-pink, turquoise, mustard and navy, show similar variety. While the pink gives only a ghost of a blush to the lady like Queen Mary buying wedding cakes, at the butchers it riots in flesh, and in the night scene outside the 'Pharmaceutical Chemist' the turquoise and deep blue come into their own. The most subtle of the colour mixtures, however, lay in the choice of a dull orchid pink, grey-green, yellow and a reduced black providing unexpectedly rich secondaries of a distinctly different grey, orange ochre, and light olive. In the illustrations where this combination has been used, one would cheerfully swear that there are at least five or six printings, and each new usage reveals a different expressive power.

John Piper enthused about the book in *Signature* several months before it was actually published and three of Ravilious's designs were printed from the plates he had drawn, but in different colourways. 'There is about them the suggestion that you are looking at a series of gay old-fashioned parties from a matter of fact street in the present,' wrote Piper. The book did indeed record a *High Street* as yet unadulterated by the chain store and the supermarket.

In 1939 Ravilious had his last show of paintings at Tooths, for by the end of the year he was attached to the Admiralty as a War

[65]

Artist. He was amazingly cheerful and busy at his watercolour painting but still dreaming of lithography. In January 1940 he got an estimate from Herbert Simon for doing a lithograph portfolio based on drawings of submarines.[6] He had been at sea in them, finding them crowded but with no roll and 'extraordinarily good in a gloomy way. There are small coloured lights about the place and the complexity of a Swiss clock,' he wrote in August.[7]

With their usual decisiveness the Ministry of Information couldn't make up their minds whether to pay for the publishing, or let him pay and then take some of the edition, but he was already altering his project to a book rather than a portfolio. Two drawings, with notes on the litho colours to be used, are among several at the National Maritime Museum, and show the frontispiece, with the artist's hand at the drawing board, and the last image in the book 'The Whitstable Mine' (which in any case was placed on the top secret 'A' list and would never have been published).

In October he wrote that the War Artists' Advisory Committee wanted to make a 1/- children's painting book and print 10,000 'so that the rising generation will clamour to go into the Navy'.[8]

The idea floundered, however, as did the suggestion that the Curwen Press should do the printing, for they had been bombed, and Ravilious not only had to publish the prints himself, but find another printer elsewhere.

'The children's book idea is gone for good', he wrote, 'and no bad thing either. Submarines aren't suitable for children.' The project was finished in April 1941 but he was never fully satisfied with the result, thinking he had perhaps used too many colours.

In 1942 his service as a war artist took him to Iceland. He had always longed to go there, imagining the scenery would look like the Swiss peaks in Francis Towne's eighteenth-century watercolours. Perhaps these combined influences would also have found their way into his lithographs for he had by no means exhausted the medium. But in September the aircraft on patrol in which he was flying was lost, and the Curwen Press never saw him again.

Barnett Freedman

On the back of one of his beautiful autolithographic Christmas cards, a minute bespectacled man staggers under the weight of a huge litho stone. It is a self-portrait by the artist, Barnett Freedman,

but the size of this figure gives no clue at all to the real largeness of the man, who seems almost as vivid now in the memories of his friends as when he rated several columns of obituary notices in *The Times* in 1958.

Freedman's career, said *The Times*, was 'a striking instance of the triumph of the ruling passion over difficulties' for he was not only of poor parentage—son of Russian Jewish immigrants in the East End—but he spent the years from age nine to thirteen in hospital. Through the irregularity of his education he was therefore rather later than the rest of his generation getting a scholarship to the Royal College. He achieved this by the direct intervention of Sir William Rothenstein, and was still at the College when Oliver Simon first met him.

Freedman was a character. He was known as 'Soc' (short for Socrates) a name which gives some inkling of his lively talent for debate, in which he liked to shock. He had a rich cockney accent and, later in life, loved to tell the story of how he had asked a taxi driver to take him to his club, The Athenaeum, and received the rejoinder: 'What, you!'

It was at least two years after he left the Royal College, during which time as he succinctly expressed it 'I starved', that he got his first commercial job, and the first at the Curwen Press. It was for 'Wonder Night', the *Ariel* poem by Lawrence Binyon in which the drawings with their swift cross-hatching made conventional use of the line block. With his second poem in 1930, 'News' by Walter de la Mare, he asked for his fee as quickly as possible since he was hard up and requiring work. Faber encouragingly told him his drawings were quite the most successful they had ever had in the series and commissioned him again for Roy Campbell's 'Choosing a Mast' of 1931, in which a sailing boat is inset in a cluster of tall trees.

Freedman also did a number of other jobs at the Press about this time: a calendar; a set of postcards, one of which he later updated and which in their first form were stencilled in the *Miscellany*; and an experimental lithograph, carefully preserved in Curwen's album, and showing a street market which has some affinity with one of the artist's oil paintings at the Tate. Since it has colour added by stencil in blue and gold, it probably dates from before 1932 when the stencilling department closed.

The work that really started to establish Freedman's reputation, however, was not done at the Press but was another commission

Barnett Freedman, postcard (Cat. 125)

from Faber to illustrate Siegfried Sassoon's *Memoirs of an Infantry Officer*. His drawings, in much the same style as the *Ariel* poems, were again made into line blocks, but, somewhat unusually, were teamed with lithographic colour.

It gives an amusing insight into the bureaucratic mind to relate that when Freedman later lithographed the interior of a gun turret as a war artist, he was paid £100 for the 'craftsmanship' but only half that sum for the design – the Curwen Press always knew it was the other way round.

He began his apprenticeship in that craftsmanship when Thomas Griffits helped him to colour the Sassoon illustration. Griffits was an extremely competent lithographic copyist who had learnt his trade translating artists' originals for reproduction. He was amazingly adept at it and was early among those lithographers who worked for Frank Pick making artists' originals into posters for the London Underground. Later in his life, by which time he had transferred from Vincent Brooks Day to Fred Phillips at the Baynard Press, he wrote a couple of books and published his findings from a remarkable and exhaustive series of colour tests.[1] He is recorded as saying that he usually printed the black first to unnerve the artist, in case he got above himself. However, he didn't unnerve Freedman, and he recalled in his book that the artist was the best pupil he had ever had who, in 1948, was still calling him up at home with queries. He was also still using a tool Griffits had given him called a 'jumper'. This is a heavy handled knife which can be skittered across the surface of the stone held at an angle, grazing the drawing with tiny wounds which print as hairline whites. It became Freedman's hallmark as his fame as an autolithographer increased.

His magnum opus, the five-volume *War and Peace* of 1938 was done with Griffits, but during the first half of the 1930s he also worked at the Curwen Press and his skill in book lithography must equally have been helped by his association with Harold Curwen who was a major pioneer of autolithography in books.

A pattern paper he made for the Press in 1934 was an extremely complicated one and the only one autolithographed by an artist as opposed to being designed in another medium and transferred by the printer. He did a related pattern on a biscuit label for Romary's and a charming all-over pattern in two shades of blue for the *Curwen Press Newsletter*. He also designed a decorative alphabet for Baynard which Oliver reproduced in *Signature*.

In 1936 he embarked on a two-volume edition of George Borrow's *Lavengro* at the Curwen Press for the Limited Editions Club of New York – a mammoth undertaking. It is worth quoting a letter in full that he wrote to Oliver's wife Ruth after completing the book.

My dear Ruth

The misery occasioned by the enormous amount of work I have had to do for *Lavengro* – the getting up at six o'clock every morning for three months – the journey to Plaistow in crowded and overheated trains – the faces of wage slaves and breadwinners, their coughs and sneezes, their smells, their conversations and newspapers. The close approximation of their bodies to my own (this sometimes was not *so* bad) – the rush and roar of the works at North Street – the bickerings of the printers – the inexperience of the lithographic department making me often leave the works at eleven at night – *all* these things and many more (including the awful weekend trying to write about what I hardly know a thing for Oliver) *are completely mitigated and relieved* by your most kind and delightful letter.

I know all this seems flowery and must sound bombastic – but it isn't felt so – for your letter has given me more pleasure than my pen can express and I am most grateful. *Sufficient to say now that the job would not have been done without Oliver's real help and enthusiasm. So God bless you and him.*[2]

The writing he mentions must be a longish article on the history of lithography which appeared under his name in the second *Signature* early in 1936. After running through the most famous artists to use the process, Freedman went on to say that the lithographic printing trade was so hedged around with secrets and stringent trade union rules that the acquisition of any first-hand information was a little hard to come by. Yet the work couldn't be done in the quietness of the country, but only in close cooperation with the printer 'surmounting a hundred difficulties which are inevitable when an artist cooperates with the world at large'.

Piper remembers how helpful Freedman was – 'one of those chaps who thought there were no secrets and it didn't matter to whom you gave the show away – if there was a show to give away'.[3]

Rowley Atterbury recalled in a talk that one could still meet the occasional compositor or pressman who had been berated by Freedman and 'asked if he would relish the opportunity and encouragement to produce such work again, is apt to get a nostalgic look about the eyeballs'.[4]

When Atterbury was collecting material for his talk, Herbert Simon wrote to him: 'The real artist broadened horizons and also produced techniques which were appreciated. Barnett was a master of smooth chalk work and he taught the transfer men how to be sparing of ink so as to hold the chalk work and not coarsen it. . . . Of course if a trade craftsman can have contact with artists from outside and feel he has found new friendships, then you get something approaching what Harold used to call "the spirit of joy". Certainly there was always joy and determination to give of their best when Barnett, Piper, Ravilious or Bawden appeared at the Plaistow works. The artist brought a new attitude to work. . . .'

Barnett himself had concluded his article with a bouquet to copyists as skilful as Griffits, but also the belief:

When all is said and done, nothing can take the place of an artist working in a medium which he thoroughly understands, producing marks on a flat surface which go straight into the printing press without 'let or hindrance'.

The result must necessarily be vital given that the work itself is vital. A bad artist, of course, will never produce a good lithograph, but a good artist scarcely does himself justice when a photograph or 'hand copied' reproduction is all that he gives.

One of the techniques Freedman developed with Harold Curwen's help in the early 1930s was a way of drawing for the black-and-white line block to achieve lithographic qualities associated with drawing on grained stone. The cross-hatching of the *Ariel* poems vanishes in favour of chalk drawings which harmonize more fully with the colour lithographs, a technique which in *Lavengro* appears fully-fledged.[5] The colour pages are very subtle, employing to great effect rose-pink, tan, gold, blue and green in charmingly lit landscapes and character sketches, but the black-and-white endpieces such as 'The Dingle' are equally lovely in their own way, matching the lithographic character of the main illustrations, the granularity of chalk on coarse paper accented here and there by fine pen touches.

Oliver Twist and *Henry IV* (like *Lavengro* done for American limited editions clubs) were completed the year war broke out. Anne Spalding's set of the Shakespeare lithographs reveals an attractive habit Freedman had of specially binding sets of prints from his illustrated books for his friends. The large format of *Henry IV* allows him scope for sonorous colour, particularly striking in the battle encampment at sunset, while in depicting groups of people

Barnett Freedman, decorative initial

Barnett Freedman, 'The Dingle' from *Lavengro*, 1936 (Cat.140)

the artist makes increasing use of light–achieved by leaving the paper blank–to dramatize the expression on their faces.

Throughout all these book commissions, Freedman was continuing with his commercial poster work. Several for London Transport were produced by him at the Curwen Press in 1936–37 and, unlike the majority of artists, he drew them as lithographs himself. The men always marvelled at his prodigious skill. There are two splendid two-sheet advertisements for 'The Theatre' and 'The Circus' in which the broadly brushed and crayoned faces of a clown and an actress are actually divided in two. The colour breaks all the rules, lights being printed over darks, and in that characteristically recurring crescent-ripple pattern of his, a varnish has been applied which has the marvellous effect of doubling the impact of each colour over which it passes so that, for example, the black in places is absolutely matt and in others glistens brilliantly.

The Imperial Airways poster blank is also masterly, its hand-drawn border punctuated by symbols around a marigold yellow centre. An artist's note on the rough tells the customer the design will be drawn freely by the designer for offset lithography, the yellow ground being carefully aerographed 'not just anyhow as I've got it here'.

A whole host of book jackets were also autolithographed during the decade, which must have left the artist's unmistakable stamp on every bookshop. It is wonderful to think that not only the illustrations inside were originals, but even the ephemeral paper covers as well.

Freedman himself believed in the essential unity of all the arts. 'What's commercial art?' he would ask when the topic was raised. 'There's only good art and bad art' and he would probably have agreed with Eric Gill that to make a drainpipe is as much the work of an artist as anything else.

Sir Stephen Tallents writing an appreciation for the catalogue of the Arts Council memorial exhibition commented that Freedman was:

> . . . certainly a pioneer in a movement which today happily insists that the vital power of the artist to bring truth alive is not demeaned and may be advantageously disciplined by its exercise upon workaday material however humble. The lead which he gave in this field may well prove his most enduring claim to remembrance.[6]

[71]

Ironically, however, autolithography as a book process did not really become as widespread as was hoped. After a short postwar flowering in the hands of publishers like Noel Carrington, it was overtaken by the camera and by union restrictions. Even in pre-war days many autolithographed books not only went out of the country, but into the small province of the specialized book collector.

In his article in the 1950 *Penrose Annual*, Freedman revealed that it was not the precious limited edition, but autolithography specially planned for machine production that particularly interested him and was, he felt, the real sphere for the future activities of artists if they could overcome apprehension on the part of the professional copyists and photomechanical operatives that artists might become competitors.

Freedman also liked to work in offset lithography, in which the image is reversed onto a rubber blanket before printing, because it facilitated spontaneity on the stone without the need for thinking back-to-front. At the height of the 'originality' controversy however, many print purists would not have admitted offset into the canon of approved techniques.

In 1940 Freedman went to war and almost immediately came up against officialdom, finding a dearth of cooperation and bitterly complaining about it. Coote suggested he be told that he need only give a month's notice.

By August 1940 he was reminding one of Paul Nash (only more fruitily) by fulminating about the reproduction of a work in postcard form, in which, Kenneth Clark eventually admitted, the rather too dark purple tarmac did give a distorted rendering. At Christmas the same year a card which has made use of his work without consultation is pronounced 'bloody awful and could only have been produced by the very lowest form of life'.[7]

In April 1941 he received a catalogue for an exhibition of war pictures in which he was included. In a letter to Dickey (which has been internally marked 'A little criticism for a change!') he casts his professional eye over the printing and submits it to a diatribe of withering scorn and blistering sarcasm:

> You are right, I might think the reproduction of my picture
> rotten, as you say – but then I might not. I might think that the
> catalogue is a monument of muddle, and very bad
> workmanship – I might think that the printed page of names and
> titles, instead of being 'ordered' now looks like a 'spotted fever'

of a page, with caps, small caps, Heavy caps, Heavy lower c[ase],
Light lower c[ase] and 6 point piddling italic, all mixed up, living
in sin with badly spaced Corvinus, that modern type which caught
on so much before the war, and was used by every tuppeny
advertising hack—to its very death. On the other hand I might
not think so. In any case, I'm not going to express my thoughts
any more, for I've a shrewd suspicion that they are not liked. . . .[8]
To add insult to injury he enclosed a worn-out sketching permit.

In fact, the war gave Freedman the opportunity for large-scale
painting which he welcomed. Before it he had painted until four
p.m. every day and then turned to his bread and butter work.

Amazingly he found time between periods at sea (where he
painted the entire crew of a submarine who dubbed him Mike for
Michelangelo) to illustrate two more books at Curwen—*Wuthering
Heights* and *Jane Eyre*—making rich use of the 'jumper' in the
broad coloured borders on the latter.

Love, the originals for which the Tate owns, was not a litho-
graphic production but *Anna Karenina*, which was done postwar at
Curwen, showed a marked development of his style. Some of the
more tender full-colour illustrations have been likened to Renoir—
the candlelit bride beneath a delicate veil, and Anna's porcelain
portrait filling the whole of the tall narrow format in close-up.

One of the most charming postwar practices he instituted was
that of autolithographing Christmas cards, which Faber, ever
pioneers, started in 1945. His first design, which Geoffrey Faber
pronounced 'delicious', shows books, artistic implements and a guitar
in half light as a new day dawns, and centrally a branch poised
above an open page. Freedman explained that the symbolism
showed 'literature, painting and music emerging from darkness,
with the olive branch of peace poised above a new page of history'.[9]

Subsequent designs, which were also made for the bookbinders
Leighton-Straker, were equally vital. A family gathering, remini-
scent of his Contemporary Lithograph 'Charade', glows in the
Christmas firelight. The carollers, sometimes in snow, sometimes
cheerfully playing instruments, give voice. Another work based on
the four seasons was exquisitely adapted as a quadripartite Christmas
image with a country scene in the golden spring, a picnic in green
summer woods, fruit-collecting in the russet pink autumn, and
skating on the blue winter pond. Each of the colours is shafted by
the light of the paper and thrown into relief by a cast shadow of a

complementary chosen to sharpen the dominant mood. It is the casual details which are particularly enchanting; the signing strips arranged so that the sender's name can appear just to have been completed by a *trompe l'œil* pen complete with cast shadow, the robin picking up an envelope, the information about the publisher and artist written on a litho stone beside which the brush has just been set down.

Freedman was a great friend. Curwen's daughter Isabel recalls that when she visited her sick father in hospital, Barnett seemed to be there more than anyone. He also visited him when he was running his country shop and one weekend after meeting Oliver there, he wrote:

> I bethought me of the strangeness of things—you—Harold—a
> grocer's van and the huge trees and wild environment—none of
> your potty Surrealists could ever dream of anything so strange—
> surely?...[10]

Frances Macdonald remembers that the artist would take out to dinner dismal dustmen, his piano tuner, or a student who looked hungry.[11] He valued absence of parsimony in others. When Albert Rutherston, with whom he taught at Oxford, died, Freedman wrote to *The Times*: 'I would like you to know that Albert Rutherston spent a great deal of his life helping artists young and old—he did good by stealth and was held in affection by many.' It was a story Barnett's friends could have told many times over about him.

McKnight Kauffer

Kauffer was one of the artists who was already famous when he first worked at the Curwen Press.

He came from a poor home in his native America but a professor at the University of Utah, recognizing his talent, had sent him abroad, and after travel in Munich and Paris he had gravitated to England on the way back to America upon the outbreak of the First World War.

A painter, aligned first with the English Post-Impressionists and then with Wyndham Lewis and the Vorticist Group, Kauffer was one of the very early artists to be commissioned by Frank Pick to make posters for the Underground. By 1940, when he returned to the U.S.A., he had designed 150.

Eventually he abandoned painting to become a full-time graphic

designer wishing 'to keep my integrity as a painter free from depending on social hypocrisy and the necessity to paint pictures that would sell'.[1]

Kauffer's great aim was that publicity should reflect civilized values. He did not want to attach to a product a spurious symbol—lending it the frisson of sex or the piety of religion—but to find a form to express the essence of whatever it was he advertised. As Aldous Huxley put it:

> To advertise, say, a motor car by an appeal to snobbery or sexuality is easy. McKnight Kauffer prefers the more difficult task of advertising products in terms of forms that are symbolic only of these particular products. Thus, forms symbolic of mechanical power are used to advertise powerful machines; forms symbolical of space, loneliness and distance advertise a holiday resort where prospects are wide and houses few.[2]

Kauffer believed that good design would promote respect for the advertiser and he educated taste and won clients round to his views by gentle persuasion.

Writing on 'New Draughtsmen' in *Signature* in 1935 Paul Nash said:

> I have little doubt that E. McKnight Kauffer is profoundly tired of being pointed to as a phenomenon. I am a little tired of it myself. But we must admit that Kauffer is responsible, above anyone else for the change in attitude towards commercial art in this country; and it was the courage and aesthetic integrity shown in his early battles with the 'plain business man' that made it possible for Kauffer to advance and eventually consolidate his position. . . . But for the excellence of his craftsmanship and his fighting spirit I do not think the relations between artist and employer would be what they have now become. As it is, today we are able to regard drawing and designing for industry as a serious form of art.

The first sign of Kauffer at the Curwen Press is a letter of 1924 still on file there, in which he thanks them for a copy of Oliver's catalogue raisonné which, he says, he has read from cover to cover. His initial professional association with them was somewhat peripheral. He illustrated his first book—Burton's *Anatomy of Melancholy* for Francis Meynell—at Nonesuch in 1925 and over a period of months provided scores of line drawings extracted from him by forty letters from Meynell 'nagging beseeching criticising or

praising'. Curwen merely coloured the vellum luxury edition, a job which must have come right at the beginning of the Press's stencilling operation.

Meynell, who described Kauffer as an 'exquisite' in face, figure and manners, had met him when he bought his famous poster of mechanized birds for the *Daily Herald*.

> Kauffer was an example of the abandoned truth that art is indivisible: that a man with the root of the matter in him can paint, or design rugs (as he did for Arnold Bennett) or make posters, or illustrate books, or decorate a room, or parti-colour a motor-car (as he did for me) or scheme an advertisement.

In those days, Kauffer rented a studio from Meynell and as a 'romantic theorist' often dropped by for a chat. Despite his fame he wasn't rich, and Meynell used to clear off any arrears that arose in his rent by fining him every time he spoke a sentence with a 'red herring word' such as 'The artist' or 'functional'.[3]

The next Nonesuch/Kauffer book, *Benito Cereno*, was handled entirely by the Curwen Press who set the distinctive Walbaum type printed on grey Van Gelden paper as well as handling the seven full-page illustrations. Kauffer still regarded stencilling as a way of adding colour to what was essentially a reproduced pen drawing, but his sense of colour was very subtle especially in the dull harmony of a grey and chocolate negro, suddenly relieved by a pair of heliotrope lips, and in the frontispiece, of a becalmed ship, which, somewhat mistily scribbled in a design forming an oval, is coloured lilac and grey-blue.

In 1927, Kauffer began the series of four *Ariel* poems he was to illustrate for T. S. Eliot, who became a personal friend. The first, in 1927, for which he exchanged cover colours with Paul Nash, was 'The Journey of the Magi' with its geometric figures of the kings subtly ordered in beige and grey against the emerging outline of a black cross. Faber correspondence reveals that like Nash, Kauffer took up his problems about colour direct with the Press.

The second poem, 'A Song for Simeon', is illustrated with a boldly schematic single black figure. In a letter to Faber, D. H. Lawrence, who had been approached for a poem, disliked some that had been illustrated, particularly that of Yeats, but didn't mind Kauffer's 'futuristic' illustrations for Eliot.

Eliot himself was deeply appreciative of Kauffer's designs: 'all your illustrations delight me' he wrote in a letter of 1931.[4] But in

E. McKnight Kauffer, illustration from *A Song for Simeon*, 1928 (Cat. 158)

1930 he had asked for a change to the third poem 'Marina'—not because he criticized the drawing, but because words from 'The Waste Land' 'Datta. Dayadhvam. Damyata' had been attached to it.

> It seems to me a pity that de la Mare did not show me the
> drawing when he received it, as it might have saved you
> considerable trouble [Eliot wrote]. My criticism was not of the
> drawing at all, but merely meant that I don't want what I write
> now to have 'The Waste Land' stamped upon it. But I think you
> will appreciate my point without my saying anything more.[5]

Six proof copies of the original version were given by the artist to his friends, but inscribed to the effect that the words had been deleted at the poet's request.

The final poem he illustrated for the poet was 'Triumphal March'. In 1929 Kauffer took on both Cassell's Arnold Bennett title *Elsie and the Child* and Defoe's *Robinson Crusoe* for Etchells and MacDonald. Unlike *Benito Cereno* which conceives of illustration as a line drawing with added colour, both new books employ the unparalleled richness of stencilled gouache applied as colour solids. There are blues in the Defoe as intense as those in early Italian tempera paintings, but as a whole, the book lacks the homogeneity of Cassell's masterpiece, because the text (done by Robert Maclehose) fails to integrate with the Curwen illustrations. In *Elsie and the Child*, an upstairs/downstairs tale, Kauffer's colour frequently breaks into stipple, and sometimes cleverly used over a black or brown lithographic key is wonderfully organized in sumptuous masses. The oblique design in which walkers in the black and emerald garden are shafted with stippled lilac light, or that in which Joe, brick red in his shirtsleeves contemplates the *Daily Mirror* below stairs, share a density and resonance unique in illustration. What completes this to perfection, is the Baskerville type in which a running heading encased in beige ruling carries one through the book, picking up a colour echo in many of the illustrations.

In *Don Quixote* of 1930, another Nonesuch book, the text and illustration were separated, the former being done at Cambridge University Press. Curwen however handled the watercolour stencilling on the illustrations in which photogravure captures the exceptionally soft rich black of Kauffer's crayon and charcoal originals. Sir Francis Meynell's widow Dame Alix still has two of Kauffer's unused preparatory works, one close in style to the frontispiece of

Volume II in which the Knight's eyes, beard and moustache are distinct, the other a smaller smokier rendering, formed by using masks and a spraygun, which marks an attempt by Kauffer to render the character of Don Quixote more mysterious, as we find him in the frontispiece to Volume I. Other drawings reveal experiments Kauffer made with different shapes for the stencillers, one on a full-length figure of the Knight who appears in a proof with somewhat confused undulating forms which have been later simplified into a shadow towering above him in blue.

There is also an autolithographic head and shoulder drawing of Don Quixote with a book which was found in a Curwen Press scrapbook and annotated in Harold Curwen's writing 'drawn by Kauffer on stone'. In its precision–the clearly drawn moustache, beard and almond eyes–the lithograph is closest in style to the drawing eventually used as the frontispiece for Volume II (in which Don Quixote is also shown with a book). The range of possibilities he tried, however, throws interesting light on the trouble he would go to to arrive at a fitting representation. The trial lithograph might simply have been the outcome of Curwen's enthusiasm for the medium; equally it could have resulted from the fact that Kauffer's mistress, Marion Dorn, made the first autolithographic illustrations for the Curwen Press book when she illustrated the Nonesuch *Vathek* the year before *Don Quixote* came out. 'I should not have thought anything possible after Doré', wrote Eliot when he saw it, 'but you have done it.'[6]

The year 1931 witnessed the last book he made at the Press– another Bennett novelette for Cassell–*Venus Rising from the Sea*. Once more the many unused drawings reveal the perfectionist at work. In fact, Dr Flower (who, as well as his wife Margaret, received one of the early drawings as a wedding present) says the matter proceeded as far as proofs for one set of drawings when Kauffer revised the whole project, simplifying the line and abandoning any sign of cross-hatching.[7] Eventually these were lithographically printed in grey, so that the line sits on the surface and is not strongly divorced from the watercolour.

Kauffer, presumably again at Curwen's suggestion, also tried a drypoint on zinc which was printed intaglio onto transfer paper for lithographic printing–a rather winsome variant of the pensive Etta, who sits staring from her bed and is shaded freely like the abandoned drawings.

[78]

The stencilling is again effected in watercolour. This time instead of confining it to within the outline, Kauffer has his lucid figures linked to their settings by swift dramatic dragged brushfuls of pale watercolour, applied with particular dash in the drawing room scene where two women sit.

There were problems with the setting of the book, and Dr Flower records in Herbert Simon's history of the Press that it was done no less than three times. Whatever happened to the text, Kauffer was delighted with the illustrations, writing to Harold Curwen:

> Your part of the job has again been done with superb artistry.
> The colours are lovely, the texture of the wash is better than the originals. Personally I feel indebted to you for having lifted these illustrations 80%.

He continues with praise for the *Miscellany* in which he is represented and says:

> I think you and Oliver have achieved the highest mark. Let us meet soon and discuss many things. I want as much work as I can get for the rest of this year. I have come back broke in pocket – but with 30 watercolours which I think a great deal of.[8]

Kauffer did no more books at the Press and only intermittent commercial work. He had designed a superb red-and-black unicorn for the Curwen Edition of School Music at the end of 1929 and in 1930–31 worked with Curwen's favourite photographer Bruguière on a corset brochure for Charnaux. It had a splendid black cover with a white star and ultra-modern lettering in gold, while through a circle cut out of the first vivid blue sheet inside, one spots the first of the amazing black-and-white photographs of 1930s ladies disporting themselves in the corsets of the day.

Otherwise Kauffer was busy for other firms and, as the unofficial art director of Lund Humphries, ran a series of important exhibitions during the 1930s which included the work of leading graphic designers and artists such as Man Ray.

Of the host of posters that were done for the hoardings – most by the litho craftsmen of Waterlows or Dangerfield – only one seems to have found its way to the Curwen Press. This was for the Natural History Museum in 1939. It was by then so close to wartime that the poster was held over, and it was only rediscovered recently and photolithographically reproduced from the proof Kauffer approved.

Sidney Garrad, Kauffer's assistant from 1933 to 1939 might well have coloured the original from which the litho craftsmen worked,

for it was Kauffer's usual practice to draw a rough, have his assistant do much of the filling in of colour, finally adding the extra details himself. Garrad remembers how particular Kauffer was, about his personal appearance, about the spotless white lino in his apartment, and about his work. However pressing the deadlines were, they were never so demanding that he could not have a leisurely bath and manicure before he even began to think about tackling them.

When war broke out, Kauffer was offered a job as a War Artist and Garrad could have gone along as a Sergeant Assistant. Instead, Kauffer decided to return to America, a move which, as it happened, not only severed his contact with the Press, but, because of a lack of understanding on the part of the American public, had a generally detrimental effect on his brilliant career.

Graham Sutherland

In 1931, Graham Sutherland illustrated an *Ariel* poem by V. Sackville-West – 'Invitation to cast out care'. A girl in white walks pensively in a landscape under an arching tree not totally unrelated to one in the etching 'Pastoral' of the previous year.

Despite the fact that the four-colour line block of his design was printed at the Press, it seems to have been several years later that Sutherland and Oliver Simon first met, introduced to each other by Robert Wellington in the Museum Tavern, Bloomsbury. In his autobiography, Oliver recalls how attractive both Graham and Kathleen Sutherland were, and how glad he was, since he had taken an instant liking to them, to receive an invitation to visit them.

Sutherland was possibly at the most important turning point in his career, for he had had considerable success as an etcher and engraver of delightful Palmer-influenced rural idylls when the financial crash in America caused the etching market to collapse. Thus it was that in addition to teaching at Chelsea (where he dropped engraving and took up the teaching of composition and book illustration at around the time he and Oliver met) he was open to suggestions for commercial work while he tried to find a new direction as a painter.

The year before he encountered Oliver, he had gone on a holiday to Wales, and this experience had crystallized for him the new direction his art was to take. It was not the sort of landscape in front of which he felt he could sit down and make finished paintings.

PLATE 17

For Curwen.

Moore

Henry Moore, *Hands II*, 1973

PLATE 18

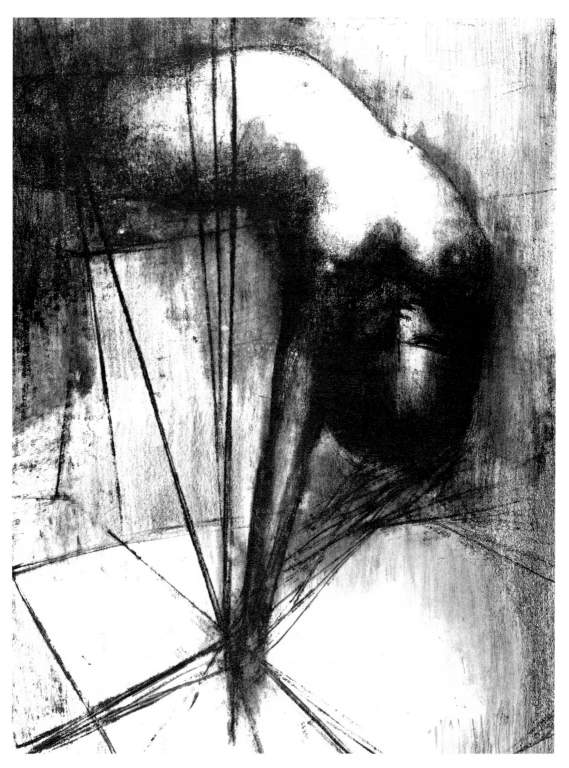

Reg Butler, *Figure in Space*, 1962–65 (DP.6061)

PLATE 19

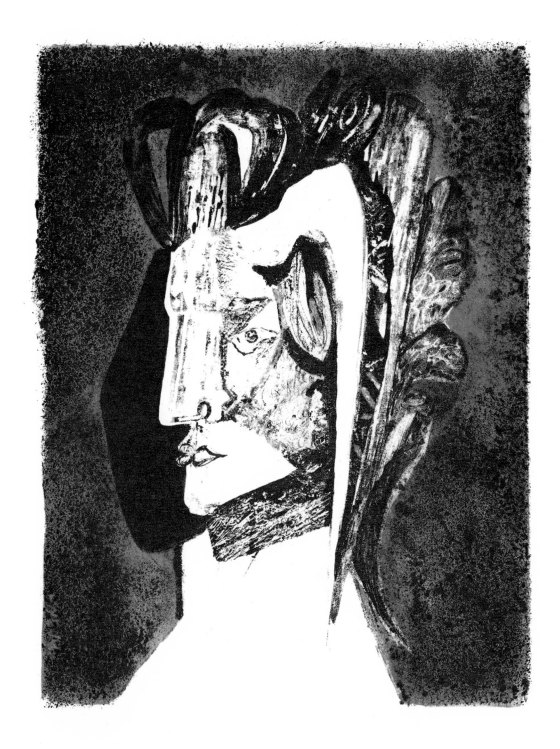

Robert MacBryde, *Head*, 1960 (DP.6342)

PLATE 20

John Piper, *Llangloffan, Pembrokeshire, the Baptist Chapel*, 1964 (DP.6445)

PLATE 21

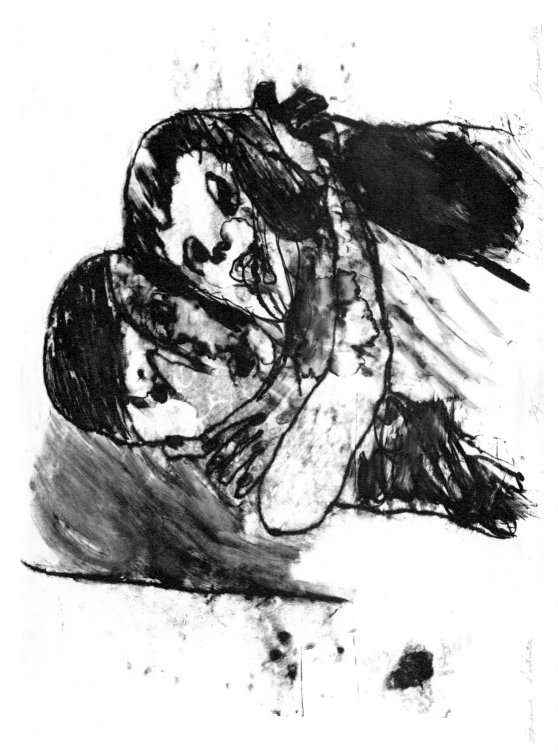

Shmuel Shapiro, *Brother and Sister*, 1966–67 (DP.6559)

PLATE 22

Graham Sutherland, *Portrait of Aloys Senefelder*, 1971 (DP.6581)

PLATE 23

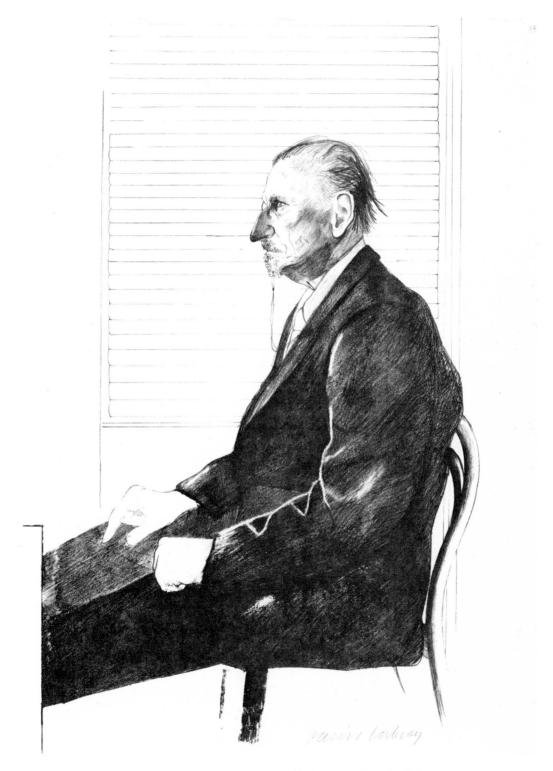

David Hockney, *The Print Collector*, 1970–71 (DP.6289)

PLATE 24

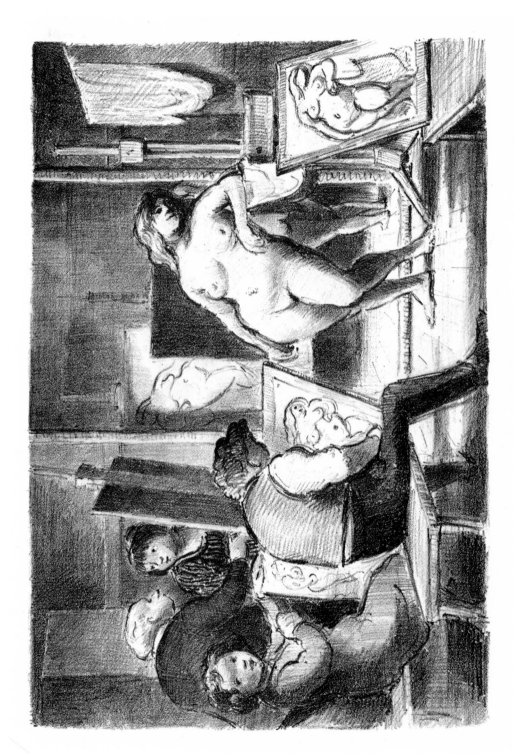

Edward Ardizzone, *Life Class*, 1960 (pp.6010)

'I found that I could express what I felt', he wrote later, 'only by paraphrasing what I saw.'[1]

Oliver was impressed when Sutherland showed him the results of this new approach and asked the artist to send a portfolio of pen and wash drawings and gouaches to his office since they represented 'a new and fresh vision which in form and colour achieved a great lyrical quality'. Dr Flower remembers Oliver telling him at about this time that he had 'discovered' a major new artist and was longing to publish his work in the magazine *Signature* that he had just conceived.

To his amazement, Oliver found few shared his enthusiasm for Sutherland's drawings until Paul Nash saw them in his office and in the first issue of *Signature* included Sutherland in his article on 'New Draughtsmen'. The drawing 'Road with Rocks' was reproduced and Nash, contrasting Sutherland's style with the deliberate, orderly approach of Edward Bawden, wrote that 'a feeling of nervous, scarcely controlled energy pervades the drawing, yet it achieves a subtle harmonious unity. Its whole atmosphere is evocative, its message lyrical.'

In issue No.3 Sutherland repaid the compliment to Nash in his own article on Draughtsmanship, but in *Signature* No.4 it was his turn to be mentioned again, this time by Kenneth Clark writing of three illustrations for *Wuthering Heights*. He praised Sutherland's as the most distinguished, its dark flashes and weird lights owing something, he suggested, to Rouault; he was to become one of Sutherland's important patrons.

Oliver and his wife shared both spring and summer holidays with the Sutherlands that year, the second in Solva where the artist had made many of his Welsh drawings. Then that Christmas they, together with Paul and Margaret Nash, enjoyed Christmas dinner at Oliver's Hampstead home.

The meeting with Oliver started for the artist a series of commissions for work at the Press. He had made posters elsewhere for Shell, lithographed in the usual way by craftsmen. But the Press payments book shows that he did a set of six autolithographed posters for the Southern Railway. They were drawn on plate and he was paid twenty guineas for each drawing plus two guineas for the lithography. Like so much ephemera, the posters seem to have sunk without trace, although the Victoria and Albert Museum Library still has a copy of his design for Barrows Christmas Gifts in the China and Glass Department.

[81]

The same Christmas he drew on stone 'Thunder Sounding' a greeting card for Robert Wellington which, since he does not include the autolithograph posters, is the first lithograph listed in the catalogue raisonné by Felix Man. In it a winged figure, like a Moore sculpture, appears to be running for cover.

The cover for the *Curwen Press Newsletter* of June 1936 was a rather splendid bivalve design with rich red and black crayoning added to work in pen and wash. The mysterious imagery appears to show a lithographic stone bearing a tiny fingerprinted drawing which is overprinted with a numbered grid, while A–Z in a floriated and undecorated face stands for the Press's typographic possibilities.

Sutherland, by this time, was associated with the British Surrealist movement and two paintings of his were exhibited at the Surrealist exhibition of 1936 that Oliver found so intriguing.

The Double Crown Club menu of the same year, which advertises Nash's talk on 'Surrealism and the Printed Book', is indebted to Ernst and employs the technique of his collage books such as *Femmes 100 Têtes* and *Une Semaine de bonté*. Upside down is an engraved wine glass holding a surprised fish, while a Double Crown Club ham with a little head poking out of the frill, seems to have forks as legs, and one of them holds a cigar, the smoke from which is growing into a tiny monster.

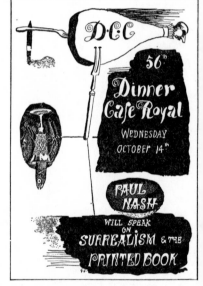

Graham Sutherland, Double Crown Club menu No.56, 1936 (Cat.185)

The same technique—even more reminiscent of Ernst's books—is employed in the artist's New Year card for 1936–37 where Victorian wood-engraved figures with animal heads greet each other while a flying insect has somehow been given a human one, and says 'Happy New Year' with it.

One of the Contemporary Lithographs aimed at school-children 'The Sick Duck' is a very early essay into full-colour lithography that because of its affinities with painting was beginning to supplant etching as his main graphic medium. It is not a subject one would immediately identify as a typical Sutherland, even in this transitional phase, and shows Dr Duck with his stethoscope approaching an invalid with a thermometer in its bill. The colour is harmonious and very sensitively drawn, and in the following year the Sylvan Press commissioned him to draw a five-colour lithograph to demonstrate economical colour effects for their specially inset advertisement in *Signature*. The result was 'Under Water'. In the same issue Sutherland in *Graven Images* enthused about the way Curwen lithographically transferred intaglio prints.

Sutherland's pattern paper design for the Press—a pastille known at the Press as 'Pink Lozenge'—was printed in two colourways, blue on pink, and pink on yellow. The colour sample the artist sent as a guide for the pink was torn from a card on which he had evidently been toying with another possibility—a repeated segment which might have come straight out of one of his Welsh landscapes. The scale drawing he provided, showing the design in pink on a yellow ground was drawn on a piece of card the reverse of which is the printed cover of a 6d catalogue for an exhibition of 'Surrealism' with the fragment of an illustration by Ernst.

In the ninth *Signature* Sutherland reverted to engraving again with a darkly romantic etching and aquatint of a Welsh landscape 'Clegyr-Boia' which Oliver inset as a frontispiece. It has been variously likened to 'Black Landscape', 'Sun Setting between Hills' of 1938, or 'Small Boulder' of 1940. Although a second and related intaglio image is not included in Man, a loose copy of 'Clegyr-Boia' found in 'Oliver's Box' was with another sheet from a plate almost the same size. With its watery sun, and strong lights and darks, it too is an evocation of Wales and there are passages in it which recall his treatment of roads through hills, or even the shadow patterning of the Tate's 'Entrance to a Lane' of the following year.

Several of Sutherland's posters of the 1930s were printed elsewhere, but one of the most imaginative of his designs was lithographed at the Press after a painting and collage known as 'Lake and Typewriter'. A yellow butterfly draws attention to the dinginess of a grey office with its abandoned typewriter. Like a thought in a bubble, a boating idyll of a lake and reflected trees above the machine suggests that the *Daily Express* cutting saying it will be snowing at Easter, raining in summer, and one should go into the country now, has been taken to heart.

Sutherland found time for one book at the outbreak of war and illustrated *Henry VI Part I* of Macy's Shakespeare for the Limited Editions Club of New York. There is a colour frontispiece of hands reaching for a red rose; otherwise of five starkly black-and-white autolithographs, four dramatize combatants.

Work as War Artist temporarily severed links with the Press, but back again in 1950 Sutherland started a series of lithographs for the Redfern Gallery. The incidence of print publishing by this time was on the increase and Sutherland was well established in the new phase of his painting which followed the war. These

lithographic works are variants of paintings in which he has focused on driftwood, roots, and other organic forms, and invested them with a mysterious presence. One of the prints of 1950 'Articulated Forms' is wildly gay with two singing pinks, yellow and light green. The other two of 1953 are sombre: 'La Petite Afrique' (presented 'with admiration' to Oliver) and 'Three Standing Forms in Black', both texturally worked in black and white.

> People ask, he wrote, about my 'Standing Forms'. What do they mean? They do not, of course, mean anything. The forms are based on the principles of organic growth with which I have always been preoccupied. To me they are monuments and presences.[2]

Although most of his subsequent printmaking has been done outside England, Sutherland also made several memorable lithographic portraits at Curwen. A three-quarter head of Somerset Maugham, whose oil portrait the artist completed in 1949, was used as a frontispiece for the Heinemann limited edition of *Cakes and Ale* in 1953.

Oliver's death in 1956 and Sutherland's own removal to the South of France lessened contact, but two prints have been made with the Press since their lithographic studio opened in 1959. One was the small print of the cosmetics manufacturer 'Helena Rubinstein', still on stone and never editioned, the other the imaginary portrait of 'Aloys Senefelder'–an image prepared for a Victoria and Albert Museum poster in 1971 appropriately celebrating the inventor of lithography.

John Piper

Oliver Simon met the Pipers early in 1937 and recalls in his autobiography that the artist was at that time deeply concerned with abstract art, though soon to emerge 'to collages, and later to a highly individual naturalistic romanticism'.

John Piper and his wife, Myfanwy Evans, were nearing the end of a run of a magazine called *Axis*, a quarterly review of abstract painting and sculpture to which they devoted a great deal of their time and attention in the years 1935–37.

Oliver's interest stemmed from the fact that while Myfanwy Piper edited the magazine, John designed the cover and the typography, not to mention making the colour blocks for it, so there was

much to talk about. In the eighth and final issue, the Nash reproduction already mentioned appeared. In previous issues Piper had quite brilliantly interpreted a subtle Ben Nicholson; a 1926 Picasso, which he printed in flat shades of cream, grey, red, and brown plus a superimposed black half-tone from a photo he had taken himself; a dazzling Hélion–a painter who influenced his own abstract period; and an intensely coloured Miro. The flat colours were printed from Paramat blocks cut from composition rubber about one-tenth of an inch thick mounted onto aluminium for printing. The secret lay in choosing images the appeal of which could be conveyed in solid colour needing only the modification that could be provided by one simple half-tone printing.

For the July issue of *Signature* in 1937 Piper did not interpret someone else's or even his own designs, but specially created a frontispiece called 'Invention in Colour', an abstract work in which slivers of an electrifying blue and a shaft of stone are held together by solid black shapes while a half-tone lends a textural interest at the centre, coincidentally creating a shape out of the whiteness of the paper.

In this work lies the crux of Piper's attitude to printing. While Nash berates the printer for failing to achieve what he himself achieved by hand, Piper studies the process–almost reinvents it– and achieves a striking success in the terms of the medium. The blue of his 'Invention' would have been quite unobtainable from customary four-colour process.

In an article on 'Book illustration and the Painter-artist' in the *Penrose Annual*, Piper wrote that 'when a painter's work is reproduced in colour by whatever method, he should ask for a lively parallel to his work, not for an imitation of it in colour or in any other particular'.[1] In 'Invention in Colour', as with illustrations for later articles in *Architectural Review*, Piper went one better, creating special blocks by the use of chosen colour solids and a black half-tone. For many of these there was no 'original' since they were conceived in the terms of the printing process, all of which made the writer of his biography in the Double Crown Club Register comment on the individuality of his approach to block-making 'used not simply as a camera process but to employ the fullest aid of the craftsman in the production of printing surfaces'.

During the period 1936–38 Piper was responsible for a great deal of work coming into the Press when he and Robert Wellington

started an imaginative print publishing venture which foundered because of the war but which proved a harbinger and blueprint for much postwar print publishing activity.

The Council for Art and Industry had published a report on art in schools which said:

> The whole course in art should aim at enriching the stock of images and impressions which the child gathers at school. Out of a liberal store will come efforts at comparison and out of efforts at comparison will come attempts at criticism.

Quoting this belief, and pointing to the original nature of an autolithograph from a living artist, the Contemporary Lithograph operation was conceived to bring good and inexpensive art to schoolchildren. The publicity by Piper and Wellington claimed that while with any method of photographic coloured reproduction there must be a loss of vitality through the change of medium, with their prints no interpreter was involved other than the artist.

The lithographs made for this series by artists featured here have been treated in the appropriate sections, but in addition to works by regular visitors to the Curwen Press, a number of the artists involved were making lithographs for the first time. Piper's role was to act as a works manager at the Press for those who were new to the process and wanted help. He remembers in particular working with Frances Hodgkins, who adapted a beautiful de Stael-like watercolour, suggesting glass jugs, vases and fruit. She was very uncertain, needing encouragement at every stroke. In fact Piper did quite a bit of the print for her and would then encourage her to take the chalk and try again. The result quite transforms the original idea, reversing some of the forms and particularizing a cut-glass ashtray formerly barely hinted at. Piper also helped his friend Ivon Hitchens in what was his first and only lithograph. John Aldridge, a collaborator with Bawden in a later wallpaper venture, was also coping with the medium for the first time, but he found the Curwen craftsmen very helpful and was 'wonderfully looked after'.

Piper himself did a boldly coloured abstract with dominant reds and blues played off against textured areas of crayon and brush-work. He also did a two-part 'Nursery Frieze' which was too big for the Press equipment and had to be done at Waterlows. Here, he remembers, he was tucked away in an upstairs warehouse covered in cobwebs to work on the plates, because there had been union murmurs among the men about taking on new staff.

'Curwen and Baynard got round this', he said, 'by making arrangements with all the workers that it was a good thing to have artists in because they were going to produce more work than if they didn't have artists in.'[2]

Just as Oliver met Sutherland at a transitional stage in his art, so too Piper was moving away from his absorption with abstraction, writing about his feelings in his contribution to the collection of artists' essays edited by his wife in 1937 and called *The Painter's Object*. In his essay 'Lost–a valuable object', he talks of a beach and a room interior which haunt him. 'Beyond these simple but very baroque structures, monuments of a clever but only half directed age', he concludes, 'it will be a good thing to get back to the tree in the field that everybody is working for.'

By 1939–40 he had got back to some trees, but mainly to architecture in the lovely book of *Brighton Aquatints*. He both wrote the text and made twelve prints for it, sublimely graduated aquatints ranging from pale grey to deepest black, with a grain almost amounting to minute crazing due to the largeness of the dusted resin. The plates are enlivened by deliciously calligraphic etched squiggles with the capacity to conjure up everything from wrought iron balconies to park benches. 'The Pavilion' bubbles like milk, 'St Bartholomew' looms blunt and dark almost as idiosyncratic as a stegosaurus, while ingenious photographically-transferred typography creates the shadow and texture on the 'Chapel of St George, Kemp Town'. 'From the Station Yard' the town stretches away beyond St Peters in rhythmic patterns of back-to-back housing.

The prints, some of which were hand-coloured by Piper (helped by his friend John Betjeman who found the occupation therapeutic), were not printed by the Press but they handled the text.

From this point on landscape and architecture, which were always among the artist's enthusiasms, provide the themes for most of his work.

Just before the war, Piper drew the Curwen Press buildings for the cover of the *Newsletter* he had designed. In 1940 he provided a panoramic pullout of Cheltenham to accompany an article on the town by John Betjeman, and in 1944, in an interval from his war work, he was back to autolithography, completing in muted purple, old gold and black, the painterly and romantic illustrations for *English, Scottish and Welsh Landscape*.

Oliver Simon found in Piper 'a painter who writes admirably'

John Piper, drawing for *Curwen Press Newsletter*, 1939 (Cat.201)

and invited him to contribute several articles to *Signature*. The artist wrote on Ravilious's *High Street*, on Fuseli, on 'Aspects of Modern Drawing' (with a Miro reproduced on sandpaper) and in 1950 on 'Picturesque Travel Illustrated'. This last was not unrelated to the first paper he gave to the Double Crown Club in 1946, when he talked on 'Local Guide Books from 1790–1890'. Herbert Simon was now President and he and Piper shared many interests, including what the artist called in a letter 'Industrialiana'.

Despite all this, however, Piper's work at Curwen had scarcely begun. For it was after the Curwen Studio opened in 1959 that he made his most major contribution to the art of the autolithograph.

John Farleigh and John Nash

Farleigh and Nash had a great deal in common in the pre-war period. Both were painters and members of the London Group, and both were members of the Society of Wood Engravers and enthusiastic about wood engraving. Within a year of each other in the 1920s both had illustrated Swift texts for the Golden Cockerel Press. Both exhibited at the Royal Academy and both, as it happened, made illustrations of botanical subjects for books printed by the Curwen Press.

Nash, the first to work there, cut on wood the illustrations for the beautiful *Poisonous Plants* in 1927. His already deep interest in gardening grew after buying a cottage in the Chilterns in 1921, and he made a series of flower paintings as well as illustrating a seed catalogue for the famous horticulturist Clarence Elliott to whom the *Poisonous Plants* book was dedicated. The illustrations range from the barely delineated yew glimmering in a churchyard, to delicately cut close-ups of plants such as the foxglove and henbane. The book was actually printed not from the wood but from electrotype casts, sometimes taken to preserve the blocks, but the effect on a lovely dark cream Ingres paper is extremely handsome. One of the blocks – 'Black Bryony' – was appropriated in 1935 by the Press to advertise a printing paper, and was suitably framed by a red Bawden border.

In 1929, however, Nash specially cut the block of another poisonous plant – tobacco – for a splendid large-scale advertisement. Curwen proudly circulated it, as a specimen of what they could do, in one of their publicity books called *How to Buy and Sell Money* which went out to their customers that year.

Nash also appeared in the Cresset *Apocrypha* with a sombre cut

of Judith and Holofernes and several times in *The Woodcut* the annual that Oliver published. A tranquil fishing scene was chosen by Harold Curwen to illustrate his article on printing from the wood in the *Curwen Press Miscellany* of 1931.

All the rest of the work he did at the Press was lithographic. In 1937 he drew a most delicate cover for the Press's fourteenth *Newsletter*, making four colours work overtime not only by clever overprinting, but by varying the weight of the drawn stroke within each colour from wisp-like crayoning to concentrated brush-loads. The grey and yellow, plus the subtlety of his drawing in the printing of the main leaf shade, gives an astonishing illusion of several greens, while the brilliantly orange flashes of two goldfish come from a pink, used on the unfurling arrowheads, stippled over the yellow. He achieved the same economical variety from green, red, blue and brown in another flowerpiece which Baynard printed specially for an advertisement for *Signature* in 1939.

The Contemporary Lithograph he did in the first batch of 1937 is a river subject from the Stour Valley. He discovered this part of East Anglia in 1929 and eventually made his home there. The country-side also informs *Men and the Fields* which he illustrated for a country neighbour of his. With six original lithographs by the artist and a prodigal scattering of amusing line drawings in the text, it was one of those 9/6d bargains that still make one gasp. Once more, Nash's patient stippling and subtle adjustment of the transparent colours of yellow and cyan with rose-pink and a grey erring towards warmth, achieve the suggestion of infinitely more colour, particularly lovely in the lilac-russet of some trees, or in the illustration opposite Chapter 7 where a pot-bellied bee hangs by a brilliant orange snapdragon. Nash is still affectionately remembered by Bert Wootton, who worked with him, as one of the few artists who would roll up their shirt sleeves and help clean the machines.

Farleigh worked on two books at the Press in the late 1930s commissioned by Noel Carrington at *Country Life*.

He had often been in the front line of the artist-complainants at the Double Crown Club. Indeed, in a 1933 biography on one of his menus, he lists addressing the Double Crown Club as one of his recreations. His amusing menu in collaboration with Harold Curwen in 1932—a clutter of mixed typefaces embellished with a thumb-print—was a comment on the artist-printer wreaking havoc in a typographic world.

Moran records him as bewailing the fact that no machine printer could ever print a black from his blocks properly – the difficulty being that of giving a solid area its full bloom without clogging the finer engraving.

But this complaint was in 1934 when hand-printing was under discussion at the Club, and whether the Press satisfied him in 1936 when it undertook the printing of his wood engravings for Ethel Armitage's *A Country Garden* is unrecorded.

In 1929 he had engraved a large block of a cow parsnip plant which he says he entitled inaccurately 'Hemlock'. It was inspired by seeing the sun shining through the plant's leaves. Its size was an antidote to the smallness of habitual bookwork and in doing it he was converted absolutely to white line engraving. When Carrington asked if he engraved flowers, he produced 'Hemlock' and was given the job of *A Country Garden*. The book was also influenced by garden magazines of 1860–70 in which he had become fascinated. It's fashionable to despise the late nineteenth-century engravers for their slavish competition with the photograph but Farleigh found much to admire in them.

John Farleigh, 'The Down' from *A Country Garden*, 1936 (Cat.214)

The cuts themselves are very beautiful, for Farleigh, who had served an apprenticeship in the printing trade as a wax engraver, was an extremely skilful craftsman. His most celebrated engravings were probably those he made in collaboration with Bernard Shaw for *The Black Girl in Search of God*, but those for *A Country Garden* have a quiet beauty – one slender flower spike climbing in a narrow column up the edge of a page and trees and downland evocatively stylized and crisply cut.

While still engaged on the wood-engraved book, Carrington and Sacheverell Sitwell discussed the possibility of illustrating Sitwell's book on *Old Fashioned Flowers*. After three years' work it at last came out and the publisher claimed it was one of the most ambitious experiments in lithography since the great nineteenth-century days of floral prints. It was published in 1939. The illustrations with a preponderance of reds and purples, celebrate historical garden flowers such as polyanthus, auricula, tulips and early roses.

Farleigh's autobiographical textbook *Graven Image*, written the same year, was printed by the Curwen Press. In it he told the story of designing two posters for the Underground in 1937, a job that he did at the Press. He regarded the commission as a 'plum' and the nearest thing the modern artist can get to the decoration of a public building:

My mind was full of flowers, drawn or engraved in colour, so that when I was asked to make some posters for the Underground, I suggested the designs should be based on wild flowers and grasses. It seemed to me that a mixture of wood and lithography would give the contrasting qualities of softness and hardness that are so peculiar to plant forms.

Accordingly, Farleigh made a key drawing on a full-scale piece of side-grain wood which he cut standing up at an easel. His second block was of lino, and both blocks were transferred to zinc for lithographic printing, while the three remaining colours were autolithographically drawn.

Commenting that he had worked intuitively and with no concrete plan – a somewhat dangerous procedure – he nevertheless added:

. . . If one has the nerve, it is worth doing at least one job in this way, for more is learned by taking a few risks than by being eternally careful, and if it is nerve-racking, at least one is alive.

Edward Ardizzone and Lynton Lamb

Sharing the comparatively rare distinction of having been Illustrator-Presidents of the Double Crown Club (in 1953 and 1958 respectively) Lynton Lamb and Edward Ardizzone both form a bridge between the pre-war and postwar periods at the Press.

Oliver Simon and his wife celebrated their silver wedding anniversary with Mr and Mrs Ardizzone in 1951 and received one of the artist's delicious illustrated thank-you letters. The D for Dear is formed by the rotundity of the artist's profiled stomach as he raises a glass in toast. He was, wrote Oliver, 'a large edition of one of his own celebrated character drawings, accepting the world and its ways philosophically'. Indeed when the 'artist problem' at the Double Crown Club finally erupted at its bitterest in 1947, Ardizzone was only heard bewailing the fact that it was difficult to buy liquor towards the end of the proceedings. The contributions he made to the Club included a talk on the nature of the artist-illustrator, plus the design of the menu when the Club dined at Brighton in 1958.

Oliver first met Ardizzone when the artist was struggling for recognition and asked him to do several jobs for the Press. One of them was making ten drawings of life at the Press which were published in their *Newsletter* No.15 in 1938 with the information that there were 150 employees of whom twenty-five had been there

for a quarter of a century or more. The drawings show sales and office staff, the compositors, the foundry, letterpress and lithographic production, and the bindery. The text claimed the characters portrayed were purely fictitious so there's no inkling as to whether any of them resembled the legendary Wally Gapp, still fondly remembered by the artist. Gapp was a pressman and a perfectionist in charge of the lithographic transfers and he made his own transfer ink, the cooking of which, once smelt, was never forgotten.

As Ardizzone remembers Gapp, so he is remembered at the Press as a great character with his snuff, his partiality to a pint, and his propensity for eating fish and chips on the homeward walk with Bert Marsh after work.

Ardizzone's first two autolithographed books were done at the Press in 1939. One celebrates *The Local*. In an article about Ardizzone's work in *Signature* J. M. Richards wrote that the illustrations are essentially atmospheric and observe 'the quality of the light that filters into the mahogany-fretted bar of a Victorian gin palace'. In the second book, *Great Expectations*, instead of drawing in a soft crayon as he did for his pubs, Ardizzone worked on a smaller scale with finely drawn pen work, and clear strong colour added to the fairly dramatic treatment of such scenes as Miss Havisham in flames.

The Contemporary Lithograph the artist drew pre-war was surprisingly broadly brushed for an artist happiest at working on a small scale, and showed a powerfully framed lady arguing with a conductor at the bus stop.

Like most of the other artists, Ardizzone went to war, and his early experiences were related in *Baggage to the Enemy* which the Press printed in 1941.[1] There are some amusing character sketches of Bawden finding Ardizzone's attack of lumbago in Arras funny, and of Barnett Freedman tossing up to decide whether to paint a General whose name was mentioned by everyone else in reverential whispers. On evacuation from France, Freedman missed the boat by racing back to fetch a picture and then solitarily dined off three bottles of champagne and a tin of bully beef in a railway siding before eventually leaving Boulogne. Among the many watercolours Ardizzone made of his war experiences, two were hand-copied at the Press and, like Paul Nash's, were published by the National Gallery.

After the war there was another lithographic book—*Ali Baba*—and this time the artist used a combination of pen and soft chalk

work together with clear gentle shades of blue, pink, yellow and orange. There are magnificent endpapers in which *Ali Baba* surveys his treasure.

The growth of the limited edition print market is reflected in the appearance of more print popularizing ventures such as the Lyons lithographs (done at Baynard) and the series of Guinness lithographs which the Curwen Press printed. By various artists, these had to take as their subject some aspect of the Guinness Book of Records. In Ardizzone's a circus barker drawing attention to the claims of 'The Fattest Woman in the World' is ignored by all but a couple of small children and a dog scratching for fleas–and possibly the dog has more important things on his mind.

Several superb menus for Hatchett's and Overton's, the plates for which are still in use today, were drawn on stone and transferred to plate in the 1950s and again carry an artist's originals into an unlikely area of ephemera. An original Ardizzone also graced the jacket of *The Newcomes* published by Faber in 1954.

By 1960, when he drew at the Press the two specially commissioned finely graduated lithographs of Trinity College Oxford in his favourite black and white, the Curwen Studio had opened. A number of subsequent prints, including 'Life Class' and a typical boating scene were thus the product of this special establishment for artists' lithographs that had grown naturally from Harold Curwen's pioneering.

Lynton Lamb, at any rate in his association with the Press, was as much writer as illustrator and Oliver Simon marked him down in his biography as yet another of those artists who could write well. Before the war, Lamb wrote the article on Ambroise Vollard as publisher, comparing the strength of his imagination with English equivalents and marvelling at the way he chose the best artists and then let them tackle the problems as they wished:

> Vollard was not content with ingenious embellishments or harmonious backgrounds to antique tales: he realised that a large intellect is needed to grapple with the disturbing statements of genius.[2]

In a postwar *Signature* Lamb's 'Predicaments of Illustration' took up related themes, dwelling on the lost opportunities in English book illustration and the need for good drawing as its basis. An illustration, he said, was more than a collection of loose plates or embellished and animated rules.

Edward Ardizzone, illustration from *Visiting Dieppe*, 1951 (Cat.228)

[93]

Influenced in his lithography by A. S. Hartrick, the artist made a Contemporary Lithograph before the war, but most of his illustration at the Press was done after it, including lithographs for George Eliot's *Silas Marner*, Trollope's *Two Heroines of Plumplington* and Wilkie Collins' *The Woman in White*.

In each of the books the illustrations are gentle and charming, spontaneously drawn yet tentative in their delicate search for the form and clearly influenced by the example of Bonnard. The two-colour chapter headings for *Silas Marner* are particularly felicitous.

In 1951 Lamb wrote another article for *Signature* at Oliver's suggestion, this time, he said, celebrating the artistic heritage of Dieppe. The town had been visited by Cotman, Bonington, Delacroix, Corot, Daubigny, Vollon, Boudin, Gauguin, Pissarro, Blanche, Degas, Renoir, Monet, Whistler, Conder, Beardsley, Sickert, Gore, Rothenstein, Beerbohm, Dobson, Braque, Albert Rutherston, Pasmore and Coldstream. After them (and with Lamb) came Ardizzone and Freedman.

Accompanying his article was a delightful illustrated diary by Ardizzone mentioning the whisky-drinking crossing, moules in a sailor's bistro, Lobster Mayonnaise for lunch, Sole Dieppoise at the Arcades, Sunday lunch with Château Talbot '29, and Terrine de Canard in the evening. The wife of an antiques dealer quite upset him by telling him his snuff would collect in a ball behind his forehead and destroy his wits; but not sufficiently to stop him from enjoying Tournedos with Bearnaise sauce for supper–'a splendid finish'.

At a memorial Double Crown Club dinner for Oliver, after his death in 1956, Lamb spoke of Oliver's attitude to artists and of his championing of unknowns. He wrote about him in an account of the Double Crown Club privately printed in 1969:

> When I was a young man those of us who used to work on the
> stone with Wally Gapp at North St, Plaistow in the
> neighbourhood of the Jeyes Fluid Factory and the cinema that
> used to show films of the Norma Talmadge vintage (I hope I
> have made the period approximately clear) the good opinion of
> Harold Curwen and Oliver Simon was very valuable to us in
> what is now odiously known as 'graphics', just as was Roger
> Fry's and Walter Sickert's at the London Group. . . .[3]

Postwar Printmaking
and the Curwen Studio

The change in lithography after the war depended upon several factors. Among them was the spread of photolithography which replaced the old hand craftsmen by camera operatives, and the tightening of union restrictions, which in some cases served to exclude free-lance artists from the shop floor. Under these influences, autolithographic book illustration, carried on as Freedman most valued it in the environment of the commercial houses, waned. Output of artists' editioned original prints however, aimed at the wall rather than the portfolio, which one had seen tentatively emerging in the Contemporary Lithograph venture of 1937–38, increased. During the 1960s, aided by developments in screen-printing and an economic boom, the steady trickle became a flood.

The pioneer in what has sometimes been called the postwar print renaissance was the Hon. Robert Erskine, who began a publishing programme at the St George's Gallery, London, in the second half of the 1950s. He was inspired by various European houses such as the Guild de la Gravure, and said he wanted good art to reach 'the Mums and Dads of Pinner and Wigan'. He immediately became aware that whereas on the Continent there was a long tradition of specialized fine art master-printers for limited editions, such as Mourlot and Matthieu, England had little more than a few presses at art schools and commercial printers, albeit some enlightened ones.

Of course, occasional single sheet lithographs were already being editioned at the Curwen Press as has already been mentioned in the case of Sutherland and Ardizzone and they did such jobs as the exquisitely sensitive sheets of self-portraits by the ageing Augustus John in 1954, although these were later trimmed to provide a frontispiece to a book on his work being published by George Rainbird.

Another man interested in improving the editioning situation was Timothy Simon, Oliver's son, who was in charge of sales and

design at the Press. With the stimulus provided by Erskine, Timothy Simon persuaded the Board of the Curwen Press under the chairmanship of his uncle Herbert Simon, to set aside funds for a separate lithographic studio for artists. In May 1958 they agreed to convert No.32A St Mary's Road, just around the corner from the North Street Works, for the purpose. The budget makes one smile today. They allowed capital expenditure of £570 for rebuilding a small engineering workshop wedged between two terrace houses, £80 for connecting charges, £200 for equipment and £100 for contingencies. The annual running costs set aside were £600 for a printer's salary, £50 for power, £210 for paper, ink and stones, £50 for despatch, with the contingency sum bringing the grand total to a round £2,000.[1]

Tragically, Timothy Simon died still a young man aged 41 in 1970 but not before, as his obituarist in *The Times* put it, he had 'with his peculiar combination of charm and persistence . . . persuaded almost all the best contemporary English artists to join in the enterprise'.

Henry Moore, John Piper, William Scott, Ceri Richards and Josef Herman were among the celebrated artists who worked in the very early days at the new studio in Plaistow and produced the first Studio publications celebrated at a party in their Bloomsbury Square premises in 1962.

After his nephew's death, Herbert Simon wrote of him to John Dreyfus:

I shall always rank his establishing of a professional studio to produce artists' original lithographs as important in Curwen history as Harold's stencil process and Oliver's provision of borders and vignettes by his artist friends.

PLATE 25

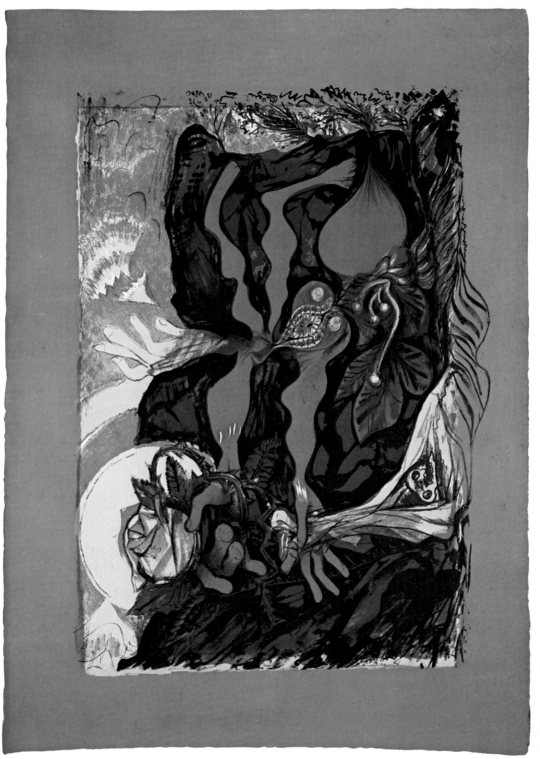

Ceri Richards, *The force that through the green fuse drives the flower*, 1965 (DP.6475)

PLATE 26

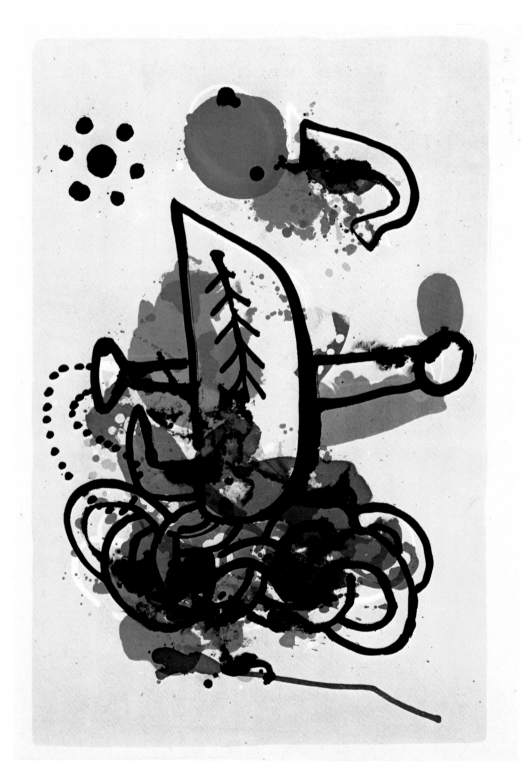

Alan Davie, *Celtic Dreamboat I*, 1965 (DP.6105)

PLATE 27

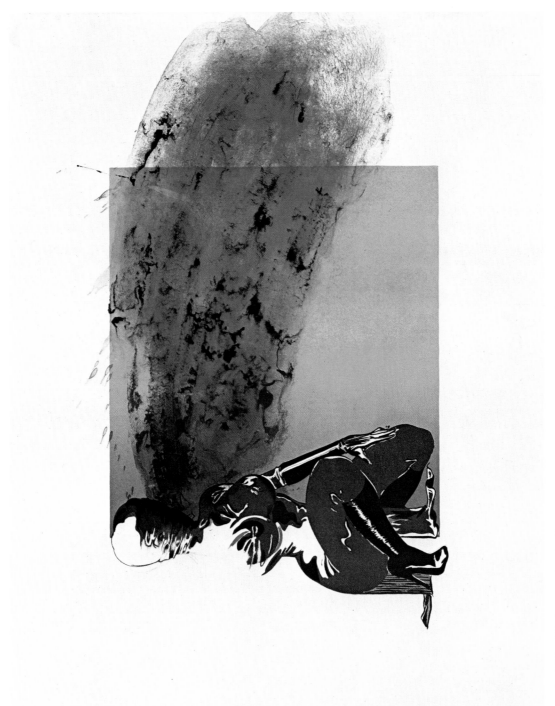

Allen Jones, *Left Hand Lady*, 1970 (DP.6558)

PLATE 28

John Piper, *Beach in Brittany*, 1961–62 (DP.6423)

PLATE 29

David Hockney, *Lilies*, 1971 (DP.6290)

PLATE 30

Derrick Greaves, *Vase and Falling Petal*, 1971 (DP.6244)

PLATE 31

Barbara Hepworth, *Porthmeor*, 1969 (DP.6257)

PLATE 32

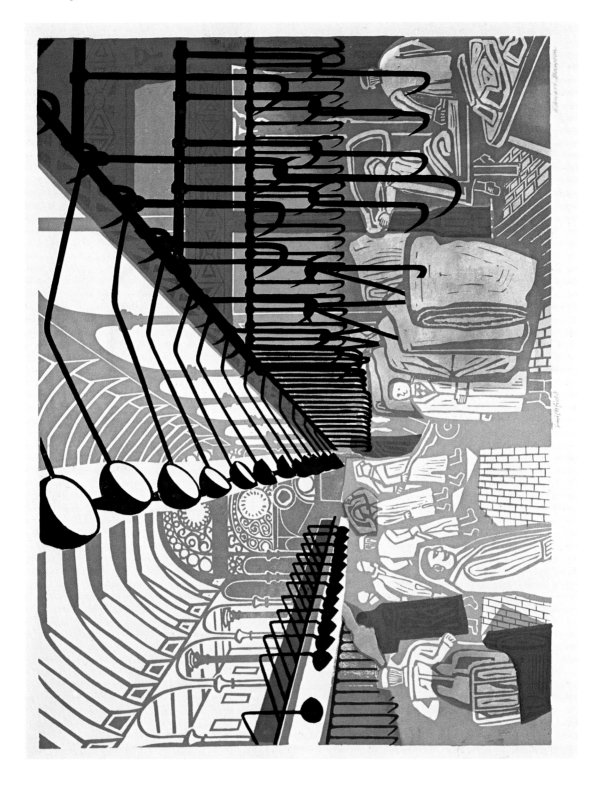

Edward Bawden, *Smithfield Market*, 1967 (pp. 60-24)

Stanley Jones

Stanley Jones[2] was the lithographer chosen to run the Studio when it first opened and he has remained its Manager ever since. Hailing from Wigan, he attended the Slade from 1954 to 1956 where Ceri Richards was one of his teachers. Then he won a scholarship to the Ecole des Beaux Arts in Paris where he specialized in stone and plate lithography. Between 1956 and 1958 he worked at the Atelier Patris, printing, in addition to his own images, work by Hayter, Severini, Le Moal, Sugai, Corneille, Matta and Giacometti.

In 1958 Erskine arrived at the Patris studio and told him of the desire that he and Timothy Simon had to set up an English studio somewhat along French lines. The result was that during 1958, while things were being arranged at the Plaistow end, Stanley began a pilot scheme at a studio in Fore St, St Ives, working with Ben Nicholson, Barbara Hepworth, Roger Hilton, Terry Frost, Bryan Wynter, Peter Lanyon and Patrick Heron.

When the St Mary's Studio opened, the first artist to work there was Stanley's former teacher, Ceri Richards. 'The Hammerklavier Suite' which they produced together in 1959, inspired by the piano music of Debussy, was an immediate triumph, winning a major prize at Ljubljana.

Among the sheets from that portfolio were two printed at Erskine's request on Japanese straw paper. With its surface texture, the paper suited the pond image of 'Le Poisson d'Or' particularly well, but as several overprinted colours built up, the straw began to be shed and Stanley Jones found his was the unenviable duty of chasing errant bits of grass and carefully glueing them back again.

In many ways it might be argued that the separation of the rather precious limited edition fine art printing from a commercial environment is a bad thing. Certainly there is much in the development of trade lithography today that could be (and sometimes is) harnessed by artists who know about it. But the artist has often been

separated from the technological mainstream, and hampered by outmoded prejudices and beliefs about, say, the superiority of stone, or the unsuitability of offset lithography as an 'original' medium. Stone is certainly irreplaceable for certain kinds of imagery, just as direct printing gives densities in ink deposit which cannot be achieved by offset. But a really creative artist will explore any range of possibilities open to him and the potential is far greater where the studio is attached to a forward-looking commercial house willing to share its expertise, than where it is a separate and sometimes ana-chronistic institution insisting, as they did when they resumed lithography in America, that one should 'bring back the stone age'. The separation of machine-made from hand-made dies hard, and to a certain extent it is this old dichotomy that prevents the develop-ment of autolithography in a commercial situation and is at the same time revealed by the imagined need for a special place set aside for artists. In the days when artists did work at Plaistow many a story reveals the rapport that existed; Ravilious really enjoying the collaboration, Freedman, fierce at times but basically very warm and kindly and still missed, John Nash rolling up his sleeves and helping clean up, Ardizzone sharing a pint or a homeward-going bag of fish and chips, Sutherland playing darts during the lunch break, John Piper fondly remembered by Bert Marsh as a 'quiet and unassuming man'.

On the other hand, the exacting personal service that was necessi-tated by the 'Poisson d'Or' drama, where a previously untried (but very beautiful and appropriate) paper had been used experiment-ally, is one of the jobs that could only be undertaken in a specialist situation. Another forceful reason for a separate studio is that whereas a designer usually has a job cut and dried in advance, the majority of artists work intuitively and frequently don't know quite what they are looking for until they find it. This can be maddening, but often it results in a job being in the nature of an exciting experi-ment, rather than an academic exercise resulting in what has always worked well in the past being done that way yet again. When this exploratory approach is adopted, even more when the artist (who has to begin somewhere) is making his first effort, he may need someone sensitive to his needs and not too hamstrung by com-mercial considerations, to help him get everything together. This is the master-printer's role.

Stanley has a fund of stories he can tell which not only reveal his

absolute dedication to his job, but the trials that can make the life of an artist-printer no laughing matter.

When 'the two Roberts'–Colquhoun and MacBryde–were commissioned by Erskine in 1960 to draw a series of lithographs for the St George's Gallery, Erskine made the tactical error of paying them for the work before they had done it. The pair were in the closing stages of the progressive disintegration through addiction to alcohol that Sir John Rothenstein has chronicled.[3] During the period in which they worked at the Studio, both Stanley and Timothy Simon frequently had to go out in search of them, and usually found them in the nearest pub. Yet the images they made–Colquhoun's 'Two Horsemen' and 'Mysterious Figures' and MacBryde's strange Fuseli-like 'Head' and 'Still Life' (in which he has written EPAG for page and neglected to reverse it) have considerable power. The 'Two Horsemen' was drawn on transfer paper when Colquhoun was totally inebriated and he used Indian ink instead of lithographic ink. The proofer, working hours rather than minutes, had to help him etch out much of the drawing with nitric acid, which by increasing its raggedness, emphasized the tortured quality of the animals. When he saw it sober, the artist was enormously pleased with the effect.

It wasn't the last time that irregular or problematic materials resulted in a tour de force. John Piper, who believes a medium should be 'bashed about', splashed and spattered the marvellously free image of 'San Marco, Venice' in gouache on an onion-skin transfer paper. This provided a negative resist over which the lithographic tusche was painted. As its name implies, this paper is so thin, that when Stanley came to dampen and transfer the drawing, instead of doing it as is normal in one simple operation, he had laboriously to mould the paper onto the plate round every little blob, because the sixteenth of an inch of gouache built up inhibited it from contacting the stone properly. Despite this slow painstaking stage in the process, the image retains its sperzzatura.

Another artist who provided a transfer problem was Reg Butler, an enthusiastic lithographer who had experimented with his own home-made transfer paper, on which he provided Stanley with the images of 'Tower' and 'Figure in Space'. It was of such thick gelatine, and so impervious to moisture that again instead of transferring it simply in the normal way, Stanley spent two days *ironing* it onto stone. Nevertheless, the combination of heat and gelatine

gave a uniquely subtle quality to the drawing quite unimaginable by any other means. 'All my thanks to you for all the trouble and care you have taken' wrote the artist to Stanley in 1962; although he never knew that the trouble had involved two days ironing.

Of course, not every artistic encounter at the studio has such a successful outcome. Allen Jones describes the first image he made, printed partly at the Press and partly at the Studio, as a 'cock-up' and in consequence he took the 'Concerning Marriages' portfolio of almost hermaphroditically fused men and women to Zurich. The disliked first proof of it is consequently very rare. However, when he returned to the Studio to draw 'Left Hand Lady' and 'Leg-splash' in 1970, Stanley Jones more than made up for the early print with the delicacy of his printing of what the French call 'lavis' utilized by the artist in both these images. Stanley has made a special study of the way to preserve such delicate washes on the plate by reducing chemical interference to a minimum. This results in almost 100 per cent of whatever the artist puts down surviving in the print, which is frequently not the case, since 'lavis' tends to be fugitive.

Among other artists working postwar at the Press was William Scott who went on to the Studio to make some lyrically beautiful abstract images to which he gave the evocative names of Scottish islands. These make superb use of the contrast between opaque and transparent inks and employ the most lovely ranges of neutrals or earth colours, sometimes enlivened by a breath-taking blue. 'Barra' which is especially subtle with its overprinted modifying transparent white incorporates an amusing hazard. Amidst the small drawn circles is one finer larger circle set apart, yet within the background area. It was where the artist's tea mug rested while he was working, and he so liked this accidental effort that he retained it. William Scott wrote recently:[4]

In France the Artist lithographer printing press had retained a high level of quality inherited from the nineteenth century. Stanley Jones was one of the first British artists to realise this and after some time of practical working experience in Paris he knew what was needed in London.

Stanley and the Curwen Press embarked on a revolution in Art lithography, bringing the artist and printer together as in France. I was fortunate in being an early visitor to the Studio and listened to Stanley on the importance of quality in printing

paper and ink. His message got through and today, thanks to the Curwen Press we have a level of Artist lithography of which we can be justly proud.

In addition to the 'San Marco' image already mentioned, one of John Piper's earliest images at the Studio was 'Beach in Brittany' related to collages by the artist on the same theme. Always technically very inventive, Piper made the print by cutting out paper shapes, creating a resist with them by glueing them to the stone with gum arabic. He then painted over them with litho ink diluted with benzine achieving wonderfully liquid effects so there is tension between the free gestural washes and the controlled cut elements.

Piper says that Stanley was a great help to him since the minute he asked 'What happens if . . .' Stanley would say 'Well, we'll try it'. Piper's major suite of twenty-four prints 'A Retrospect of Churches' was undertaken in 1963–64 in the wake of the publication of Mourlot's catalogue of Picasso's lithographs which had used the entire repertoire of possible (and sometimes impossible) techniques. Thus Piper was inspired to try a diversity of means himself. The 'Retrospect' employs collage and frottage applications, a mezzotint procedure scratching back to light from a dark application of tusche on the stone, an ingenious incising of transfer paper with a sharp tool afterwards allowing the broadside crayon to skid over it, deliberate misregistration to avoid a static quality in architecture, and the use of gouache as a resist on transfer paper before drawing. Piper even tried marbling in litho ink on transfer paper–'but all it makes is a filthy mess' he said.

'My ambition', said John Piper of the 'Retrospect' recently, 'was to make the prints look frightfully casual. . . . This is very difficult, as printing is a very deliberate and calculated thing and you have to wait days or even weeks and be very ingenious to appear spontaneous.'[5]

One of the most intriguing images in the portfolio is that of 'Llangloffan'. In 1964 it was extremely daring to include photographic imagery in a fine art print, for few would have been inclined to accept photography into the canon of 'originality' and even fewer would have categorized it as art. The artist, himself an expert with the camera, felt photographic matter-of-factness was exactly right to convey several Welsh Nonconformist buildings. The technician transferring the camera image down onto plate (for photolithography is done at the Press rather than the Studio) made quite a scene when Piper cut up a fragment of a tree and asked for it to

[101]

be placed in the top right-hand corner. Nor was it easy for the Studio to print the result, for such a plate is designed for a mechanical charge of ink, and when hand inked is easily clogged. The photographic image was actually printed on top of an impression pulled by inking up the reverse side of a litho stone—a kind of objet trouvé which had been waiting about for suitable use to be made of it ever since the portfolio had been begun. As John Betjeman remarked in the introduction to the suite, it is a distillation of half a century's looking at churches.

In 1965, Ceri Richards returned to make a suite based on the poetry of Dylan Thomas, using a similarly unhampered repertoire of techniques, including the printing down of leaves and other natural objects onto the litho stones. The suite was rendered in a heady range of intense colours. One of the prints has a broad border of such dynamic blue that the artist had to try signing it in white, black and red to find out which worked best. There are also two moving black-and-white prints in the series—'The Flowering Skull' from the poem 'And Death Shall have no Dominion', and the image of an owl turning a body out of a winding sheet which comes from the villanelle Thomas wrote for his dying father. 'The Flowering Skull' cost the artist infinite pains and it was three months before he had resolved it. Since it is in parts solidly black, the stone had to have a tooth in the dense areas, but in other parts a finer surface was necessary to do justice to the quality of some of the drawing; therefore the stone was selectively ground before the artist worked on it. Painted tusche, broad chalk work, transferred frottage (which creates the sun from rubbings of corrugated cardboard and cut glass) are combined in an image which, once drawn, took twenty minutes to ink for each impression. The stone, the image on which was not defaced as is usual in limited edition printing, has been given to the Tate archive.

In the mid-1960s Alan Davie made several prints which the Studio published and Stanley Jones admired the total freshness he brought to the task, drawing with no preconceived ideas, treating every image as a gamble, and achieving in his opinion a result which images first imagined in another medium however roughly, cannot have. When first commissioned in 1960, and asked by Timothy Simon to 'design' for lithographs, Davie wrote that, as in painting, his results were the outcome of 'complete immersion body and soul in the procedure of working'.

[102]

For me, therefore [he added] it would not be satisfactory to do
designs for lithographs and as you could imagine the design
should in fact be something which we should arrive at in the end.[6]
His way of working was to draw one plate, proof it in several colours,
reflect upon the result, and then proceed by building the next colour
on the first. The accidental was often welcomed as part of the
image in a way the old litho craftsmen would have found hair-
raising.

Another of Timothy Simon's ideas, before his untimely death,
was the commissioning of a set of prints from sculptors, and a
number of notable artists worked at the Studio. One of them was
Robert Adams, who had this to say recently:[7]

> The things that stand out in my mind about the period that I spent
> at the Curwen Press, are the patience and expertise of Stanley
> Jones. No matter what new ideas or technique one wished to try
> out, Stanley was always ready with sound advice, and he also
> seemed to know when one wished to be left alone to get on with
> the job. I found his colloboration invaluable.

In 1966, Herbert Simon asked Barbara Hepworth if she would
consider the project.

> First [he wrote] because it will make it possible for people of
> modest means to own something by Barbara Hepworth, and
> secondly because I suspect you would enjoy working on stone
> and find you have a real affinity for it.[8]

His approach bore fruit and in November 1968, when the sculptress
created about a dozen lithographs for the Studio thematically related
to her sculptures, she wrote to Herbert Simon that she was enjoying
making the lithographs with Stanley, 'who is so terribly helpful and
very inspiring'.[9] One of the images, 'Porthmeor', furnished Stanley
with another problem, for when he brought the plate which she
had drawn in St Ives back to London to print, he discovered it had
a curious effect in the upper part of the 'sky' which he could not
explain. Needing to know how it had been done, so that he could
plan how to treat it, he rang the artist who later said she could only
think it was some work she had done with an ivory-handled spatula.
By the time this information came through, in thinking back to her
studio situation, Stanley had realized that it must actually have
been caused by the oxidation of sea spray which had blown in
through the window onto the metal. Mercifully he was able to
preserve it so that it survived the editioning, and the intriguing

passage in the drawing is now known affectionately at the Studio as Barbara's 'ivory-handled spatula effect'.

In the later *Aegean Suite*, 'Sun and Marble' also gave him considerable heartache, for the plate providing what is now a marvellously fluid green background had been accidentally drawn in black enamel instead of litho ink. A little more sweat and midnight oil, not to mention carbolic acid and pumice, cleared the enamel to reveal on the plate a residue of grease which the turpentine used originally with the paint had deposited. When the artist saw how this printed, she was delighted at her partnership with chance, admitting she could not have done better however hard she tried!

In 1967 Edward Bawden used his lino/litho technique once again for a series of prints which the Curwen Studio commissioned. The artist left his country home with his butcher early in the morning and drew on the spot in various London markets, finding prints a relaxation after a spell of very tiring mural painting.

The Studio has kept up a constant output of immensely popular topographical prints both by regular artists, such as David Gentleman, and in special portfolios like the amusing series of architectural follies that they published.

Writing to Herbert Simon of his long association with the Studio in 1974 David Gentleman said:

I get the greatest pleasure from the personal links at the Studio.
The team that has been built up there, veterans and younger
ones alike, is unique in my experience as a pleasantly interested,
concerned and conscientious group (without any danger of being
too flattering to artists, one might add!)[10]

Among other interesting images made at the Studio have been Terry Frost's print laced like a corset, Man Ray's lithograph combined with screenprinting, Elizabeth Frink's first set of freely crayoned and fiercely scraped 'Spinning Men' and the subsequent animals and birds teased from washes of litho ink drying in distilled water. Hockney drew 'Lilies' from life, creating the flowers by breaking the continuity of Hogarthian cross-hatching. His portrait of the print collector and publisher Felix Man was also drawn straight onto plate from life. Mary Fedden's landscapes and still life studies drawn with a 7H pencil were a theoretical impossibility (lithographically speaking) although everybody was delighted when an image resulted. Derrick Greaves made his cool vases and petals believing in a minimum of technical fuss. Zadkine, who drew three transfer lithographs for

Timothy Simon signed the whole lot of them sitting in the back of Simon's car to avoid carting them in and out of his house.

In 1966, the Curwen Gallery opened and with Herbert's son Robert as production manager at the Press now running the Studio which had moved to Midford Place and the gallery ably managed by Rosemary Simmons, Curwen's name was constantly in the forefront of graphic activity. A 1966 exhibition reviewed the autolithographs that had been made at Plaistow between 1920 and 1950 and announced in the catalogue introduction that the same spirit of adventure and craft ability was still very much alive.

In 1969 another exhibition of Curwen work was introduced by Ruari McLean. It was difficult, he said, for any one printing firm nowadays to achieve the kind of eminence in design once held by Curwen, especially since most printing clients now employ their own designers. However, he said, the Curwen Press in their 106th year and under their new Managing Director Basil Harley, were aiming to become the best colour printing house in the world.

One of the most fascinating exhibits in this display was Harold Cohen's interpretation of the Pinter play 'The Homecoming' which the artist designed jointly with Robert Simon and which was published by H. Karnac. Since it was basically photolithographic, depending on the colour manipulation of photographs the artist himself had taken, much of the work for it was done at the Press rather than at the Studio. Two years previously the artist had worked at the Studio on details of his own paintings blown up photolithographically to large scale. By making transparent overlays with a spray gun, he then built up rich harmonic colour in repeated overprintings. The procedure was not only exploratory technically, but had many possible pitfalls, for overprinted colours of the complexity seen in these 'Close-Ups' frequently change upon absorption and drying. However, the results more than compensated for the agonies. Such a work, involving both Studio and the Press for the photolithography, may suggest the rapprochement possible between technological advance and personal service for an artist.

Another example where press facilities were indispensible was when the huge bed-size of 38 × 55 ins was needed for the portfolio of outsize images that Bernard Jacobson published in 1972. The four artists involved accepted the challenge of utilizing offset lithography creatively. Peter Blake gave a glimpse at his studio tackboard, full of favourite postcards and photographs. Joe Goode spent

hours proofing, making the subtle adjustments he felt necessary to his largest print ever – 'Clouds' – by working from noon until nearly midnight. Bob Graham drew the thirty-two studies of one turning female figure on Agralon, a transparent plastic sheet the drawing on which is transferred to plate by ultra-violet light. John Walker created his print 'For the Last of the Ogalala Sioux' in a combination of four-colour half-tone from an original, overprinted by four colours drawn direct.

These huge prints were run on a £150,000 Roland press which can print four colours in one run and needs four men to control it. Its efficiency rate is 6,000 sheets an hour, so the workmen were no doubt somewhat bemused when limited editions of precisely 115 prints were run off in each case.

The Studio tried to overcome the artificial restrictions of limited editions with their Unicorn prints, which, by using various lithographic processes and selling the results very cheaply and unsigned, challenged the ubiquitous reproduction in the late 1960s. Several of the artists involved used the conventional techniques of lithography, but Geoffrey Ireland deployed the technological resources of the Press creatively by basing his image on the photograph of a crystal structure and processing it by means of a complicated electronic scanner known as a Vario-Klischograph.

In his own work, Stanley Jones has pursued an interest in continuous tone lithography (which has rid itself of the half-tone dot) by using since 1969 the new diazo plates which work by ultra-violet light transfer, without a camera being involved. To use the positive version of this process, the artist can work on any transparent support with any light-opaque drawing medium, and the image may then be controlled by length of exposure time, which is very critical. Information with which to print several colours or tones of one colour, can be extracted from a single tonal drawing. Henry Moore, one of the first, as well as one of the most recent artists to work at the Studio, has become a past-master at making prints by drawing such transparency separations, a procedure he first developed in his collographs.

Some of the early lithographs he made at the Curwen Studio were shown at the Tate Gallery in 1975, but his recently protracted period of lithography began when he broke an ankle which prevented him getting on with his sculpture. Among the images for diazo he then drew were two inspired by contemplating his inactive

hands. He has developed a whole range of techniques for transparency drawings which Stanley goes out to his studio to collect, and then proofs upon his instruction. Moore said recently:

> Stanley is one of the nicest people I know. He is so amenable, so receptive to any suggestion of experiment. And compared to Mourlot and other Continental lithographers, the big advantage of Curwen is that it is on the spot. Once I used to go down there, but now Stanley Jones comes to me so it is almost the same as working in my studio.[11]

Throughout the eighteen years of its existence, the Studio has kept a copy of practically every image it printed, and when the Institute of Contemporary Prints was formed in 1973 to make a graphic collection to present to the Tate Gallery, the Studio generously presented their output since opening in 1959. These prints were accepted by the Tate Gallery Trustees in 1975 and now total something in excess of 750 images.

The gift is now celebrated in an exhibition which shows how work done by artists encouraged pre-war by an idealistic Press has led to the setting up of the first English lithographic atelier along Parisian lines. When he heard about it, Edward Bawden, whose working life both at the Press and the Studio spans the whole period under review said: 'Of course! It's a logical development isn't it—from the days of Harold Curwen up to Stanley Jones.'[12]

Lovat Fraser, tailpiece from *The Luck of the Bean-Rows*, 1921 (Cat.30)

Harold Curwen

1 All quotations in this section and throughout the book credited to Oliver Simon are from his autobiography *Printer's Playground*, Faber and Faber, 1956, unless otherwise stated.

2 This and all subsequent quotations naming Christian Barman from 'Harold Curwen', *Penrose Annual*, Lund Humphries, 1956.

3 George Truscott, former compositor at the Curwen Press in conversation with the author, 27 October 1976.

4 Letter to Harold Curwen from Edward Bawden, 1 October 1931 (courtesy Curwen Press).

5 Holbrook Jackson 'A Cross Section of English Printing–the Curwen Press 1918–1934', published in the Curwen Press *Newsletter*, March 1935.

6 Letter to the Curwen Press from Ashley Havinden, May 1949 (courtesy Curwen Press).

7 Letter to Oliver Simon from E. C. Gregory of Lund Humphries, 30 November 1922 (courtesy Curwen Press).

8 Letter to Curwen Press from Henry Tonks, 30 November 1922 (courtesy Curwen Press).

9 Letter to Harold Curwen from Albert Rutherston, 17 November 1922 (courtesy Curwen Press).

10 Harold Curwen 'Autolithography', *Penrose Annual*, Lund Humphries, 1938.

11 Letter to Faber from Harold Curwen, 2 September 1929 (courtesy Faber and Faber).

12 Herbert Read, *Philosophy of Modern Art*, Faber and Faber, 1952.

13 Letter to Oliver Simon from Paul Nash, undated but probably 1928 (Simon 3, transcribed by Anthony Bertram and quoted by courtesy of the Victoria and Albert Museum).

14 Harold Curwen, *Processes of Graphic Reproduction in Printing*, Faber and Faber, 1934; revised and extended by C. Mayo, 1966.

Oliver Simon

1 Christian Barman, as note 2 above.

2 Oliver Simon and Hamish Miles, *A Conversation Piece*, privately printed for friends at the Curwen Press, February 1933.

3 'The Four Seasons' issued as Curwen Press calendar and publicity, 1922.

4 Herbert Simon, 'Oliver Simon', *Penrose Annual*, Lund Humphries, 1957.

5 Holbrook Jackson, *Early History of the Double Crown Club*, privately printed, 1969.

6 Letter to C. H. Prentice of Chatto and Windus from Stanley Spencer, 22 October 1926 (courtesy Chatto and Windus). For copies of the Almanack annotated by the artist see Tate Gallery Archive 733.4.2 and 733.4.3.

7 H. Simon, *Song and Words–a history of the Curwen Press*, George Allen and Unwin, 1973.

8 Letter to Oliver Simon from Paul Nash undated but probably 1928 (see note 13 above).

9 Letter to Oliver Simon from Harold Curwen, 11 September 1931 (courtesy Cambridge University Library).

10 Jill Goodman, account of her father, Oliver Simon, sent to the Tate Gallery, December 1976.

11 Letter to the Tate Gallery from Graham Sutherland, 11 November 1976.

12 Letter to Oliver Simon from Edward Bawden, 1 July 1939 (courtesy Cambridge University Library).

13 Letter to Oliver Simon from Michael Ayrton, 5 September 1947 (courtesy Cambridge University Library).

14 Letter to Oliver Simon from Margaret Nash, 1 February 1953. Tate Gallery Archive 7050.2197.

15 James Moran, *The Double Crown Club–a history of 50 years*, Westerham Press, 1974.

16 Quoted by Helen Binyon–see section on Eric Ravilious, pp.60–66.

17 *Signature*, No.2, 1936. Called a quadrimestrial of graphic arts, the magazine was first published November 1935 and ran for 15 issues until December 1940. After the war, publication was resumed, the new series beginning again at No.1 and running from July 1946 to 1954.

18 See note 15 above.

19 Quoted by Sir Francis Meynell in his autobiography *My Lives*, Bodley Head, 1971.

20 Letter to Paul Nash from Oliver Simon, 5 December 1945. Tate Gallery Archive 7050.572.

21 Letter to Oliver Simon from Edward Gordon Craig, 18 December 1938 (courtesy Cambridge University Library).

22 Letter to Oliver Simon from Barnett Freedman, 21 January 1941 (courtesy Cambridge University Library).

23 Letter to Sir William Rothenstein from Oliver Simon, 13 July 1942 (courtesy Houghton Library, Harvard University).

24 Letter to Oliver Simon from Beatrice Warde, 7 July 1946 (courtesy Cambridge University Library).

The Press Postwar and Herbert Simon
1 H. Simon, *Introduction to Printing — the craft of letterpress*, Faber and Faber, 1968.
2 Noel Carrington, *Industrial Design in Britain*, George Allen and Unwin, 1976.
3 H. Simon, 'Oliver Simon', *Penrose Annual*, Lund Humphries, 1957.

Claud Lovat Fraser
1 Holbrook Jackson, 'Claud Lovat Fraser', *The Bookman*, August 1921.
2 Haldane Macfall, *The Book of Lovat*, Dent and Sons, 1923.
3 *Claud Lovat Fraser*, exhibition catalogue, Victoria and Albert Museum, London 1969, introduction by Grace Lovat Fraser.

Albert Rutherston
1 Correspondence relating to Harold Monro and The Poetry Bookshop (courtesy British Library manuscripts division).

Paul Nash
1 *Double Crown Club — register of past and present members*, privately printed for members to celebrate 100th meeting, May 1949.
2 Quoted by Anthony Bertram, *Paul Nash — the portrait of an artist*, Faber and Faber, 1955.
3 Letter to Oliver Simon from Paul Nash, 29 August 1940 (Simon 9, transcribed by Anthony Bertram and quoted by courtesy of the Victoria and Albert Museum).
4 Paul Nash, *Room and Book*, chapter on 'Modern Processes in Illustration', Soncino Press, 1932.
5 Letter to Faber from Paul Nash, 9 May 1929 (courtesy Faber and Faber).
6 Letter to Oliver Simon from Paul Nash, probably 1927 (Simon 2,

transcribed by Anthony Bertram and quoted by courtesy of the Victoria and Albert Museum).
7 Letter to Faber from Paul Nash, undated but c. end May 1929 (courtesy Faber and Faber).
8 Letter to Faber from Paul Nash, undated but c. June 1929 (courtesy Faber and Faber).
9 Letter to Faber from 'A.E.', August 1929 (courtesy Faber and Faber).
10 Letter to Faber from Paul Nash, undated but c. June 1929 (courtesy Faber and Faber).
11 *A Specimen Book of Pattern Papers designed for and in use at The Curwen Press*, introduction by Paul Nash, The Fleuron, 1928.
12 See note 4 above.
13 Letter to Paul Nash from Oliver Simon, 11 May 1944, Tate Gallery Archive 7050.569.
14 See note 2 above.
15 Letter to Harold Curwen from Paul Nash, 31 January 1933 (courtesy Curwen Press).
16 See note 5 above.
17 Letter to Tate Gallery from Mrs Olive Smith, 30 November 1976.
18 Letter to Paul Nash from Oliver Simon, 11 February 1946, Tate Gallery Archive 7050.573.

Edward Bawden
1 D. P. Bliss, 'An Appreciation' in catalogue of the exhibition, *The World of Edward Bawden* at The Minories, Colchester, 1973.
2 Transcript of a tape recording, 14 July 1975, Edward Bawden talking to the writer.
3 Letter to Harold Curwen from Edward Bawden, 21 May (no year, but 1930?) (courtesy Curwen Press).
4 Letter to Edward Bawden from Eric Ravilious dated August (1930?) (courtesy of the Ravilious family).
5 R. Harling, *Edward Bawden*, 'Art and Technics' series, 1948.
6 Letter to Faber from Edith Sitwell, 7 June 1928 (courtesy Faber and Faber).
7 Letter to E. M. O'Rourke Dickey of the War Artists' Advisory Committee from Edward Bawden, 27

July 1942 (courtesy Imperial War Museum).
8-10 Letters to Harold Curwen from Edward Bawden (illustrated) undated and dated 9 September 1930, 16 November 1930 (courtesy Potter Books Ltd).
11 Letter to Edward and Charlotte Bawden from Harold Curwen writing from North End Stores, Henley, 19 December 1939 (courtesy Edward Bawden).
12 Letter to the Tate Gallery from Edward Bawden, 21 October 1976.

Eric Ravilious
1 Much of the information in this section is by courtesy of Helen Binyon who allowed the writer to read an as yet unpublished memoir about the artist, largely based on his letters.
2 Information about this and other payments to artists comes from the record books of payments to artists: I. 16 November 1926 to 29 May 1933; II. 30 May 1933 to 3 March 1941 (courtesy Curwen Press).
3 *The Wood Engravings of Eric Ravilious*, introduction by J. M. Richards, Lion and Unicorn Press, 1972.
4 Letter to a friend from Eric Ravilious, 17 February 1935 (courtesy Helen Binyon).
5 Letter to Eric Ravilious from Harold Curwen, 25 August 1936 (courtesy Helen Binyon).
6 Estimate from the Curwen Press, 23 January 1940 (courtesy Imperial War Museum).
7 Letter to E. M. O'Rourke Dickey from Eric Ravilious, 2 August 1940 (courtesy Imperial War Museum).
8 Letter to Helen Binyon from Eric Ravilious, 29 October 1940 (courtesy Helen Binyon).

Barnett Freedman
1 T. Griffits. *The Technique of Colour Printing by Lithography* and *Colour Printing*, Faber and Faber, 1940 and 1948 respectively.
2 Letter to Ruth Simon from Barnett

Freedman, 15 July 1935 (courtesy Cambridge University Press).

3 Transcript of a tape recording of a conversation between John Piper and the writer, 11 December 1975.

4 Rowley Atterbury, *The Contributors*, paper of a talk to the Wynkyn de Worde Society, 16 May 1974, Westerham Press, 1974.

5 Barnett Freedman's black-and-white work fully discussed in Jonathan Mayne, *Barnett Freedman*, 'Art and Technics' series, 1948.

6 Sir Stephen Tallents, introduction to catalogue of the memorial exhibition run by the Arts Council of Great Britain, 1958, *Barnett Freedman 1901–1958*.

7 Letter to E. M. O'Rourke Dickey from Barnett Freedman, 19 December 1940 (courtesy Imperial War Museum).

8 Letter to E. M. O'Rourke Dickey from Barnett Freedman, 2 April 1941 (courtesy Imperial War Museum).

9 Letter to Faber from Barnett Freedman, 10 September 1945 (courtesy Faber and Faber).

10 Letter to Oliver Simon from Barnett Freedman, 21 January 1941 (courtesy Cambridge University Library).

11 Letter to the Tate Gallery from Frances Macdonald, received November 1976.

McKnight Kauffer

1 Statement by artist in catalogue, *Posters by E. McKnight Kauffer*, New York, Museum of Modern Art, 1937.

2 Introduction by Aldous Huxley in the same catalogue.

3 Sir Francis Meynell, *My Lives*, Bodley Head, 1971.

4 Letter to McKnight Kauffer from T. S. Eliot, 1931 (courtesy Pierpoint Morgan Library, New York).

5 Letter to McKnight Kauffer from T. S. Eliot, 8 August 1930 (courtesy Pierpoint Morgan Library, New York).

6 Letter to McKnight Kauffer from T. S. Eliot, undated but *c.* 1930 (courtesy Pierpoint Morgan Library, New York).

7 See article by Dr Desmond Flower, 'Book Illustration by E. McKnight Kauffer', *Penrose Annual*, Lund Humphries, 1956.

8 Letter to Harold Curwen from McKnight Kauffer, 4 October 1931 (courtesy Curwen Press).

Graham Sutherland

1 The artist quoted in the catalogue of his exhibition *Drawings of Wales*, Welsh committee of the Arts Council, 1963.

2 The artist's statement, 'Thoughts on Painting' reprinted from *The Listener*, 6 September 1951, in catalogue to his exhibition at the Kunsthaus, Zurich, March–April 1953.

John Piper

1 John Piper, 'Book illustration and the Painter-Artist', *Penrose Annual*, Lund Humphries, 1949.

2 John Piper talking to the writer, transcription of tape recording made 11 December 1975.

Edward Ardizzone and Lynton Lamb

1 E. Ardizzone, *Baggage to the Enemy*, John Murray, 1941.

2 Lynton Lamb, 'Vollard as a Publisher', *Signature*, No.8, March 1938.

3 Holbrook Jackson, *Early History of the Double Crown Club*, privately printed 1969 and including 'A Second Impression' by Lynton Lamb.

Postwar Printmaking and the Curwen Studio and Stanley Jones

1 Minutes of a Board Meeting held at the Curwen Press, 30 May 1958 (courtesy Curwen Press).

2 All information about Studio prints in this section taken from a transcription of a tape recording made by Stanley Jones and the writer at the Tate Gallery, 27 April 1976.

3 Sir John Rothenstein, *Modern English Painters – Wood to Hockney*, MacDonald, 1974.

4 Letter to the Tate Gallery from William Scott, 11 December 1976.

5 See John Piper, note 2 above.

6 Letter to Curwen Studio from Alan Davie, 26 November 1960 (courtesy Curwen Studio).

7 Letter to the Tate Gallery from Robert Adams, 10 December 1976.

8 Letter to Barbara Hepworth from Herbert Simon, 30 August 1966 (courtesy Curwen Studio).

9 Letter to Herbert Simon from Barbara Hepworth, 2 November 1968 (courtesy Curwen Studio).

10 Letter to Herbert Simon from David Gentleman, 11 March 1974 (courtesy Curwen Studio).

11 Henry Moore – telephone conversation with writer, 26 October 1976.

12 Transcript of tape recording of conversation between Edward Bawden and writer, 14 July 1975.

Catalogue

Measurements are given in centimetres, height followed by width. Those of books and leaflets refer to the cover measurement when closed.

The term autolithograph is used to differentiate a lithograph that the artist personally drew on stone, plate, or transfer paper from one in which an artist's design has been copied either manually or photolithographically by craftsmen.

The following periodicals recur:
Signature
A quadrimestrial of typography and the graphic arts, edited by Oliver Simon.
Nos.1–15; November 1935 to December 1940
New series Nos.1–18; July 1946 to 1954
Curwen Press Newsletter
An occasional publicity booklet published by the Press in sixteen issues which appeared between June 1932 and September 1939.

The Curwen Press

1 Oliver Simon
 Instructions for the spine of *Lavengro*, 1936
 Pencil, 16.1 × 12.4
 Cambridge University Library

2 Percy Smith
 Design for house mark for Oliver Simon
 Ink, 18.5 × 14.5
 Mrs Sue Simon

3 Double Crown Club Menus
 a Gerard Meynell
 Menu No.2 (pastiche of Curwen and Simon),
 1924
 Letterpress with stencilled colour, 18 × 12
 Cambridge University Library and
 John Dreyfus
 b Noel Carrington
 Menu No.62 (menu as timetable), 1937
 Letterpress, 22.2 × 14.7
 John Dreyfus
 c Hans Schmoller
 Menu No.134 (in memory of O. Simon), 1956
 Letterpress, 25 × 17
 Cambridge University Library
 d Colin Banks
 Menu No.219 (in memory of H. Curwen),
 1973
 Letterpress, 23 × 14
 Cambridge University Library

4 *Apropos the Unicorn*, by J. Thorp, 1919–20
 Letterpress, 15 × 9
 Mr and Mrs R. Simon

5 Publicity Leaflets
 a Artist unknown
 I am showing . . ., undated
 Letterpress, 25.4 × 10.2
 Bodleian Library, John Johnson Collection
 b Signed 'D.M.B.'
 La Mariposa . . ., undated
 Letterpress, 24.8 × 10.8
 Bodleian Library, John Johnson Collection

 c Doyle Jones
 Printing with a spirit, undated
 Letterpress, 16 × 6.2
 Curwen Press Ltd
 d John Nash
 By the way, 1959
 Letterpress, 24.1 × 18.4
 Bodleian Library, John Johnson Collection

6 *Business Printing*, 1921
 Letterpress, 32 × 23.5
 Mr and Mrs R. Simon

7 *Specimen Book of Types and Ornaments in use at
 the Curwen Press*, 1928
 Letterpress, 30 × 21.5
 Curwen Press Ltd

8 *Curwen Press Miscellany*, 1951
 Letterpress with wood engraved and stencilled
 illustrations, 30 × 21.5
 Curwen Press Ltd

9 Postcards of the Press
 a Lynton Lamb
 Letterpress, 10 × 15
 Mr and Mrs R. Simon
 b Barnett Freedman
 Lithography, 11 × 15
 Cambridge University Library
 c Edward Ardizzone
 Lithography, 11 × 15
 Cambridge University Library

10 Albert Rutherston
 Illustration, untitled and undated
 Letterpress with stencilled colour, 19 × 13
 a Progressive proofs for the above
 Letterpress with stencilled colour, 19 × 13
 b Set of stencils for the above, celluloid
 Curwen Press Ltd

11 Album of Curwen Press Unicorns, various dates
 Proofs and drawings, album size 31 × 26
 Curwen Press Ltd

12 Marion Dorn
 Vathek, by William Beckford, published by the
 Nonesuch Press, 1929
 Autolithography, 23.5 × 34.3
 Victoria and Albert Museum (Library)
The first book illustrations autolithographed at the
Curwen Press.

13 Bert Smith
 Menus for the British Transport Commission,
 1950–60
 a Tregenna Castle Hotel
 Letterpress, 31 × 18.5

 b Easton Hotel
 Letterpress, 34 × 18.5
 c Royal Station Hotel
 Letterpress, 34 × 18.5
 d Midland Hotel (dinner dance ticket)
 Letterpress, 11.5 × 15.5
 Charles Mayo

14 Orders and payments to artists
 Ms. ledger from Curwen Press Records
 a 16 November 1929–29 May 1933
 b 30 May 1933–3 March 1941
 Curwen Press Ltd

Artists at Curwen

Claud Lovat Fraser 1890–1921

15 Original designs, colourways and prints of
 pattern papers
 Mr and Mrs R. Simon and *Curwen Press Ltd*

16 *The First Four*, order form for Decoy Prints,
 1919
 Letterpress, colour line, 25 × 10.5
 Grace Lovat Fraser

17 Pointers – gummed poster labels for
 MacFisheries Ltd, undated
 Fisherman; Lobster; Flat Fish; Boathouse;
 Mackerel; Boat
 Letterpress, colour line, from 8.7 × 16.2 to
 8.7 × 15.6
 Victoria and Albert Museum

18 Curwen publicity shots
 a *A Playful Touch*, 1919–20
 Letterpress, colour line, 17.5 × 7.6
 Mr and Mrs R. Simon

 b *The Curwen Unicorn*, 1920
 Letterpress, colour line, 21.5 × 8.5
 Bodleian Library, John Johnson Collection
 c *Get the Spirit of Joy into your printed things*,
 1920
 Letterpress, colour line, 22 × 14
 Bodleian Library, John Johnson Collection

19 Programme and announcement card
 Grace Crawford and Arthur Bliss concert at
 139 Piccadilly, London W1, 15 December 1920
 Letterpress, colour line, 33.5 × 14 and 14 × 9
 respectively
 Grace Lovat Fraser

20 Stationery
 a Card for 23 Elm Park Gardens, 1920
 Die-stamping and letterpress, 13.5 × 8
 Grace Lovat Fraser
 b C. Lovat Fraser's compliments slip, 1920
 Letterpress, colour line, 9 × 5
 Grace Lovat Fraser

21 *Safety First Calendar*, September 1921–
August 1922
'A short cut, a quick end'
Letterpress, colour line, 37 × 24.5
Grace Lovat Fraser
 a Original drawings for the above
 Pen and coloured inks, 25 × 34
 Victoria and Albert Museum
 b Proofs for the above
 Letterpress, colour line, 13 × 18
 Victoria and Albert Museum

22 Poster for Witney Blankets, undated
Calligraphy by H. Ball
Lithography, 56.5 × 37.5
Grace Lovat Fraser

23 *Our Model Policemen*, humorous character
sketch for boys
One of 21 designs for music covers, 1919–21
Ink, 24.5 × 27
Curwen Press Ltd

24 *A Great Step Forward*, publicity for the New
Comptometer, 1921
Letterpress, colour line, 31 × 22
Cambridge University Library

25 *A Diary of 1745*, booklet by Joseph Thorp for
Fripp's Olive Oil Soap, 1922
Letterpress, colour line, 13 × 9
Cambridge University Library

26 Original idea for the London Transport poster,
By Underground for Pleasure, conceived 1921,
completed by Albert Rutherston, 1922
Pen and coloured inks, 36.9 × 25.4
Victoria and Albert Museum

27 Marriage announcement of Frieda Margaret
Simpson and Harold Spedding Curwen, 1923
Letterpress, 15.5 × 11
Mr and Mrs R. Simon

28 Leaflet for French agent with samples of seven
Lovat Fraser papers, 1924
Lithography, 33 × 25
Cambridge University Library

29 *The Lute of Love*, published by Selwyn and
Blount, 1920
Letterpress, 16.5 × 10.5
Curwen Press Ltd

30 *The Luck of the Bean-Rows*, translated by
Charles Nodier and published by Daniel
O'Connor, 1921
Letterpress, colour line (first book thus printed at
the Curwen Press), 25.5 × 16
Curwen Press Ltd

31 Drawings for *A Shropshire Lad* by A. E.
Housman, 1921
Unused, but purchased by Harold Curwen for
general decorative use
Published as a complete set by the First Edition
Club in 1924
Pen and ink, each sheet 26 × 20
Grace Lovat Fraser

32 *A Painting Book of Designs by Claud Lovat
Fraser*, published by Eno's, 1922
Letterpress, colour line, 31 × 25
Grace Lovat Fraser
 a Original drawing for p.9 of the above
 Pen and gouache with pencil instructions to
 the printer (adjustments later made),
 26 × 19.5
 Grace Lovat Fraser

33 Nurse Lovechild's Legacy, *Nursery Rhymes*,
first published by The Poetry Bookshop, 1916,
here reprinted by the Curwen Press, 1922
Letterpress, 18.5 × 12.5
Curwen Press Ltd

34 *The Woodcutter's Dog*, translated by Charles
Nodier, published by Daniel O'Connor, second
edition 1922
Letterpress, colour line, 25 × 15.5
Curwen Press Ltd

35 *Poems from the Works of Charles Cotton*,
published by The Poetry Bookshop, 1922
Letterpress, 22 × 14.5
Curwen Press Ltd

36 Letter from Harold Curwen to Lovat Fraser on notepaper the artist had designed; undated but between 5 June 1920 and the artist's death
Black line block heading, coloured by hand, no printed address, paper size 24.5 × 14
Grace Lovat Fraser
a Letterhead based on the above design
Letterpress, colour line, 22 × 13.5
Mr and Mrs R. Simon

Albert Rutherston 1881–1935

37 Pattern papers – designs of 1925–27 and printed examples which occurred in the Curwen Press
Specimen Book of Pattern Papers, 1928
Watercolour and pen designs, lithographically repeated
Mr and Mrs R. Simon and *Curwen Press Ltd*

38 *By Underground for Pleasure*, poster published by London Transport, 1922, to make model theatre for a play, published by Wells Gardiner Darton and Co.
Lithography, 102 × 63.5
Tate Gallery (Archive), presented by Robert Simon
a Original drawing for the above
Pen and watercolour, 80.7 × 47.6
Victoria and Albert Museum

39 *Forgetfulness*, by Harold Monro, New Broadside published by The Poetry Bookshop, *c.*1920
Letterpress, colour line, 44 × 20
Cambridge University Library

40 *Little Romances*, booklet for Gurr, Johns and Co. valuers, 1926
Letterpress, colour line, 17 × 11
Cambridge University Library

41 Wine list for the Gargoyle Club, undated
Letterpress, 26 × 19
Cambridge University Library

42 Christmas List for Barrow's Stores, 1936
Lithography, 14 × 21.5
Curwen Press Ltd

43 Christmas Cards
Letterpress
a *Christmas Eve*, by John Drinkwater, published by Oliver Simon, 1922
24 × 16
The artist's grandchildren and executors
b *Dialogue at Christmas*, by John Drinkwater, published by The Fleuron, 1925
20 × 15
Cambridge University Library
c *Poem for A Christmas Card*, by Edith Sitwell, published by The Fleuron, 1926
24 × 16
The artist's grandchildren and executors
d Best wishes from Henry Ainley, 1929
18 × 12
Cambridge University Library

44 *The Four Seasons*, calendar published by the Curwen Press, 1922
Letterpress, colour line, 13 × 8.5
The artist's grandchildren and executors
a Four loose proof illustrations from the above
Letterpress, colour line, each 13 × 8.5
The artist's grandchildren and executors

45 *A Box of Paints*, poems by Geoffrey Scott, published by The Bookman's Journal, 1923
Letterpress, colour line, 25 × 18
Curwen Press Ltd
a Three original designs for the above
Letterpress key with watercolour, 25 × 19
The artist's grandchildren and executors

46 *Poor Young People*, by Edith, Osbert and Sacheverell Sitwell, published by The Fleuron, 1925
Letterpress, colour line, 26 × 20
Curwen Press Ltd

47 Almanack, published by Chatto and Windus, 1926
Letterpress, 18.5 × 12.5
Curwen Press Ltd

48 *Holy Face and Other Essays*, by Aldous Huxley, published by The Fleuron, 1929
Letterpress key with stencilled colour, 26 × 19.5
Curwen Press Ltd

49 *The Haggadah*, translated by Cecil Roth,
published by The Soncino Press, 1930
Letterpress key with stencilled colour, 32 × 25
Curwen Press Ltd
a Title page, rough sketch and design as printed
and stencilled
15.5 × 23 and 23.5 × 17 respectively
b *Moses and the Burning Bush*, original design
and printed key of final design with
watercolour
33 × 23
c Five full-page illustrations
Experimental hand-coloured proofs, each
29 × 23
d Four full-width head-pieces
Experimental hand-coloured proofs, each pair
26.5 × 20.5
e *Moses in the basket*, original design (unused)
Pen and watercolour, 22 × 18.5
f *Finis* design, variant hand-coloured proofs,
each 16 × 13.5
The artist's grandchildren and executors

50 *Yuletide in a Younger World*, by Thomas Hardy,
published by Faber and Gwyer, 1927
(*Ariel* poem No.1)
Letterpress, colour line, 18.5 × 12.5
Curwen Press Ltd

51 *Winter Nights*, by Edmund Blunden, published
by Faber and Gwyer, 1928
(*Ariel* poem No.17)
Letterpress, colour line, 22 × 14.5
The artist's grandchildren and executors

52 *Inscription on a Fountain Head*, by Peter
Quennell, published by Faber and Faber, 1929
(*Ariel* poem No.24)
Letterpress, colour line, 22 × 14.5
Curwen Press Ltd

53 *To Lucy*, by Walter de la Mare, published by
Faber and Faber, 1931
(*Ariel* poem No.33)
Letterpress, colour line, 22 × 14.5
Curwen Press Ltd

Paul Nash 1889–1946

54 Pattern papers – wood-engraved units of 1925
and 1927 and two drawings of 1927
lithographically repeated
Curwen Press Ltd

55 Stock blocks for Curwen Press made from the
design for Nash's exhibition at the Leicester
Galleries in May 1924, and the bird from
Welchman's Hose, 1925
Used in:
a Leaflet for Elsa Booth of Oxford –
Christmas presents
Letterpress, 14 × 9
Cambridge University Library
b Gifts seasonable and reasonable – Barrow's
Stores, 1934
Letterpress, 15.5 × 11.5
Curwen Press Ltd
c C.E.M.A. catalogue for exhibition of Applied
Design by Paul Nash, 1943
Letterpress, 19 × 11
Bodleian Library, John Johnson Collection

56 Menu for the Double Crown Club 3rd dinner,
1925
Woodcut, 34 × 20
Cambridge University Library

57 Typographic borders designed exclusively for the
Press in 1927 used here on *Something to Think
About*, publicity for the Press, 1931
Letterpress, 33.5 × 25.5
Curwen Press Ltd

58 Cover for *Match Making*, by E. P. Leigh
Bennett, published by Bryant and May Ltd, 1931
Lithography, 23.5 × 18
Curwen Press Ltd

59 Cover for *Shell Mex House*, published by Shell,
1933
Lithography, 18.5 × 10.5
Curwen Press Ltd

60 Cover for *Curwen Press Newsletter*, No.11,
December 1935
Lithography, 26 × 19
Curwen Press Ltd

61 *Genesis* from Chapter 1, authorized version of
The Bible, published by The Nonesuch Press,
1924
Woodcuts and Koch's 'Neuland' typeface,
28 × 19.5
Curwen Press Ltd

62 *Welchman's Hose*, by Robert Graves, published
by The Fleuron, 1925
Woodcuts, 21 × 16
Curwen Press Ltd

63 *Saint Hercules and other stories*, by Martin
Armstrong, published by The Fleuron, 1927
Letterpress with watercolour stencilling,
30 × 20.5
Curwen Press Ltd
 a *St Hercules and other stories*, frontispiece
design, undated but *c*.1927
Autolithography, 35.5 × 28
Curwen Press Ltd

64 *Urne Buriall* and *The Garden of Cyrus*, by Sir
Thomas Browne, published by Cassell and
Company, 1932
 a Illustrations: *Frontispiece, Tokens, Buried
Urne, Funeral Pyre*, and *Sorrow* from *Urne
Buriall; Poisonous Plantations, The Quincunx
Artificially Considered* and *The Order of Five*
from *The Garden of Cyrus*
Collotype and stencilled watercolour, each
sheet 31.5 × 23.5
Dr Desmond Flower
 b *The Mansions of The Dead*
Collotype and stencilled watercolour,
31.5 × 23.5
Dr Desmond Flower
 c Proofs: *Vegetable Creation, The Quincunx
Naturally Considered* 1 and 2, and *The
Quincunx Mystically Considered* from The
Garden of Cyrus
Collotype and stencilled watercolour,
each sheet 24 × 11
Mr and Mrs R. Simon
 d *Phoenix and Snake*, preliminary drawing for
illustration on p.14 of *Urne Buriall*
Pencil and black and red crayon, 15.5 × 22
Mrs Sue Simon
 e Collotype and stencilled interpretation based
on the above, 31.5 × 23.5
Dr Desmond Flower

65 *Poised Objects*, published in *Axis*, No.8, 1937
Letterpress, 22.5 × 22
Myfanwy Piper
This is a reproduction of a chalk and watercolour
drawing of 1933, based on one of the *Garden of
Cyrus* illustrations. The Paramat blocks for *Axis* were
cut by John Piper.

66 *Nativity*, by Siegfried Sassoon, published by
Faber and Gwyer, 1927
(*Ariel* poem No.7)
Letterpress, colour line, 18.5 × 12
Curwen Press Ltd

67 *Dark Weeping*, by 'A.E', published by Faber and
Faber, 1929
(*Ariel* poem No.19)
Letterpress, 20 × 14.5
Curwen Press Ltd

68 *Landscape of the Megaliths*, published by
Contemporary Lithographs, 1937
Autolithography, 50.5 × 76.5
Arts Council of Great Britain

69 *The Raider on the Moors*, 1940
Pencil and watercolour, 50 × 69.5
Visitors of The Ashmolean Museum, Oxford
 a *The Raider on the Moors*, 1941, reproduction
published by the National Gallery for the
Ministry of Information
Lithography, 50 × 69.5
Tate Gallery (Archive), presented by Robert
Simon

70 *Cagnes 1926*, from *Riviera Sketches*, a New
Year's Card
Inscribed 'For Ruth and Oliver with love from
Paul and Margaret, 1928'
Pencil and crayon, 25.5 × 18
Mrs Sue Simon

71 Landscape collage (untitled), 1938
Inscribed 'Ruth from Paul, Christmas 1938'
Photographic collage on watercolour background,
18 × 26
Mrs Sue Simon

72 Untitled Landscape, 1938
Inscribed 'For Oliver from Paul, Christmas 1938'
Pencil and watercolour, 18×26
Mrs Sue Simon

Edward Bawden b.1903

73 *Pottery Making at Poole*, booklet for Poole
Pottery, 1925
Letterpress, colour line, 20×16
Tate Gallery (Library)

74 Calendar for the Curwen Press, 1925
Letterpress, 32.5×15.5
Bodleian Library, John Johnson Collection

75 Press settings and leaflets for The Westminster
Bank: *When touring the French Cathedrals*, 1927;
The Banking System and Maintenance of Plant,
1928–29; *Points before Travelling*, 1928–29;
Shipping, 1933; *Travel in Germany*, 1936
Letterpress, respective sizes, 35.5×16,
20.5×12.5, 20×11.5, 25×19, 18.5×12
The artist

76 Pattern papers, 1927–28
Lithographically repeated from etched units
Curwen Press Ltd

77 Unused pattern paper, undated
Etching
Mr and Mrs R. Simon

78 Leaflet for Hawes and Curtis of St James's, 1928
Letterpress with stencilled colour, 15.5×9.5
Tate Gallery (Library)

79 Decoration for *The Stencil Process*, by Holbrook
Jackson, published by the Curwen Press, 1928
Letterpress with stencilled colour, 28×19.5
The artist

80 *The Bibliolaters Relaxed*, menu for the Double
Crown Club 16th dinner, 1928
Letterpress with stencilled colour, 13.5×17
Tate Gallery (Library)

81 Catalogue of an exhibition of books, printed at
the Curwen Press, issued by John and Edward
Bumpus Ltd, 1929
Letterpress with stencilled colour, 25.5×18
Curwen Press Ltd

82 *East Coasting*, booklet by Dell Leigh, published
by the London and North Eastern Railway, 1930
Letterpress, colour line, 24.5×15.5
Tate Gallery (Library)

83 *The Choice of a Shipping Agent*, booklet for
Thomas Meadows and Co. Ltd, 1931
Letterpress, 20×14
Tate Gallery (Library)

84 Cover for *Curwen Press Newsletter*, No.8, 1934
Lithography after linocut, 26×19.5
Curwen Press Ltd

85 Cover paper for London Transport Board, 1935
Lithographically repeated from etched unit
The artist

86 Menu for the Double Crown Club 48th dinner,
1935
Letterpress, 15×21
Cambridge University Library

87 Menu Cards for Barrow's Stores, Birmingham,
1937
Letterpress, colour line, 22×14
The artist

88 *Campions and Columbine*, illustration for
Predicaments of Illustration, by Lynton Lamb in
Signature, No.4 new series, 1947
Lithography after linocut, 25×19
Curwen Press Ltd

89 Cover of *A Store Record 1824–1949*, published
by Barrow's Stores, Birmingham, 1949
Autolithography, 22×14
Curwen Press Ltd

90 Proof of typographic border for title page of
One Hundred Title Pages, published by John
Lane at The Bodley Head Ltd, 1928
Letterpress, 24×22.5
The artist

91 Typographic border used on back cover of
 The Curwen Press Newsletter, No.2, September
 1932
 Letterpress, 26 × 19
 The artist

92 Typographic border on leaflet for *The Plaistow
 Wallpapers*, published by the Curwen Press,
 1933
 Letterpress, 25.5 × 17.5
 The artist

93 Typographic border known as *Boiled Sweets*, 1938
 Letterpress, 22 × 14.5
 The artist

94 Typographic border known as *Window Boxes* on
 cover of *The Inauguration of the Empire Air Mail
 Programme*, published by Imperial Airways,
 1938
 Letterpress, 27.5 × 21.5
 The artist

95 *That's What We Want! Dried Beet Pulp*,
 published by the Empire Marketing Board, 1930
 Lithography, 76.5 × 102.2
 Victoria and Albert Museum

96 *Le Touquet – The Ideal Sunday or Weekend
 Trip*, published by Imperial Airways, undated
 Lithography, 49.5 × 31
 The artist

97 *Chestnut Sunday*, published by London Passenger
 Transport Board, 1936
 Lithography after linocut, 25 × 31.5
 London Transport

98 *Country Houses – Tring, Downe, Westerham*,
 published by London Passenger Transport
 Board, 1936
 Lithography after linocut, 102 × 63
 London Transport

99 *Kew Gardens*, published by London Passenger
 Transport Board, 1936
 Lithography after linocut, 101 × 63
 London Transport

100 *Kew Gardens*, unused design, 1936
 Lithography after collage, 101 × 63
 Tate Gallery (Archive)

101 *Dahlias at Regent's Park*, published by London
 Passenger Transport Board, 1936
 Lithography after linocut, 100 × 62.5
 London Transport

102 *Now for Holidays*, published by London
 Passenger Transport Board, 1938
 Lithography, 25.5 × 73.5
 The artist

103 *Homage to Dicky Doyle*, for *Curwen Press
 Miscellany*, 1931
 Letterpress with stencilled colour, 35.5 × 26.5
 The artist

104 *Cattle Market*, published by Contemporary
 Lithographs, 1937
 Lithography after linocut, 50.8 × 76.2
 The artist

105 Illustration in *Graven Images*, by Graham
 Sutherland, published in *Signature*, No.6,
 July 1937
 Engraving, 25 × 19
 Curwen Press Ltd

106 *Hail: The Rest House of the Anti-Locust Mission.
 Shaddad Salem and his son Abdullah. Saudi
 Arabia*, 1944
 Watercolour, 39 × 50
 Trustees of the Imperial War Museum

107 *Interior of Shaikh Muzhir Al-Gassid's Mudhif,
 Iraq*, 1944
 Watercolour, 39.5 × 50.8
 Trustees of the Imperial War Museum

108 *Shaikh Wabdan Jal-Sa'dun and his brother Jabir,
 Iraq*, 1944
 Watercolour, 39.5 × 50.8
 Trustees of the Imperial War Museum

109 Calendar in *Review of Revues*, published by
 Jonathan Cape, 1930
 Letterpress, colour line, 21 × 14
 Curwen Press Ltd

110 *Good Soups* and *Good Potato Dishes*, book covers
for series by Ambrose Heath, published by
Faber and Faber, 1935
Lithography after linocuts, 20×30 and 20×51
respectively
Cambridge University Library

111 *Travellers' Verse*, chosen by M. G. Lloyd Thomas,
published by Frederick Muller Ltd, 1946
Autolithographic illustration, 21×14.5
Curwen Press Ltd

112 *The Arabs*, by R. B. Serjeant, Puffin Picture
Book, 1948
Autolithographic illustration, 18×22
The artist and *Curwen Press Ltd*
a Sketch book with detailed drawings for the
above
Pen and ink, watercolour, crayon, 31×25
The artist
b Centre spread from the book
Autolithography, 33×50
The artist

113 *Life in an English Village*, by Noel Carrington,
King Penguin, 1949
Autolithographic illustrations, 18.5×12.5
The artist

114 *Vathek*, by William Beckford, published by The
Folio Society, 1958
Autolithographic illustrations, 22×13
Curwen Press Ltd

115 *Popular Song*, by Edith Sitwell, published by
Faber and Gwyer Ltd, 1928
(*Ariel* poem No.15)
Letterpress, colour line, 22×14.5
Curwen Press Ltd

116 Wallpapers
a *Sahara; Pigeon; Knole Park; Conservatory;
Seaweed and Whale; Leaf; Riviera; Cows in
Fields; Wave; Wave and Mermaid; Seaweed;
Ivy and Bird's Nest; Napkin and Fruit;* from
1926
Lithography after linocuts
The artist and *Mr and Mrs R. Simon*
The designs for these papers were created in repeat-
able units, produced in sheet form at the Curwen
Press, and sold by Modern Textiles.

b *Facade; Node; Ashlar; Salver;* 1933
Lithography after linocuts
The artist and *Mr and Mrs R. Simon*
These designs, commissioned in 1932 by Oliver Simon,
were each designed as a whole block of standard size
(86×55).

117 *Heads, Bodies, Tails,* sent by Edward and
Charlotte Bawden to Oliver and Ruth Simon as
Christmas Greeting, *c.*1935
Original drawing, 23×18
Cambridge University Library

118 Christmas Card showing Brick House, Great
Bardfield which Bawden and Ravilious shared
from 1930, undated
Letterpress, 14×24
The artist

119 Christmas Card sent by Edward and Charlotte
Bawden to Oliver and Ruth Simon, 1939
Frottage from lino with watercolour,
23.5×32
Mrs Sue Simon

120 'I am rather curious . . .', illustrated letter from
Edward Bawden to Curwen undated
Pen and ink and watercolour, 18.2×11.4
Potter Books Ltd

121 'I shall be delighted to draw you a happy cow.
Moo-o-o-o . . . EB', illustrated letter from Edward
Bawden at The Leach Pottery, St Ives, to
Curwen, undated (but E.B. commissioned
8.9.30)
Pen and watercolour on headed paper, 5.5×21
Potter Books Ltd

122 'By a Promethean labour . . .', illustrated letter
from Edward Bawden at Holbein Studios, 52
Redcliffe Road to Curwen
Pen and ink on folded sheet, 18×23
Potter Books Ltd

123 Letter from Harold Curwen to Edward Bawden,
13.11.30
Typescript, 27×16.5
The artist

124 'One of my periodic flights . . .', illustrated letter
from Edward Bawden to Curwen, 16.11.30
Pen and ink and crayon, 18.2×11.4
Potter Books Ltd

Barnett Freedman 1901–58

125 Set of postcards, undated
Letterpress, each 10×15
Cambridge University Library

126 Menu for Paladin Club 8th meeting, 1933
Autolithography, 23×19
Cambridge University Library

127 Cover for *Curwen Press Newsletter*, No.5,
September 1933
Autolithography, 26×19
Curwen Press Ltd

128 Pattern paper, 1934
Autolithography
Curwen Press Ltd

129 Romary's Biscuit Label, 1934
Autolithography, 7×23
Cambridge University Library

130 Menu for the Double Crown Club 115th dinner,
1952
Autolithography, 22×16
Cambridge University Library and *Dr and
Mrs B. L. Wolpe*

131 Christmas Cards
 a For Faber and Faber 1945, 1947 and 1950
 b For Leighton-Straker 1953, 1954, 1955 and
 1956
Autolithography, various sizes
Cambridge University Library and *private
collection*

132 Original design for Leighton-Straker Card, 1953
Pencil, watercolour and coloured inks, 22.5×18
Private collection

133 Market scene, undated (but between 1927 and
1932)
Experimental autolithography with stencilled
colour, 35×28
Curwen Press Ltd

134 *Charade*, published by Contemporary
Lithographs, 1937
Autolithography, 51×76
Dr and Mrs B. L. Wolpe

135 *Darts Champion*, published by Arthur Guinness
Son and Co., 1956
Autolithography, 56×82
Tate Gallery, presented by the Curwen Studio

136 *Portrait of Oliver Simon*, undated
Chalk and pen, 21.5×14
Mrs Sue Simon

137 *Circus*, two sheet poster for London Transport,
1936
Autolithography, each sheet 100×62.5
London Transport

138 *Theatre*, poster for London Passenger Transport
Board, 1936
Autolithography, 31.7×36.4
London Transport

139 Imperial Airways, poster blank, 1937
Autolithography, 102×64.5
Tate Gallery (Archive), presented by Robert
Simon
 a Original design for the above, 1937
 Pen and ink and watercolour, 40×24
 Private collection

140 Original drawings for *Lavengro*, published by the
Limited Editions Club of New York, 1936
Pen, pencil and watercolour, 65.5×128.5
Private collection
 a Set of plates from the above book
 Autolithography, each 23.5×15.5
 Cambridge University Library

141 Six proofs from *Henry IV part I*, published by
the Limited Editions Club of New York, 1939 –
bound for presentation
Autolithography, 32.5×21
Private collection

142 Illustrations from *Jane Eyre*, published by The
Heritage Club of New York, 1942
Autolithography, 101.5×63.5
Tate Gallery, presented by Robert Simon

143 *Wuthering Heights*, by Emily Brontë,
published by The Heritage Club of New York,
1941 – this reprint by Collins, 1955
Autolithography, 24.5×15.5
Curwen Press Ltd

144 Original drawings for *Anna Karenina*, published
by the Limited Editions Club of New York, 1950
Pen, pencil and watercolour, 69.2 × 142.2
Mr and Mrs J. R. Huntington
a Set of plates from the above book
Autolithography, each 24 × 16.3
Tate Gallery, presented by Robert Simon

145 *Ghost Stories*, by Walter de la Mare, published by
The Folio Society, 1956
Autolithography, 23 × 15
Curwen Press Ltd

146 *Wonder Night*, published by Faber and Gwyer,
1927
(*Ariel* poem No.3)
Letterpress, colour line, 18.5 × 12
Curwen Press Ltd

147 *News*, by Walter de la Mare, published by Faber
and Faber, 1930
(*Ariel* poem No.31)
Letterpress, colour line, 22.5 × 14.5
Curwen Press Ltd

148 *Choosing a Mast*, by Roy Campbell, published by
Faber and Faber, 1931
(*Ariel* poem No.38)
Letterpress, colour line, 22.5 × 14.5
Curwen Press Ltd

149 Original design for *Victoria of England*, by
Edith Sitwell, 1935
Pen, gouache and watercolour, 25.5 × 16.3
Dr and Mrs B. L. Wolpe

150 Jacket for *Victoria of England*, by Edith Sitwell,
1935
Lithography, 25.5 × 16.3
Dr and Mrs B. L. Wolpe

151 Book jackets for Faber and Faber titles, 1935–49
The Motherly and Auspicious, by Maurice Collis;
Behold this Dreamer, by Walter de la Mare;
Affairs of a Painter, by J. F. Joni; *The Land of
the Great Image*, by Maurice Collis; *Africa
Dances*, by Geoffrey Gorer; *Grand Tour*, by
R. S. Lambert; *The Fool*, by Enid Welsford;
The Grand Peregrination, by Maurice Collis
Faber and Faber

E. McKnight Kauffer 1890–1954

152 *Benito Cereno*, by Herman Melville, published
by The Nonesuch Press, 1926
Letterpress with stencilled watercolour, 31 × 21
Curwen Press Ltd

153 *Elsie and the Child*, by Arnold Bennett, published
by Cassell and Co., 1929
Lithographic key with stencilled gouache,
26 × 20.5
Dr Desmond Flower
a Loose proof illustrations from the above,
Each 25 × 19.5
Two from *Mr and Mrs R. Simon*
One from *Dr Desmond Flower*, signed and
inscribed
b Preliminary sketch of Eva for the title page,
Signed and inscribed 'Eva, first rough'
Pencil and watercolour, 20.5 × 14
Dr Desmond Flower

154 Proofs for *The Life and Strange Surprising
Adventures of Daniel Defoe*, published by
Etchells and MacDonald, 1929
Lithographic key with stencilled gouache, each
25.5 × 19
Mr and Mrs R. Simon

155 *Don Quixote*, Vols. I and II, by Cervantes,
published by The Nonesuch Press, 1930
Photogravure and stencilled watercolour,
23.5 × 15.5
Victoria and Albert Museum
a Loose proofs from the above
Each 23 × 14.5
S. A. Garrad

b Variant proof for one of the illustrations
Photogravure and watercolour, 23 × 14.5
Simon Rendall

c Related drawing to the above
Signed 'E. McKnight Kauffer'
Crayon and watercolour, 43.2 × 24.2
Helen Rendall

d Early drawing for *Don Quixote* (unused)
Signed 'E. McKnight Kauffer'
Crayon, charcoal and watercolour, 45 × 33
Dame Alix Meynell

e Drawing for *Don Quixote* (unused)
Sprayed watercolour and pen, 28 × 18
Dame Alix Meynell

f Four experimental proofs from one stone,
possibly drawn with *Don Quixote* in mind,
undated but 1929–30?
Autolithography, each sheet 35.5 × 28
 i chalk drawn lithograph printed in black
 ii reversed print, white values out of black
 iii as i) but in terracotta colour
 iv printed on black paper and aluminium
 powdered
Curwen Press Ltd

156 *Venus Rising from the Sea*, by Arnold Bennett,
published by Cassell & Co., 1931
Lithographic key with stencilled watercolour,
28.5 × 21
Dr Desmond Flower

a Drawing for the above (unused), 1930
Signed and inscribed 'For Desmond from Ted'
Pen and watercolour, 46 × 35.5
Dr Desmond Flower

b Drawing for the above (unused), 1930
Signed and inscribed 'For Margaret from Ted'
Pen and watercolour, 57 × 42
Mrs Margaret Flower

c Illustration, possibly for *Venus Rising from
the Sea*, c.1930
Produced experimentally by Harold Curwen,
printed by lithographic transfer from a
drypoint by Kauffer on zinc, 35.5 × 28
Curwen Press Ltd

157 *The Journey of the Magi*, by T. S. Eliot,
published by Faber and Gwyer Ltd, 1927
(*Ariel* poem No.8)
Letterpress, colour line, 19 × 12.2
Curwen Press Ltd

158 *A Song for Simeon*, by T. S. Eliot, published by
Faber and Gwyer, 1928
(*Ariel* poem No.16)
Letterpress, 22 × 14
Curwen Press Ltd

159 *Marina*, by T. S. Eliot, published by Faber and
Faber Ltd, 1930
(*Ariel* poem No.29)
Letterpress, colour line, 18.7 × 12
Curwen Press Ltd

160 *Triumphal March*, by T. S. Eliot, published by
Faber and Faber Ltd, 1931
(*Ariel* poem No.35)
Lithography, 19 × 12
Curwen Press Ltd

161 Cover for *Curwen Edition of School Music*,
1929–30
Letterpress, 24.2 × 18
Mr and Mrs R. Simon

162 Cover for *Charnaux Corsets*, 1931
Letterpress with applied gold powder, 20.5 × 16
S. A. Garrad

163 Shell advertisement in *Signature* No.5, March
1937
Letterpress, colour line, 25 × 18.5
Curwen Press Ltd

164 *Visit your Museum: Natural History*, poster for
London Transport, proofed 1939 but due to war
produced 1975
Lithography, 101.5 × 64.5
Basil Harley

Eric Ravilious 1903–42

165 Pattern paper, 1927
Woodblock unit (1926) lithographically repeated
Curwen Press Ltd

166 Booklet for The Pavilion Hotel, Scarborough,
1930
Letterpress, colour line, 19 × 13
The Ravilious family

167 Vignettes made for various purposes and subsequently bought as stock designs by the Press between 1933 and 1936
Wood engravings
a Device for the artist's own exhibition of watercolours at Zwemmer, November 1933
Tate Gallery
b Possibly experimental wine label device for Kemp Town Brewery, commissioned in 1934 but not used, seen here on a 1936 Christmas Card
Cambridge University Library
c Device used in Westminster Bank advertisements from 1935, and on The Arts Council Memorial Exhibition catalogue 1948
Cambridge University Library
d Device for the jacket of *The Shining Scabbard*, by R. C. Hutchinson, published for Cassell and Co., described as new acquisition, 1936
Curwen Press Ltd
e Stock block No.1008
Curwen Press Ltd

168 Cover for *Curwen Press Newsletter*, No.6, January 1934
Wood engraving, 26 × 19
Curwen Press Ltd

169 Cover design for *Clothes instead of Cloth*, published by Austin Reed, 1935
Lithography, from wood engraving, 18 × 12
Curwen Press Ltd

170 *Jubilee* pattern paper, designed for Heal and Son, 1935
Used on cover of *Thrice Welcome*
Lithography
Cambridge University Library

171 *Thrice Welcome*, publicity booklet by the Southern Railway of England for the Royal Jubilee, 1935
Cover and headpiece for chapter by S. P. B. Mais
Letterpress and wood engraving, 16 × 10.5
Curwen Press Ltd and *The Ravilious family*

172 Proofs from the above
Wood engravings, 10 × 36.5
Mr and Mrs R. Simon

173 Menu, Double Crown Club 49th dinner, 1935
Wood engraving, 15 × 21
The Ravilious family

174 *The Grapehouse*, Christmas Card for Sir Stephen and Lady Tallents, 1936
Autolithography, 20.5 × 14.5
The Ravilious family

175 Book jacket for *London Fabric*, by James Pope-Hennessy, published by Batsford, 1939
Autolithography, 25 × 28.5
Curwen Press Ltd

176 *Proserpina*, for article *The Tools of the Wood Engraver* by D. P. Bliss in *The Woodcut Annual*, II, published by The Fleuron, 1928
Wood engraving, 29 × 21
Curwen Press Ltd

177 *The Boxroom*, frontispiece in luxury edition of *The Woodcut Annual*, IV, 1930
Inscribed 'To Oliver Simon November 1929' and signed
Wood engraving, 27.5 × 18
Mrs Sue Simon

178 *High Street*, by J. M. Richards, published by Country Life Ltd, 1938
24 autolithographs, each 23.5 × 15.5
a Sketch and finished title illustration
Pencil and wood engraving, 29 × 23 and 16 × 17 respectively
b On-the-spot and working drawings for *Wedding Cakes*
Pencil, 25 × 33 and 23 × 15 respectively
c On-the-spot drawing for *Oyster Bar*
Pencil, 43.5 × 27.5
d Scale drawings for (left to right)
Public House; Knife Grinder; Coach Builder; Clerical Outfitter; Hardware; Theatrical Properties; Pharmaceutical Chemist; Baker and Confectioner
e Scale drawings for *The Naturalist-Furrier-Plumassier* and *The Letter Maker*
Pencil with watercolour, 15 × 15 and 18 × 15
f *The Naturalist-Furrier-Plumassier* and *The Letter Maker* as they appeared in *Signature*, No.5, March 1937
Autolithography
The Ravilious family

High Street was originally conceived as 'An Alphabet of Shops'. There are preliminary sketches dating from 1935–36, and the autolithographs were drawn (on plates) during 1936–37. *Signature* ran an illustrated article before the book was published.

179 Drawings for *Submarine Lithographs*, 1940–41 (not published)
 a Gouache, 29×47
 The Ravilious family
 b *Frontispiece* and *Whitstable Mine*
 Pencil and watercolour, each 28.8×46
 National Maritime Museum
All drawings bear lithographic colour notations

180 *Elm Angel*, by Harold Monro, published by Faber and Faber, 1930
 (*Ariel* poem No.26)
 Two wood engravings, 19×12 and 22×14.5 respectively
 Curwen Press Ltd

181 *The Greenhouse*, signed and dated, 1935
 Watercolour, 47×59.7
 Tate Gallery (5402), presented in memory of the artist by Sir Geoffrey and the Hon. Lady Fry, 1943

182 *Newhaven Harbour* ('Homage to Seurat'), published by Contemporary Lithographs, 1937
 Autolithography (drawn on stone 1936), 55×85
 Peggy Angus
 a Original drawing for the above, 1936
 Watercolour, 55×86
 The Ravilious family

Graham Sutherland b.1903

183 *Thunder Sounding*, 1935
 Christmas Card for Robert Wellington
 Autolithograph (Man 39), 10×19
 Cambridge University Library

184 Cover for *Curwen Press Newsletter*, No.12, June 1936
 Autolithograph (Man 40), 26×19
 Curwen Press Ltd

185 Menu for the Double Crown Club 56th dinner, 1936
 Reprinted in *Signature*, No.4, March 1937
 Letterpress from collage, 26×17
 Cambridge University Library

186 New Year Card from the artist and his wife, 1936–37
 Letterpress, 16×13
 Cambridge University Library
 a Original for the above
 Collage, 16×13
 Cambridge University Library

187 *Pink Lozenge*, pattern paper designs and colour suggestions, June 1937
 Lithography (two colourways); designs gouache and pencil
 Curwen Press Ltd

188 *Under Water*, printed by The Sylvan Press as advertisement for *Signature*, No.6, July 1937
 Autolithography (Man 42), 10×13
 Curwen Press Ltd

189 *Lake and Typewriter*, published by London Transport Passenger Board, 1938
 Lithography, 101×64
 London Transport

190 Illustrations to *Henry VI part I*, published by the Limited Editions Club of New York, 1940
 Autolithography (1939) (Man 43), 22.5×14
 Cambridge University Library

191 *Portrait of Somerset Maugham II*, proof of frontispiece to the limited edition of *Cakes and Ale*, published by Heinemann Ltd, 1953
 Autolithography (Man 57), 22.5×25
 Mrs Sue Simon

192 *Invitation to Cast out Care*, by V. Sackville-West, published by Faber and Faber, 1931
 (*Ariel* poem No.37)
 Letterpress, colour line, 22.5×14.5
 Curwen Press Ltd

193 *The Sick Duck*, published by Contemporary Lithographs, 1937
 Autolithography (1936) (Man 41), 49×77
 Oliver S. Simon

194 *Clegyr-Boia*, frontispiece for *Signature*, No.9,
July 1938
Etching and aquatint (Man 37), plate 24.4 × 18.4
Tate Gallery (DP 2068)

195 Untitled, probably made at the same time as the
above (not listed by Man)
Etching and aquatint, plate 29.5 × 23.5
Mrs Sue Simon

196 *Entrance to a Lane*, 1939
Oil on canvas on hardboard, 61.5 × 50.75
Tate Gallery (6190)

197 *Articulated Forms (Pink Background)*, published
by the Redfern Gallery, 1950
Autolithography (Man 47), 30 × 58.25
Mr and Mrs R. Simon

198 *La Petite Afrique*, published by the Redfern
Gallery, 1953
Signed and inscribed 'To my friend Oliver Simon
with admiration. 23.6.53'
Autolithography (Man 52), 57.5 × 44
Mrs Sue Simon

199 *Three Standing Forms in Black*, published by the
Redfern Gallery, 1953
Autolithography (Man 54), 47.2 × 36.5
Victoria and Albert Museum

John Piper b.1903

200 *Invention in Colour*, frontispiece to *Signature*,
No.6, July 1937
Letterpress, 25 × 19
Enid Marx
The Paramat blocks were cut by the artist

201 Drawing of Curwen Press used for the cover of
Curwen Press Newsletter, No.16, May 1939
Pen and ink wash, 23 × 29.5
The artist

202 *Cheltenham*, fold-out panorama from *Signature*,
No.13, January 1940
Autolithography, 25 × 19
Curwen Press Ltd

203 *Abstract*, published by Contemporary
Lithographs, 1938
Autolithography, 67.5 × 51
The artist

204 *Brighton Aquatints*, text and prints by the artist,
published by Duckworth, 1939
Etching and aquatint, 26 × 40
Curwen Press Ltd

205 Cover for *English, Scottish and Welsh Landscape*,
by J. Betjeman and G. Taylor, published by
Frederick Muller, 1944
Autolithography, 28.5 × 46
 a *Pistyll Cain, Weathercote Cave, Easegill*
 Each 18 × 12
 b *Trawsfynnydd, Approach to Gordale Scar,*
 Park Place
 Each 12 × 18
 c *Tomen-y-mur, Grongar Hill, At Lewknor,*
 Rievaulx Abbey, Talland Church and
 Stonefield
 Each 12 × 18
Tate Gallery, presented by Robert Simon

John Nash b.1893

206 Advertisement for Southern Rhodesia Tobacco,
reproduced in Curwen Publicity Book *How to Buy*
and Sell Money, 1929. Originally cut, 1928
Wood engraving, 46 × 31
Curwen Press Ltd

207 Leaflet for John Dickinson's Evensyde Printing
Paper, 1935
Wood engraving and letterpress, 28 × 24
Edward Bawden
The leaflet incorporates a wood engraving from
Poisonous Plants and a typographic border by Bawden.

208 Cover for *Curwen Press Newsletter*, No.14,
November 1937
Autolithography, 26 × 19
Curwen Press Ltd

209 Frontispiece made for *Signature*, No.12, July
1939, at the Baynard Press
Autolithography, 25 × 19
Curwen Press Ltd

210 *Poisonous Plants – Deadly, Dangerous and
Suspect*, published by Etchells and MacDonald,
1927
Wood engravings, 31×20
Curwen Press Ltd

211 *Men and the Fields*, by Adrian Bell, published by
B. T. Batsford Ltd, 1939
Letterpress and autolithography, 22×15
Curwen Press Ltd

212 *The Early Whistler*, by Wilfred Gibson,
published by Faber and Gwyer Ltd, 1927
(*Ariel* poem No.6)
Letterpress, colour line, 19×12.5
Curwen Press Ltd

213 *The Stour at Bures*, published by Contemporary
Lithographs, 1937
Autolithography, 48×58.5
Victoria and Albert Museum

John Farleigh 1900–65

214 *A Country Garden*, by Ethel Armitage,
published by Country Life, 1936
Wood engravings, 23×16.5
Curwen Press Ltd
a Proofs from the above
Wood engravings, 16.5×10 and 11×16
Courtesy of Mrs Farleigh
Printed from the artist's blocks for exhibition

215 *Old Fashioned Flowers*, by Sacheverell Sitwell,
published by Country Life, 1939
Autolithography, 25.5×20
Curwen Press Ltd

216 *Where Tides of Grass break into foam of
flowers . . .* and *Strong blossoms with perfume of
manhood . . .* published by London Passenger
Transport Board, 1937
Wood and linocut transferred to litho plate,
plus autolithography, 101×62.5 each
London Transport

217 Menu, Double Crown Club 32nd dinner, 1932
Letterpress with hand additions, 14×12.5
Mr and Mrs R. Simon

Edward Ardizzone b.1900

218 Booklet for Blumenthal Ltd, *Let's Have a Party*,
undated
Letterpress illustrations, 21×14
Curwen Press Ltd

219 Christmas Card for the Arts Council, 1948
Letterpress, 22×10
Cambridge University Library

220 Menu for the Double Crown Club 49th dinner,
1948
Letterpress, 19×13
Cambridge University Library

221 Book jacket for *The Newcomes*, by Thackeray,
published by the Limited Editions Club, 1954
Autolithography on cloth, 24.5×16
The artist

222 Menu for Overton's, *c.*1953 (still in production)
Autolithography, 31.7×40
Curwen Press Ltd

223 Menu for Hatchett's, *c.*1955 (still in production)
Autolithography, 31×39.7
Curwen Press Ltd

224 Original drawings for *Curwen Press Newsletter*,
No.15, May 1938
*The Bindery, The Van, Letterpress Machines,
The Foundry, Litho Poster Printing, Litho
Artists, The Office, Sales*
Pen and ink, each sheet of two illustrations
26×18
Mr and Mrs R. Simon

225 *Great Expectations*, by Charles Dickens,
published by The Heritage Club of New York,
1939
Autolithography, 51×63.5; proof sheet
Mr and Mrs R. Simon

226 *The Local*, by Maurice Gorham, published by
Cassell and Co. Ltd, London, 1939
Autolithographic illustrations, 23×15
The artist

227 *The Tale of Ali Baba and the Forty Thieves*,
translated by J. C. Madrus, published by the
Limited Editions Club, New York, 1949
Autolithographed endpapers and chapter
heading, 30.5×20
Curwen Press Ltd

228 Illustrations to *Visiting Dieppe*, by Lynton Lamb,
in *Signature*, No.13, 1951
Letterpress, 25×19
Curwen Press Ltd

229 *The Bus Stop*, published by Contemporary
Lithographs, 1938
Autolithography, 46×61
Mrs J. L. Benson

230 *The Fattest Woman in the World*, published by
Arthur Guinness Son & Co., 1956
Autolithography, 58×91.5
Mr and Mrs R. Simon

231 *The Inner Quad* and *The Porter's Lodge*,
commissioned by Trinity College, Oxford, *c*.1960
Lithography, each 38×56
Mr and Mrs R. Simon

Lynton Lamb b.1907

232 *Grand Union Canal*, published by Contemporary
Lithographs, 1938
Autolithography, 51×70
The artist

233 *Silas Marner*, by George Eliot, published by the
Limited Editions Club, 1953
Autolithography, book 26×17.5; proof sheet
38.4×26.1
The artist

234 *Two Heroines of Plumplington*, by A. Trollope,
published by Deutsch, 1953
Autolithography, book 22.2×14.5; proof sheet
38×29
The artist

235 *The Woman in White*, by Wilkie Collins,
published by The Folio Society, 1956
Autolithography, 23×15.2
The artist

Edward Wadsworth 1889–1949

236 *Sailing Ships and Barges of the Western
Mediterranean and Adriatic Seas*, published by
Etchells and MacDonald, 1926
Engraving, 31×20.5
Mark Glazebrook
a Proof engravings for the above: Title, 25.5×20;
Dechargement, 12×16.5; Spanish Goèlettes,
15.5×20.5; Coral Fishing Boat, 12×17;
Adriatic Trabaccoli, 15.5×20.5
Mark Glazebrook

237 *Untitled Port Scene*, published by Contemporary
Lithographs, 1938
Autolithography, 45.3×61
Victoria and Albert Museum

238 *Cubic Surface*, published by London Transport
Passenger Board, 1936
Lithography, 101×63.5
London Transport
a Original design for the above, 1936
Gouache, 62.5×62.5
London Transport

239 *Science Museum*, published by London Transport
Passenger Board, 1936
Lithography, 101×63.5
Tate Gallery (Archive)

Stanley Spencer 1891–1959

240 Almanack for Chatto and Windus, 1927
Letterpress, 16.5×13
Curwen Press Ltd and *Tate Gallery* (Archive
733.4.2 and 733.4.3)
Drawings for the above
a Half pages for January 1 and December 1
Pen and ink, 24.1×42.4 and 25.7×42.2
b Title pages, June and July
Pen and ink, 54.6×38.1 and 38×29.3
Richard Carline

Mildred Farrar

241 *The Mask of Comus*, by J. Milton and H. Lawes,
 published by The Nonesuch Press, 1937
 Letterpress (linocuts), 39.4×53.3
 Victoria and Albert Museum (Library)
 a Proof illustration from the above
 Letterpress (linocut), 35.5×28
 Curwen Press Ltd

Contemporary Lithographs

242 Frances Hodgkins
 Arrangement of Jugs, 1938
 Autolithography, 44.7×60.5
 Arts Council of Great Britain
 a Drawing for the above
 Pencil and watercolour, 48.5×64.2
 John Piper

243 John Aldridge
 The Water Mill, 1938
 Autolithography, 51×67
 The artist

244 Ivon Hitchens
 Flowers in a Majolica Jar, 1938
 Autolithography, 84.5×74.5
 The artist

245 Mary Potter
 The Thames at Chiswick, 1938
 Autolithography, 60.7×45
 Victoria and Albert Museum

Augustus John 1878–1961

246 Proofs for illustration of a book on the artist's
 drawings, published by George Rainbird Ltd,
 1957
 Autolithography (drawn on plate 1954), each
 50×63.5
 Mrs Sue Simon

Harold Cohen b.1928

247 Prints from *The Homecoming*, by Harold Pinter,
 published by H. Karnac, 1968
 Photolithography, 49.8×39.5
 Tate Gallery, presented by the artist

From **Fourteen Big Prints Portfolio**, published by
Bernard Jacobson

248 Joe Goode
 Clouds
 Offset lithography, 100×139.7
 Bernard Jacobson

249 John Walker
 For the Last of the Ogalala Sioux
 Offset lithography, 140×100
 Bernard Jacobson

250 Bob Graham
 Untitled
 Offset lithography, 67×140.3
 Bernard Jacobson

Unicorn Prints

251 Robert Scott
 Peruvian Night, 1966
 Lithography, 46×62
 Tate Gallery, presented by the Curwen Studio

252 Geoffrey Ireland
 Sagres, 1965
 Lithography, 45.7×61
 Tate Gallery, presented by the Curwen Studio

The Curwen Studio

Details of prints from the Curwen Studio Gift
are given in the listing on p.135

Robert Adams
253 *Untitled*, 1961
254 *Screen I*, 1962

Edward Ardizzone
255 *Life Class*, 1960
256 *Boating Pond*, 1961

Michael Ayrton
257 *Greek Landscape II*, 1960–61
 a Study for the above
 Gouache, 24×32
 Tate Gallery (T.2104)

Edward Bawden
258 *Borough Market*, from 'Six London Markets',
 1967
259 *Leadenhall Market*, from 'Six London Markets',
 1967
260 *Smithfield Market*, from 'Six London Markets',
 1967

Richard Beer
261 *Ca Rezzonico*, 1971

Trevor Bell
262 *Five Stages*, 1961

Elizabeth Blackadder
263 *Dark Hill, Fifeshire*, 1960

Arthur Boyd
264 *St Francis Taking the Rosary*, 1970

Reg Butler
265 *Figure in Space*, from 'Europaeische Graphik I',
 1962–63
266 *Italian Girl*, from 'Europaeische Graphik I',
 1963

Lynn Chadwick
267 *Moon in Alabama*, from 'Europaeische Graphik I',
 1963
268 *Moon in Alabama* (colour variant), 1963

Prunella Clough
269 *Electrical Area*, 1961

Harold Cohen
270 *Close-Up V*, 1966
271 *Close-Up VI*, 1966

Robert Colquhoun
272 *Mysterious Figures*, 1960
273 *Two Horsemen*, 1960

Alan Davie
274 *Celtic Dreamboat I*, 1965
275 *Celtic Dreamboat II*, 1965
276 *Italian Image*, 1968

Mary Fedden
277 *Basket of Lemons*, 1971
278 *Etching Table*, 1972

Elisabeth Frink
279 *Spinning Man V*, 1965
280 *Spinning Man VIII*, 1965
281 *Horse and Rider III*, 1970–71

Terry Frost
282 *Red and Black Linear*, 1967–68
283 *Lace I*, 1968
 Autolithography, 76×58
 Presented by Waddington Galleries through
 I.C.P.

David Gentleman
284 *Kelmscott House, Chiswick*, from 'Ten
 Topographical Lithographs', 1970
285 *Warehouses Between Shelton St and Earlham St*,
 from 'Covent Garden Suite', 1972

Duncan Grant
286 *Interior*, from 'Penwith Portfolio', 1973

Derrick Greaves
287 *Vase and Falling Petal*, from 'Europaeische Graphik VII', 1971
288 *White Vase*, 1972

Barbara Hepworth
289 *Porthmeor*, 1969
290 *Sun Setting*, from 'Aegean Suite', 1970–71
291 *Sun and Marble*, from 'Aegean Suite', 1970–71

Josef Herman
292 *Mother and Child*, 1961–62
293 *Figure Against Dark Sky*, 1965
294 *Study for a print*
Gouache, 56.2×76.5
Tate Gallery (2097)

Patrick Heron
295 *Black and Blue Stripes*, 1958
296 *Grey and Black Stripes*, 1958

David Hockney
297 *The Print Collector*, from 'Europaeische Graphik VII', 1970–71
298 *Lilies*, from 'Europaeische Graphik VII', 1971

Bill Jacklin
299 *First Light*, 1974–75
300 *Sky Light*, 1975

Allen Jones
301 *Untitled*, 1964
302 *Left Hand Lady*, 1970
303 *Leg-Splash*, from 'Europaeische Graphik VII', 1970–71

Stanley Jones
304 *Essex Landscape*, 1962
305 *Madron*, from 'Europaeische Graphik VIII', 1970–71

David Kindersley
306 *Letters are Things*, 1971

Robert MacBryde
307 *Head*, 1960
308 *Still Life I*, 1960

Samuel Maitin
309 *For Ollie*, from 'Set of Ten Lithographs', 1968

Henry Moore
310 *Five Reclining Figures*, 1963
311 *Two Seated Figures in Stone*, from 'Europaeische Graphik I', 1963
312 *Hands I*, 1973
Lithography, 65.9×50.5; 21.1×24.8
Presented by the artist
a Drawing (for transfer) for the above
Henry Moore
b Plate for the above
Curwen Studio
313 *Hands II*, 1973
Lithography, 65.5×50; 23.7×20.3
Presented by the artist

Victor Pasmore
314 *Points of Contact No.3*, 1965

John Piper
315 *Beach in Brittany*, 1961–62
316 *San Marco, Venice*, 1961–62
317 *Malmesbury, Wiltshire: the South Porch*, No.8 from 'A Retrospect of Churches', 1964
318 *Llangloffan, Pembrokeshire, the Baptist Chapel*, No.19 from 'A Retrospect of Churches', 1964
319 *Christ Church, Spitalfields, London: by Nicholas Hawksmoor*, No.21 from 'A Retrospect of Churches', 1964
320 *Bethesda Chapel*, 1966–67

Man Ray
321 *Untitled III*, 1969
Autolithography with screenprinting

Ceri Richards
322 *Cathédrale Engloutie II*, from 'Hammerklavier Suite', 1959
323 *Le Poisson d'Or*, from 'Hammerklavier Suite', 1959
324 *Trafalgar Square*, 1961–62
325 *The force that through the green fuse drives the flower* (trial proof), No.2 from 'Twelve Lithographs for Six Poems by Dylan Thomas', 1965
326 *Blossom* (trial proof), No.4 from 'Twelve Lithographs for Six Poems by Dylan Thomas', 1965
327 *The force that drives the waters through the rocks*, No.5 from 'Twelve Lithographs for Six Poems by Dylan Thomas', 1965

328 *The Flowering Skull*, No.9 from 'Twelve
Lithographs for Six Poems by Dylan Thomas',
1965
 a Stone for the above
 Tate Gallery (Archives)

William Scott
329 *Arran*, 1960
330 *Benbecula*, 1961–62
331 *Barra*, 1962
332 *Scalpay*, 1963

Shmuel Shapiro
333 *Woman Shielding her Child*, No.1 from 'Tor des
Todes', 1966–67
334 *Brother and Sister*, No.2 from 'Tor des Todes',
1966–67

Norman Stevens
335 *Winter*, from 'Lower Wessex Lane', 1976

Graham Sutherland
336 *Portrait of Helena Rubinstein III*, 1960
Lithography, 13.5×25.7
Curwen Studio
 a Stone for the above
 Curwen Studio
337 *Portrait of Aloys Senefelder*, from 'Europaeische
Graphik VIII', 1971

Philip Sutton
338 *Samoa*, 1966
339 *San Francisco*, 1966

Ossip Zadkine
340 *Figure with Guitar*, 1964

Lenders

John Aldridge 243
Peggy Angus 182
Edward Ardizzone 221, 226
Arts Council of Great Britain 68, 199, 242
Visitors of the Ashmolean Museum 69
Edward Bawden 75, 79, 85, 87, 90–94, 96, 102–104,
 112, 113, 116, 118, 123, 207
Mrs J. L. Benson 229
Bodleian Library, John Johnson Collection 5a, 5b,
 5d, 18b, 18c, 55c, 74
Cambridge University Library 1, 3a, 3c, 3d, 9b, 9c,
 24, 25, 28, 39–41, 43b, 43d, 55a, 56, 86, 110, 117,
 125, 126, 129–131, 140a, 141, 167b, 167c, 170,
 183, 185, 186, 190, 219, 220
Curwen Press Ltd 5c, 7, 8, 10, 11, 14, 15, 23, 29,
 30, 33–35, 37, 42, 45–50, 52–54, 55b, 57–62, 63a,
 66, 67, 76, 81, 84, 88, 89, 105, 109, 111, 112, 114,
 115, 127, 128, 133, 143, 145–148, 152, 155f, 156c,
 157–160, 163, 165, 167d, 167e, 168, 169, 171, 175,
 176, 180, 184, 187, 188, 192, 200, 202, 204, 206,
 208–212, 214, 215, 218, 222, 223, 227, 228, 240,
 241a
Curwen Studio 312b
Richard Carline 240a, 240b
John Dreyfus 3a, 3b
Faber and Faber 151
Mrs E. Farleigh 214a
Dr Desmond Flower 64–64b, 64e, 153–153b,
 156, 156a
Mrs Margaret Flower 156b
S. A. Garrad 155a, 162
Mark Glazebrook 236
Basil Harley 164
Ivon Hitchens 244

Mr and Mrs J. R. Huntington 144
Trustees of the Imperial War Museum 106–108
Bernard Jacobson 248–250
Lynton Lamb 232–235
London Transport 97–99, 101, 137, 138, 189,
 216, 238
Grace Lovat Fraser 16, 19, 20, 21, 22, 31, 32
Enid Marx 200
Charles Mayo 13
Dame Alix Meynell 155d, 155e
National Maritime Museum 179b
Henry Moore 312a
John Piper 201, 203, 242a
Myfanwy Piper 65
Potter Books Ltd 120–122, 124
Private collections 131, 132, 139a, 140, 141
The Ravilious Family 166, 171, 173, 174, 178,
 179a, 182a
Helen Rendall 155c
Simon Rendall 155b
Albert Rutherston's Grandchildren and
 Executors 43a, 43c, 44, 45a, 49a–49f, 51
Mrs Sue Simon 2, 64d, 70–72, 119, 136, 177, 191,
 195, 198, 246
Oliver S. Simon 193
Mr and Mrs R. Simon 4, 6, 9a, 15, 18a, 27, 36a, 37,
 64c, 77, 116, 153a, 154, 161, 172, 197, 206, 217,
 224, 225, 230, 231
Tate Gallery 38, 69a, 73, 78, 80, 82, 83, 100, 135,
 139, 142, 144a, 167a, 181, 194, 196, 205, 239, 240,
 247, 251, 252, 257a, 294, 328a
Victoria and Albert Museum 12, 17, 21a, 21b, 26,
 38a, 95, 155, 213, 237, 241, 245
Dr and Mrs B. L. Wolpe 134, 149, 150

The Curwen Studio Gift

Information is given in the following order:
artist; title; date; dimensions in centimetres, sheet size followed
by image size; publisher; accession number.

Robert Adams b.1917

Untitled, 1961
80.3×57.6; 68.6×53.8
Proofed only
DP.6001 (Cat.253)

Screen I, 1962
81.4×57.8; 57×32.5
Curwen Prints
DP.6002 (Cat.254)

Screen III, 1962
80.6×57.5; 67.6×47.2
Proofed only
DP.6004

Screen II, 1962–63
80.1×57.9; 63×50.4
Curwen Prints
DP.6003

Screen Forms, 1973
(from The Penwith Portfolio)
77.5×57.8; 56.2×29.2
Penwith Galleries
DP.6005

Axel Amuchástegui b.1921

Ocelot Head, 1968
51.7×40.5
George Rainbird for the
Tryon Gallery
DP.6006

Leonard Appelbee b.1914

Carp, 1970–71
59×78.6; 44.9×59.2
The artist
DP.6007

Red Bream, 1971
59×78.6; 45.1×60.5
The artist
DP.6008

Edward Ardizzone b.1900

The Last Stand of the Spoons, 1959
53.7×76.2; 35.5×53
Proofed only
DP.6009

Life Class, 1960
50.1×63; 25×35.8
The artist
DP.6010 (Cat.255)

Lovers by the Sea, 1960
40×58; 21×35.2
The artist
DP.6011

Boating Pond, 1961
50.8×76.2; 34×48.3
Curwen for British Transport
Hotels
DP.6012 (Cat.256)

Boys Playing, 1961
40×57.8; 24.5×35.2
The artist
DP.6013

Kenneth Armitage b.1916

Seated Group, 1960
40.9×58.3
The artist/Marlborough Graphics
DP.6014

Balanced Figure, 1960–61
58×40.8
The artist/Marlborough Graphics
DP.6015

Michael Ayrton 1921–75

Greek Landscape I, 1960–61
60.3×82.5; 40.6×56
St George's Gallery
DP.6016

Greek Landscape II, 1960–61
58×80.8; 43.5×59
St George's Gallery
DP.6017 (Cat.257)

Greek Landscape III, 1960–61
60×82.5; 38×56.7
St George's Gallery
DP.6018

Edward Bawden b.1903

Billingsgate Market, 1967
(from Six London Markets)
58.7×77.2; 46.3×61.3
Curwen Prints
DP.6019

Borough Market, 1967
(from Six London Markets)
59.3×77.8; 46×61.2
Curwen Prints
DP.6020 (Cat.258)

Covent Garden Flower Market,
1967 (from Six London Markets)
58.8×79.2; 46.4×61.1
Curwen Prints
DP.6021

Covent Garden Fruit Market, 1967
(from Six London Markets)
58.6×77.2; 46×61.2
Curwen Prints
DP.6022

Leadenhall Market, 1967
(from Six London Markets)
58.9×77.4; 46.2×61.6
Curwen Prints
DP.6023 (Cat.259)

Smithfield Market, 1967
(from Six London Markets)
59.1×77.7; 46.2×61.8
Curwen Prints
DP.6024 (Cat.260)

Richard Bawden b.1936

Telford's Bridge, Conway, 1965
71.5×53.8; 59.8×45.8
Curwen Prints (Unicorn)
DP.6721

Sezincote, 1971
(from Follies)
57.5×77.7; 47.3×61.2
Curwen Prints
DP.6025

Richard Beer b.1928

Nash Terrace, 1970
78×59; 58×45
John Smith
DP.2026

Ca Rezzonico, 1971
80×49; 76.9×42
Curwen Prints
DP.6027 (Cat.261)

Conolly's Obelisk, 1971
(from Follies)
77.6×57.4; 65×46.4
Curwen Prints
DP.6028

Rushton Triangular Lodge, 1971
(from Follies)
77.5×57.4; 66.4×43.4
Curwen Prints
DP.6029

Greenlands, 1972
77.5×57.5; 61.3×46.5
Administrative Staff College
DP.6030

Guy Beggs b.1947

In the Shade, 1973
57.3×77.7; 23.1×23
Christopher Phillips
DP.6031

Trevor Bell b.1930

Five Stages, 1961
81×57.6
Robert Erskine
DP.6032 (Cat.262)

Elizabeth Blackadder b.1931

Dark Hill, Fifeshire, 1960
58×80.5; 48×66.7
Museum of Modern Art, New York
DP.6037 (Cat.263)

Fifeshire Farm, 1960
57.4×80.7; 47.6×67.7
St George's Gallery
DP.6034

Italian Landscape, 1960
57.1×80.3; 47.9×66.5
Proofed only
DP.6033

Roman Wall I, 1960
57.5×80.8; 53.7×71.2
St George's Gallery
DP.6036

Roman Wall II – Walltown, 1960
57.8×80.6; 49×72
St George's Gallery
DP.6038

Staithes, 1962
57.3×80.6; 52.1×78.7
G.P.O.
DP.6035

Régis Bouvier de Cachard b.1929

Solitude, 1972
77.5×57.3
Avanti Fine Arts
DP.6039

Epitase, 1972–73
57.5×77.7; 48.6×61.4
Avanti Fine Arts
DP.6040

Epitase III, 1972–73
57.3×77.6; 48.5×61.4
Avanti Fine Arts
DP.6041

Tower of London, 1972–73
57.5×77.7; 48.7×65.4
Avanti Fine Arts
DP.6042

Arthur Boyd b.1920

Bullfrog Head, 1970
51×63.5; 42.5×53.3
Maltzahn
DP.6044

Butterfly Man (Maroon), 1970
59×78.2
Maltzahn
DP.6047

Butterfly Man (Red), 1970
59.5×78.2
Maltzahn
DP.6048

Hammock Lovers, 1970
50.8×63.6
Maltzahn
DP.6043

Romeo and Juliet, 1970
52×65.8; 40.6×50.1
Maltzahn
DP.6045

St Francis Preaching Naked, 1970
59.1×78.2; 48.8×61.1
Maltzahn
DP.6046

St Francis Taking the Rosary, 1970
59.2×78.4; 48.8×61.3
Maltzahn
DP.6049 (Cat.264)

Nebuchadnezzar, 1972–74
57.4×77.7; 44.8×53.7
Maltzahn
DP.6050

Martin Bradley b.1931

Untitled, 1961
80.3×57.1; 68.5×54.5
St George's Gallery
DP.6051

Untitled, 1961
81.3×58.2; 55.5×53.8
St George's Gallery
DP.6052

Bernard Brett b.1925

The Royal Pavilion, Brighton, 1974
58.5×78.2; 49.3×70.5
David James Publications
DP.6053

The Palace Pier, Brighton, 1974
57.9×79; 50×70.2
David James Publications
DP.6054

Peter Brook b.1927

Snowline, 1973
78.9×58.7; 71.3×50.1
Christie's Contemporary Art
DP.6055

Pennine Way, 1974
57×79; 50.5×76.2
Christie's Contemporary Art
DP.6056

Frosty, 1975
57×77.5; 50.7×71
Christie's Contemporary Art
DP.6631

January, 1976–77
59.6×76.5; 51.1×71.2
Agnew's
DP.6632

February, 1976–77
57.3×77.5
Agnew's
DP.6633

March, 1976–77
57×77.5; 50.8×71
Agnew's
DP.6722

Romey Brough b.1944

Sunflowers, 1972
58.9×79.1; 44.9×69.8
Robert's Frames Ltd
DP.6723

Robert Burkert b.1930

English Garden, 1968
58.9×79; 45.8×67.8
The artist
DP.6059

Moonlit Tree, 1968
78.8×58.6; 69.8×53.5
The artist
DP.6058

Spanish Landscape, 1968
59.2×79.4; 47.9×69.2
The artist
DP.6057

Pollard Tree, 1968
64.9×51.5; 51×44.3
The artist
DP.6060

Three Trees, c.1968
59.6×82.2; 50.6×71.3
Proofed only
DP.6701

Reg Butler b.1913

Figure in Space, 1962–63
(from Europaeische Graphik I)
65.7×50.5; 60.7×45.7
Galerie W. Ketterer, Munich
DP.6061 (Cat.265)

Italian Girl, 1963
(from Europaeische Graphik I)
50.2×66; 34.3×49.3
Galerie W. Ketterer, Munich
DP.6062 (Cat.266)

Circus, 1968–69
53.7×75.8
Galerie W. Ketterer, Munich
DP.6063

Tower, 1968–69
75.7×54; 65×47.2
Galerie W. Ketterer, Munich
DP.6064

Lynn Chadwick b.1914

Untitled, 1962–63
65.8×50.2
Proofed only
DP.6065

Moon in Alabama, 1963
(from Europaeische Graphik I)
65.8×50.6
Galerie W. Ketterer, Munich
DP.6066 (Cat.267)

Moon in Alabama (colour variant),
1963
65.7×50.6
Proofed only
DP.6703 (Cat.268)

Moon in Alabama (colour variant),
1963
65.6×50.4
Proofed only
DP.6704

Figure I, 1966
82.2×59.4
Gerald Cramer, Geneva
DP.6067

Figure I (trial proof), 1966
82×59.4
Proofed only
DP.6702

Figure II, 1966
82×59.8
Gerald Cramer, Geneva
DP.6068

Figure III, 1966
81.4×59.7
Gerald Cramer, Geneva
DP.6069

Figure IV, 1966
82.1×60.1
Gerald Cramer, Geneva
DP.6070

Two Winged Figures, 1968–71
50.8×41.6
Gerald Cramer, Geneva
DP.6071

Seated Figure, 1969
59.2×81.7
International Graphic Arts Society,
New York
DP.6072

Bernard Cheese b.1925

A Fisherman's Story, 1956
(from Guinness Lithographs)
54.3×79.4; 48.3×73.4
Guinness
DP.6705

Margery Clinton

Charlotte Square, Edinburgh, 1961
57.5×80.2; 51×76.3
G.P.O.
DP.6073

Prunella Clough b.1919

Electrical Area, 1961
63.4×50.8; 48.4×44.6
Proofed only
DP.6074 (Cat.269)

Tideline, 1961–62
80.6×57.3; 53×45.7
Curwen Prints
DP.6075

Wall and Scrap, 1961–62
81×57.6; 50.2×46.2
Curwen Prints
DP.6076

Harold Cohen b.1928

Close-Up I, 1966
84.3×84.3
Curwen Prints
DP.6077

Close-Up II, 1966
84.4×84.4
Curwen Prints
DP.6078

Close-Up III, 1966
59.5×59.7
Curwen Prints
DP.6079

Close-Up IV, 1966
59.7×59.5
Curwen Prints
DP.6080

Close-Up V, 1966
59.5×59.4
Curwen Prints
DP.6082 (Cat.270)

Close-Up VI, 1966
84.2×84.3
Curwen Prints
DP.6081 (Cat.271)

Warrington Colescott b.1921

Chicago Indians, 1968
59.5×78.8
London Graphic Arts
DP.6083

No. 1, 1968
78.6×59
London Graphic Arts
DP.6084

No. 2, 1968
64.7×51
London Graphic Arts
DP.6085

No. 3, 1968
78.7×58.9; 60.4×44.6
London Graphic Arts
DP.6086

No. 5, 1968
59×79.3
London Graphic Arts
DP.6087

No. 6, 1968
79.1×58.8
London Graphic Arts
DP.6088

Robert Colquhoun 1914–62

Mysterious Figures, 1960
56.8×80.1; 40.5×53.9
St George's Gallery
DP.6089 (Cat.272)

Two Horsemen, 1960
56.8×80.4; 38.8×25.4 (each)
St George's Gallery
DP.6090 (Cat.273)

Woman, 1960
67.6×47.1
St George's Gallery
DP.6091

Don Cordery b.1942

Spectacled Owl, 1973
61.1×45.4
Christie's Wildlife and Sporting
Prints
DP.6092

Two Owls, 1974–75
50.8×63.4
Christie's Contemporary Art
DP.6093

Susan Crawford b.1941

Horse and Rider, 1973
57.7×77.9
Christie's Wildlife and Sporting
Prints
DP.6094

Peter Daglish b.1930

Area/Aria, 1969
50.8×66.3
La Guilde Graphique, Montreal
DP.6095

To Paris, 1969
50.5×65.9
La Guilde Graphique, Montreal
DP.6096

Allen David b.1926

The Sun and the Heralds, 1967
79.4×56.7; 61×45.7
The artist
DP.6097

Blue Fountain II, 1970
80.2×59; 61.3×46.7
The artist
DP.6098

Green Exploding Sun, 1970
57.5×66.2; 48.1×48.6
The artist
DP.6099

Red Fountain II, 1970
82.5×60; 61.1×46.5
The artist
DP.6100

Alan Davie b.1920

Sleep My Angel, 1961–62
57.9×81.3
Curwen Prints
DP.6101

Bird Noises, 1963
57.8×80.5
Curwen Prints
DP.6102

Celtic Dreamboat I, 1965
57.7×80.7; 51.4×76.7
Curwen Prints
DP.6103 (Cat.274)

Celtic Dreamboat II, 1965
57.3×80.7; 51.2×77
Curwen Prints
DP.6104 (Cat.275)

Celtic Dreamboat III, 1965
57.6×80.5; 51.3×76.8
Curwen Prints
DP.6105

For the Hens, 1968
57.7×80.7; 51.5×77
Proofed only
DP.6706

For the Hens (trial proof), 1968
81×57.8; 77×51.5
Proofed only
DP.6106

Italian Image, 1968
50.4×65.5; 33.3×61.3
Gimpel Fils
DP.6107 (Cat.276)

Bird Through Wall, 1973
(from The Penwith Portfolio)
56.2×77.6; 50.1×70.8
Penwith Galleries
DP.6108

Henry Dinith

Still Life, 1970
77.7×58.6; 70.2×51.3
The artist
DP.6109

Hans Dorflinger b.1941

*Study for the Wheel of Fortune
in Tarot*, 1972
50.5×65; 33.8×45.8
The artist
DP.6724

John Doyle b.1928

Canterbury Cathedral, 1974
57.5×77.6; 42.1×65.5
The artist
DP.6110

Bernard Dunstan b.1920

Room in Viterbo, 1974
77.5×57.4; 31.2×29.8
Christie's Contemporary Art
DP.6111

Geoffrey Elliott

Brighton Fish Market, 1968
59×78.8; 44.8×59.1
The artist
DP.6112

John Elwyn b.1916

Caernarvon Castle, 1969
58.5×78.8; 46.1×61.3
Proofed only
DP.6113

Harlech Castle, 1969
58.6×78.8; 46×61
Proofed only
DP.6114

Roman Erté-de Tirtoff b.1892

Zero, 1968
(from Numerals)
67×52
Grosvenor Gallery
DP.6115

Number One, 1968
(from Numerals)
67.1×51.9
Grosvenor Gallery
DP.6116

Number Two, 1968
(from Numerals)
65.1×50.3
Grosvenor Gallery
DP.6117

Number Three, 1968
(from Numerals)
65×50.2
Grosvenor Gallery
DP.6118

Number Five, 1968
(from Numerals)
64.9×50.1
Grosvenor Gallery
DP.6119

Number Six, 1968
(from Numerals)
64.9×50.2
Grosvenor Gallery
DP.6120

Number Seven, 1968
(from Numerals)
64.8×50.2
Grosvenor Gallery
DP.6121

Number Eight, 1968
(from Numerals)
64.8×50.2
Grosvenor Gallery
DP.6122

Number Nine, 1968
(from Numerals)
64.9×50.3
Grosvenor Gallery
DP.6123

Amethyst, 1969
(from Precious Stones)
64.8×49.9
Grosvenor Gallery
DP.6124

Diamond, 1969
(from Precious Stones)
64.8×50
Grosvenor Gallery
DP.6125

Emerald, 1969
(from Precious Stones)
64.5×49.9
Grosvenor Gallery
DP.6126

Ruby, 1969
(from Precious Stones)
64.8×49.8
Grosvenor Gallery
DP.6127

Sapphire, 1969
(from Precious Stones)
64.8×49.6
Grosvenor Gallery
DP.6128

Topaz, 1969
(from Precious Stones)
64.8×50
Grosvenor Gallery
DP.6129

Merlyn Evans 1910–72

St Ives Beach, 1973
(from The Penwith Portfolio)
58.8×79.6; 50.9×72.5
Penwith Galleries
DP.6130

Mary Fedden b.1915

Basket of Lemons, 1971
77.5×57.5; 75×54.9
Waddington Galleries
DP.6131 (Cat.277)

Pot of Shells, 1971
57.3×77.6; 54.7×75.2
Waddington Galleries
DP.6132

Shells and Pebbles, 1971
57.3×77.6; 54.6×75
Waddington Galleries
DP.6133

Straw Plate, 1971
77.5×57.4; 74.9×54.9
Waddington Galleries
DP.6134

Etching Table, 1972
57.6×77.6; 41.2×56.7
Waddington Galleries
DP.6135 (Cat.278)

Figs, 1972
57.5×77.5; 41×57
Waddington Galleries
DP.6136

Fritillaries, 1972
77.6×57.5
Waddington Galleries
DP.6137

Ivy, 1972
77.6×57.5; 56.9×41
Waddington Galleries
DP.6138

The Lamp, 1972
77.5×57.2; 56.3×41.1
Christie's Contemporary Art
DP.6139

Lois Fine b.1931

Sphinx, 1972
57.5×77.5; 48.2×69.3
The artist
DP.6140

John Finnie

Silver Arcade, 1956
78.8×56.7; 59×48.7
Proofed only
DP.6141

Barnett Freedman 1901–58

The Darts Champion, 1956
(from Guinness Lithographs)
54.5×79.5; 48.3×73.4
Guinness
DP.6707 (Cat.135)

Elisabeth Frink b.1930

Spinning Man I, 1965
57.5×81
Curwen Prints
DP.6142

Spinning Man II, 1965
57.2×80
Curwen Prints
DP.6143

Spinning Man III, 1965
81.2×57.8
Curwen Prints
DP.6144

Spinning Man IV, 1965
80.1×57.2
Curwen Prints
DP.6145

Spinning Man V, 1965
79.5×57.1
Curwen Prints
DP.6146 (Cat.279)

Spinning Man VI, 1965
80.3×57
Curwen Prints
DP.6147

Spinning Man VII, 1965
57.6×81.3
Curwen Prints
DP.6148

Spinning Man VIII, 1965
57.1×80.3
Curwen Prints
DP.6149 (Cat.280)

Guillemot, 1967
58.3×78.6; 53×73.5
Waddington Galleries
DP.6150

Bull, 1967
(from Images 67)
77.8×59.9
Waddington/McAlpine
DP.6151

Ducks, 1967
(from Images 67)
59.2×77.9
Waddington/McAlpine
DP.6152

Cormorant, 1967
(from Images 67)
60.4×77.8; 51×73.8
Waddington/McAlpine
DP.6153

Hare, 1967
(from Images 67)
59.1×78
Waddington/McAlpine
DP.6154

Horse, 1967
(from Images 67)
77.8×59.4
Waddington/McAlpine
DP.6155

Lioness, 1967
(from Images 67)
77.8×59.4
Waddington/McAlpine
DP.6156

Owl, 1967
(from Images 67)
78×59.4
Waddington/McAlpine
DP.6157

Wild Boar, 1967
(from Images 67)
78×59.4
Waddington/McAlpine
DP.6158

Wild Goat, 1967
(from Images 67)
78.1×59.6
Waddington/McAlpine
DP.6159

Woodpigeons, 1967
(from Images 67)
58.5×78.5
Waddington/McAlpine
DP.6160

4 untitled images, 1968
(from Aesop's Fables)
53.5×75.6
Waddington/McAlpine
DP.6161

Badger, 1970
(from Wild Animals)
52×66
Waddington Galleries
DP.6162

Bear, 1970
(from Wild Animals)
51.8×65.8
Waddington Galleries
DP.6163

Boar, 1970
(from Wild Animals)
52.4×65.4
Waddington Galleries
DP.6164

Hare, 1970
(from Wild Animals)
51.1×64.6
Waddington Galleries
DP.6165

Horse and Rider, 1970
58.9×78
Observer Art
DP.6170

Lynx, 1970
(from Wild Animals)
51.8×66
Waddington Galleries
DP.6166

Mouflon, 1970
(from Wild Animals)
52×65.5
Waddington Galleries
DP.6167

Wild Cat, 1970
(from Wild Animals)
51.9×66
Waddington Galleries
DP.6168

Wolf, 1970
(from Wild Animals)
51.6×65.8
Waddington Galleries
DP.6169

Horse and Rider, 1970–71
59.2×78.5
Waddington Galleries
DP.6181

Horse and Rider I, 1970–71
58.5×77.8
Waddington Galleries
DP.6176

Horse and Rider II, 1970–71
58.6×77.8
Waddington Galleries
DP.6177

Horse and Rider III, 1970–71
58.5×78
Waddington Galleries
DP.6178 (Cat.281)

Horse and Rider IV, 1970–71
58.5×78
Waddington Galleries
DP.6179

Horse and Rider V, 1970–71
58×78
Waddington Galleries
DP.6180

Man and Horse I, 1971
60.2×79.8
Waddington Galleries
DP.6171

Man and Horse II, 1971
59.5×79.7
Waddington Galleries
DP.6172

Man and Horse III, 1971
59.6×79.8
Waddington Galleries
DP.6173

Man and Horse V, 1971
59.5×80
Waddington Galleries
DP.6174

Man and Horse VI, 1971
59.1×79.6
Waddington Galleries
DP.6175

Eagle Owl, 1972–73
77.6×57
Christie's Contemporary Art
DP.6725

Resting Horse, 1972–73
57.5×77.5
Christie's Contemporary Art
DP.6726

The Three Riders, 1972–74
57.5×77.6
Proof Arts, DP.6182

Corrida One, 1973
57.1×77.5
Waddington Galleries
DP.6183

Corrida Two, 1973
57.6×77.5
Waddington Galleries
DP.6184

Corrida Three, 1973
57.4×77.5
Waddington Galleries
DP.6185

Corrida Four, 1973
57.4×77.5
Waddington Galleries
DP.6186

Corrida Five, 1973
57.6×77.5
Waddington Galleries
DP.6187

Rejoneadora One, 1973
57.1×77.5
Waddington Galleries
DP.6188

Rejoneadora Two, 1973
57.1×77.5
Waddington Galleries
DP.6189

Rejoneadora Three, 1973
57.3×77.5
Waddington Galleries
DP.6190

A, 1973–74
(from The Odyssey)
57.2×38.9; 25.4×16.5
Waddington Galleries
DP.6191

B, 1973–74
(from The Odyssey)
57×38.9; 25.1×16.2
Waddington Galleries
DP.6192

C, 1973–74
(from The Odyssey)
57×38.8; 25.2×16.4
Waddington Galleries
DP.6193

D, 1973–74
(from The Odyssey)
57.2×38.8; 25.4×16.6
Waddington Galleries
DP.6194

E, 1973–74
(from The Odyssey)
57.1×39; 25.6×16.3
Waddington Galleries
DP.6195

F, 1973–74
(from The Odyssey)
56.8×38.8; 25.2×16.1
Waddington Galleries
DP.6196

G, 1973–74
(from The Odyssey)
57.1×38.8; 25.2×16
Waddington Galleries
DP.6197

H, 1973–74
(from The Odyssey)
57.1×38.7; 21.1×16.4
Waddington Galleries
DP.6198

I, 1973–74
(from The Odyssey)
57.1×38.8; 19.8×16
Waddington Galleries
DP.6199

J, 1973–74
(from The Odyssey)
57.5×38.7; 25.4×15.9
Waddington Galleries
DP.6200

K, 1973–74
(from The Odyssey)
57.1×38.9; 25.6×15.6
Waddington Galleries
DP.6201

L, 1973–74
(from The Odyssey)
57×38.8; 25×16.6
Waddington Galleries
DP.6202

Cormorant, 1974
65.4×50.1
Christie's Contemporary Art
DP.6203

Gull, 1974
65.3×47.6; 61×47.6
Christie's Contemporary Art
DP.6204

Horse and Jockey, 1974
48.5×54.4
De Beers
DP.6205

Osprey, 1974
65.4×47.6; 61×47.6
Christie's Contemporary Art
DP.6206

Shearwater, 1974
65.4×47.7; 61×47.7
Christie's Contemporary Art
DP.6207

Terry Frost b.1915

Red and Black Linear, 1967–68
79×58.3; 60.7×44.1
Waddington Galleries
DP.6208 (Cat.282)

Red and Black Solid, 1967–68
78.6×58; 62.2×43.5
Waddington Galleries
DP.6209

Lace I (trial proof), 1968
76.3×60.2
Waddington Galleries
DP.6210

Peter Gauld b.1925

Farningham, 1972–74
57.4×77.5; 49.5×56
Curwen Prints
DP.6211

Scotney Castle, 1973–74
57.4×77.5; 51×54.4
Curwen Prints
DP.6212

Union Mill, Cranbrook, 1973–74
77.5×57.2; 57.5×53
Curwen Prints
DP.6213

The Pantiles, Tunbridge Wells,
1974
57.2×77.5; 47.9×53.7
Curwen Prints
DP.6214

Dennis Geden

1. Star Juggler, 1976
(from Crow Messenger Portfolio)
77.4×57.1; 66.3×47.1
The artist
DP.6634

2. Still Life and
4. Quiet Horse, 1976
(from Crow Messenger Portfolio)
57.1×77.5; 47.1×31.2 (each)
The artist
DP.6728

3. Crow Messenger, 1976
(from Crow Messenger Portfolio)
57.2×77.5; 47.1×66.1
The artist
DP.6727

5. Thumb Twiddler, 1976
(from Crow Messenger Portfolio)
77.4×57; 66.1×47.2
The artist
DP.6635

David Gentleman b.1930

Alnwick Castle, 1970
(from Ten Topographical
Lithographs)
64.5×52
Curwen Prints
DP.6215

Abbeygate, Bury St Edmunds, 1970
(from Ten Topographical
Lithographs)
64.6×51.8
Curwen Prints
DP.6216

Hardwick Hall, 1970
(from Ten Topographical
Lithographs)
51.3×65.4
Curwen Prints
DP.6217

Heveningham Hall, 1970
(from Ten Topographical
Lithographs)
51.9×65.7
Curwen Prints
DP.6218

Kelmscott House, Chiswick, 1970
(from Ten Topographical
Lithographs)
64.3×52.8
Curwen Prints
DP.6219 (Cat.284)

Little Moreton Hall, 1970
(from Ten Topographical
Lithographs)
51×65
Curwen Prints
DP.6220

The Maltings, Snape, 1970
(from Ten Topographical
Lithographs)
64.3×51.8
Curwen Prints
DP.6221

Orford Castle, Suffolk, 1970
(from Ten Topographical
Lithographs)
65.4×51.8
Curwen Prints
DP.6222

Seaton Delaval, 1970
(from Ten Topographical
Lithographs)
51.8×64.8
Curwen Prints
DP.6223

The Gatehouse, Stanway, 1970
(from Ten Topographical
Lithographs)
53.3×64.4
Curwen Prints
DP.6224

St James', Goose Creek, 1971–72
(from The Charleston Suite)
49.9×61.3; 40×53.4
Curwen Prints
DP.6225

Hampton Plantation House, 1971–72
(from The Charleston Suite)
49.7×61.2; 39×53.2
Curwen Prints
DP.6226

Charleston Market, 1971–72
(from The Charleston Suite)
49.7×61.1; 40.7×53
Curwen Prints
DP.6227

Gaillard-Bennett House, 1971–72
(from The Charleston Suite)
50×61.2; 40.5×51.4
Curwen Prints
DP.6228

Mulberry Plantation House, 1971–72
(from The Charleston Suite)
49.5×61.1; 38.5×51.4
Curwen Prints
DP.6229

Nathaniel Russell House, 1971–72
(from The Charleston Suite)
49.7×61.2; 39.2×53
Curwen Prints
DP.6230

Miles Brewton House, 1971–72
(from The Charleston Suite)
49.5×61.1; 39×51.4
Curwen Prints
DP.6231

The Wedge Plantation House,
1971–72
(from The Charleston Suite)
49.6×61; 38.4×50.5
Curwen Prints
DP.6232

Ellen Keeley's Shop, 1972
49.5×61.1; 39.3×53
Seven Dials Press
DP. 6729

Endell Street, 1972
(from Covent Garden Suite)
49.7×77.5
Seven Dials Press
DP.6233

The Flower Market, Covent Garden,
1972
(from Covent Garden Suite)
61×49.8; 53.5×42
Seven Dials Press
DP.6234

Foreign Fruit Market, 1972
(from Covent Garden Suite)
50×61.2; 39.6×52.3
Seven Dials Press
DP.6235

*Piazza Looking South Past
St Paul's,* 1972
50.6×61.1; 39.8×52.7
Seven Dials Press
DP.6730

*Seven Dials: Monmouth St,
Shelton St, and Mercer St,* 1972
(from Covent Garden Suite)
61.1×49.9
Seven Dials Press
DP.6236

*Southern Section of Piazza (James
Butler),* 1972
(from Covent Garden Suite)
50×61.1; 40.2×53
Seven Dials Press
DP.6237

Warehouse in Mercer St, 1972
(from Covent Garden Suite)
61.3×50; 52.3×39.4
Seven Dials Press
DP.6238

*Warehouses Between Shelton St and
Earlham St,* 1972
(from Covent Garden Suite)
49.9×61.1; 40×50.8
Seven Dials Press
DP.6239 (Cat.285)

Dunstanburgh Castle, 1973
57×77.5; 44.5×64.3
Christie's Contemporary Art
DP.6240

Bath Abbey Precinct, 1975
50.8×63.5; 39.4×52.5
Curwen Prints
DP.6642

Camden Crescent, 1975
63.5×51; 50.6×38.4
Curwen Prints
DP.6637

Canal in Sydney Gardens, 1975
63.5×50.8; 50.5×37
Curwen Prints
DP.6640

Dundas Aquaduct, 1975
63.5×50.8; 50.3×38.9
Curwen Prints
DP.6636

Great Roman Bath, 1975
50.9×63.5; 39×51.2
Curwen Prints
DP.6641

Lansdown Crescent, 1975
50.8×63.5; 40.2×51.7
Curwen Prints
DP.6639

Ralph Allen's Sham Castle, 1975
50.8×63.5; 41.2×53.2
Curwen Prints
DP.6638

St Thomas's Hospital, 1975
57.4×77.4
Yorke, Rosenberg, Mardell
DP.6643

Samos, 1975
57.2×77.5
Christie's Contemporary Art
DP.6644

Ronald Glendenning

*Cycle Racing, c.*1956
(from Guinness Lithographs)
54×79.4; 48.3×73.5
Guinness
DP.6708

Duncan Grant b.1885

Interior, 1973
(from The Penwith Portfolio)
77.5×57.1; 36.1×30.6
Penwith Galleries
DP.6241 (Cat.286)

Standing Woman, 1973–74
77.5×57.8; 74.6×43
Observer Art
DP.6242

Washerwoman, 1973–74
77.5×56.2; 73×52.3
Observer Art
DP.6243

Derrick Greaves b.1927

Vase and Falling Petal, 1971
(from Europaeische Graphik VII)
64.7×49.6
Galerie W. Ketterer, Munich
DP.6244 (Cat.287)

White Vase, 1972
64.3×48.3
World Graphics
DP.6245 (Cat.288)

Ha Van Vuong b.1914

Itinerant Singer, 1975
76.2×61; 63.8×48.3
Athena
DP.6645

Margaret Harrison

Good Enough To Eat, 1971
57.2×78.5
Motif Editions
DP.6246

Take One Lemon, 1971
78.8×57.4
Motif Editions
DP.6247

Liselott Henderson-Begg

Untitled, 1971
52.4×67; 29.2×36.7
Proofed only
DP.6248

Barbara Hepworth 1903–75

Untitled, 1958
65.4×44.3; 43.5×30
Proofed only
DP.6249

Three Forms Assembling, 1968–69
(from Europaeische Graphik VI)
69.6×50.4; 58.6×45.8
Galerie W. Ketterer, Munich
DP.6250

Argos, 1969
81.6×58.7
Curwen Prints
DP.6251

Autumn Shadows, 1969
81.7×59.8; 76.6×56.2
Curwen Prints
DP.6252

Genesis, 1969
81.6×59.3; 72.4×53.6
Curwen Prints
DP.6253

Mycenae, 1969
80.7×58.3
Curwen Prints
DP.6254

Oblique Forms, 1969
58.5×81.5; 55.5×73
Curwen Prints
DP.6255

Pastorale, 1969
82.5×59.4; 71.2×51
Curwen Prints
DP.6256

Porthmeor, 1969
81.7×59.7; 72.2×53.9
Curwen Prints
DP.6257 (Cat.289)

Sea Forms, 1969
59.1×82.2
Curwen Prints
DP.6258

Squares and Circles, 1969
58.1×80.6
Curwen Prints
DP.6259

Sun and Moon, 1969
80.9×58.3; 73.9×55.5
Curwen Prints
DP.6260

Three Forms, 1969
59×81.5; 45.7×59.8
Curwen Prints
DP.6261

Two Marble Forms (Mykonos),
1969
81×58.8; 73.5×48.1
Curwen Prints
DP.6262

Cool Moon, 1970–71
(from The Aegean Suite)
81.4×58.2
Curwen Prints
DP.6263

Delos, 1970–71
(from The Aegean Suite)
81.3×58.9; 76.7×54.5
Curwen Prints
DP.6264

Desert Forms, 1970–71
(from The Aegean Suite)
81.2×58.5; 76.9×54.3
Curwen Prints
DP.6265

Fragment, 1970–71
(from The Aegean Suite)
81.4×58.5; 77.6×51.5
Curwen Prints
DP.6266

Itea, 1970–71
(from The Aegean Suite)
58.8×81.2; 54.4×76.5
Curwen Prints
DP.6267

Olympus, 1970–71
(from The Aegean Suite)
80.5×57.9; 76.4×54.3
Curwen Prints
DP.6268

Sun and Water, 1970–71
(from The Aegean Suite)
81.6×58.5; 76.5×54.6
Curwen Prints
DP.6269

Sun Setting, 1970–71
(from The Aegean Suite)
81.2×58.8; 75.6×54.5
Curwen Prints
DP.6270 (Cat.290)

Sun and Marble, 1970–71
(from The Aegean Suite)
81.2×59.3; 76.8×54.3
Curwen Prints
DP.6271 (Cat.291)

Josef Herman b.1911

The Cart, 1960
40.4×58; 27.7×44.5
Proofed only
DP.6272

Two Miners, c.1960
57.5×81.1; 45.2×67.8
St George's Gallery
DP.6274

Two Miners, 1960–62
57.5×80.7; 47.4×67.7
Curwen Prints
DP.6273

Two Seated Peasants, 1961
57.7×81.1; 40.9×58.6
Curwen Prints
DP.6275

Mother and Child, 1961–62
80.8×57.5; 66.9×43.5
Curwen Prints
DP.6276 (Cat.292)

Dusk, 1965
57.3×80.6; 51×74.6
Marlborough Graphics
DP.6277

Figure Against Dark Sky, 1965
57.2×80.4; 53.2×69.9
Marlborough Graphics
DP.6278 (Cat.293)

Figure Against Dark Sky
(colour variant), 1965
57.2×79.6; 53.2×69.3
DP.6711

In the Mountains, 1965
57.2×80; 52.2×71.1
Marlborough Graphics
DP.6279

Cockle Gatherers, 1974
56.3×77.6; 49.3×64.8
Christie's Contemporary Art
DP.6280

The First Star, 1974–75
50.9×63.5; 31.5×47.6
Curwen Prints
DP.6281

Four Fisherwomen, 1974–75
57.2×77.5; 41.7×60.9
Curwen Prints
DP.6282

On the Way Home, 1974–75
50.8×63.5
Curwen Prints
DP.6284

Scene on the Shore, 1974–75
51×63.5
Curwen Prints
DP.6283

The Red Sun, 1975
50.7×63.5; 36.5×44
Curwen Prints
DP.6285

Patrick Heron b.1920

Black and Blue Stripes, 1958
76.2×53.9; 53.7×40
The artist
DP.6709 (Cat.295)

Grey and Black Stripes, 1958
76×53.9; 52.5×42
The artist
DP.6287 (Cat.296)

Grey and Brown Stripes, 1958
80.3×56.5; 52.1×41.6
The artist
DP.6710

Red and Yellow Image, 1958
74.6×54; 53.6×38.7
The artist
DP.6286

David Hockney b.1937

Connoisseur, 1970
80.6×57.3
Petersburg Press
DP.6288

The Print Collector, 1970–71
(from Europaeische Graphik VII)
67×53
Galerie W. Ketterer, Munich
DP.6289 (Cat.297)

Lilies, 1971
(from Europaeische Graphik VII)
75.2×53.2
Galerie W. Ketterer, Munich
DP.6290 (Cat.298)

Howard Hodgkin b.1932

Arch, 1970–71
(from Europaeische Graphik VII)
51.6×65.7
Galerie W. Ketterer, Munich
DP.6291

Untitled, 1971
53×67.1; 27.2×36.3
Proofed only
DP.6292

Paul Hogarth b.1917

Fez, 1975
57.1×77.5
Christie's Contemporary Art
DP.6646

Albert Houthuesen b.1903

Ancestor, 1969
45.4×57.3; 35.3×21.8
Mercury Gallery
DP.6712

Untitled, 1969
56.5×44.5
Proofed only
DP.6293

Untitled and *Sweet Note-Bitter Apple*, 1969
54.1×45.5
Mercury Gallery
DP.6294

Harry Langdon (Clown with a Small Trilby Hat), 1970
78.8×58.8; 59×45.9
Proofed only
DP.6295

1. White Faced Clown, 1970
(from A Portfolio of Clowns)
78.3×58.9; 59.7×46.5
Mercury Gallery
DP.6296

2. Auguste, 1970
(from A Portfolio of Clowns)
78.3×58.9; 59.5×45.5
Mercury Gallery
DP.6297

3. Juggler Clowns, 1970
(from A Portfolio of Clowns)
78.6×58.8; 59.2×46.9
Mercury Gallery
DP.6298

4. Night, 1970
(from A Portfolio of Clowns)
78×59.3; 61×47.5
Mercury Gallery
DP.6299

5. Muse and Clown, 1970
(from A Portfolio of Clowns)
58.7×78.5; 49.1×63.2
Mercury Gallery
DP.6300

Harry Langdon, 1970–74
77.9×58.8; 58.7×46
Richard Nathanson
DP.6301

White Face in Straw Hat, 1970–74
78×58; 55.8×44.2
Richard Nathanson
DP.6302

Philemon, 1971
52.3×34.3; 36.2×31.1
Richard Nathanson
DP.6303

Of the Company of St Philemon, 1974
77.9×58; 75.7×49.5
Richard Nathanson
DP.6304

Clown with Striped Hat, 1974
77.8×58.1; 58×45
Richard Nathanson
DP.6305

Dancer, 1974
66.3×50.8; 58×45.3
Richard Nathanson
DP.6306

Dancers, 1974
66.2×50.8; 54.5×39.5
Richard Nathanson
DP.6307

Laurel, 1974
66.2×50.8; 54.2×42.5
Richard Nathanson
DP.6308

Mariner, 1974
66.2×50.5; 50.2×38.1
Richard Nathanson
DP.6309

Buster (Keaton), 1974
77.8×58.3; 75.5×49.3
Richard Nathanson
DP.6310

Reflections, 1974
66.5×50.7
Richard Nathanson
DP.6311

Stage Actors, Adam and Eve, 1974
66.1×50.9; 58×45.6
Richard Nathanson
DP.6312

White Face with Plumed Hat, 1974
66.5×50.5; 57.6×44.8
Richard Nathanson
DP.6313

Stone Cutter, 1974
66.5×50.6; 51×37.5
Richard Nathanson
DP.6647

Celebration, 1974–75
66×50.7
Richard Nathanson
DP.6648

The Beauty Patch, 1975
66.2×50.6; 58.4×45.6
Richard Nathanson
DP.6651

Cleft Tree, 1975
50.5×66; 38.7×50.9
Richard Nathanson
DP.6650

Hubbub, 1975
66×50.8; 58.3×45.5
Richard Nathanson
DP.6649

Magician, 1975
66×50.6; 50.6×31.9
Richard Nathanson
DP.6654

Sea Shell, 1975
51×66; 38.4×50.5
Richard Nathanson
DP.6655

Sun Over Lake, 1975
66×50.6; 50.5×38.5
Richard Nathanson
DP.6652

Trilogy, 1975
66×50.5; 56.2×40.9
Richard Nathanson
DP.6653

Peter Howell b.1932

The Last Furlong, 1973
58×79.9; 48.2×70.6
Christie's Wildlife and Sporting Prints
DP.6314

Geoffrey Ireland

Frail Hunter, 1965
50.5×63.5
Curwen Prints (Unicorn)
DP.6731

Sagres
47.5×61
Curwen Prints (Unicorn)
DP.6759

Bill Jacklin b.1943

First Light, 1974–75
57.4×56.7; 45.8×46.2
Bernard Jacobson Ltd
DP.6656 (Cat.299)

Northern Light, 1975
56.6×56.5; 46.4×46.3
Bernard Jacobson Ltd
DP.6657

Ancient Light, 1975
57×56.7; 45.7×46.5
Bernard Jacobson Ltd
DP.6658

Daylight, 1975
56.5×56.7; 45.8×46.3
Bernard Jacobson Ltd
DP.6659

Sky Light, 1975
56.9×56.8; 46×46.3
Bernard Jacobson Ltd
DP.6660 (Cat.300)

Night Light, 1975
56.8×56.7; 46×46.2
Bernard Jacobson Ltd
DP.6661

Janice Jacobs

Abstract, 1973
77.6×57.7; 70.7×52.8
The artist
DP.6732

Allen Jones b.1937

Untitled, 1964
80.1×57
Proofed only
DP.6337 (Cat.301)

Left Hand Lady, 1970
57.3×76.3
Petersburg Press
DP.6338 (Cat.302)

Right Hand Lady, 1970
57.3×76.5
Petersburg Press, DP.6339

Leg-Splash, 1970–71
(from Europaeische Graphik VII)
65.9×50.5
Galerie W. Ketterer, Munich
DP.6340 (Cat.303)

Woman-Splash, 1970–71
(from Europaeische Graphik VII)
76.3×53
Galerie W. Ketterer, Munich
DP.6341

Barbara Jones

The Aviary, Dropmore, 1971
(from Follies)
77.5×57.5; 61.3×48.4
Curwen Prints
DP.6315

Pineapple House, Stirling, 1971
(from Follies)
77.6×57.3; 63×47.5
Curwen Prints
DP.6316

Rosura Jones b.1932

Euston
45.4×61
Curwen Prints (Unicorn)
DP.6733

Phoebus, 1965
53.8×69
Curwen Prints (Unicorn)
DP.6734

Stanley Jones b.1933

Porthmeor, 1959
57×80.4; 40.5×59.5
St George's Gallery
DP.6317

Essex Landscape, 1962
57.8×81; 47.7×74.6
St George's Gallery
DP.6318 (Cat.304)

Madron, 1970–71
(from Europaeische Graphik VIII)
70.8×54.2
Galerie W. Ketterer, Munich
DP.6319 (Cat.305)

Charles Keeping

City Tiered Stables, 1965
51.8×79.6; 41.8×67
Curwen Prints (Unicorn)
DP.6735

David Kindersley b.1915

Letters are Things, 1971
66.9×52.1; 58.5×45.7
Curwen Prints
DP.6320 (Cat.306)

Quality Before Quantity, 1971
66.9×52.2; 58.3×45.7
Curwen Prints
DP.6321

Jeremy King b.1933

A Cheshire Stream, 1972–73
38.1×47.9
Book of the Month Club
DP.6736

Lynton Lamb b.1907

Winter Landscape, 1962
51×76.2; 33×48
British Transport Commission
DP.6322

Osbert Lancaster b.1908

Pineapple Poll, 1973
54×36.7; 42×31.5
John Cranko Scholarship Fund
DP.6323

Reg Lander b.1913

Polperro, 1975
61×76.2; 42×56.6
Athena
DP.6662

Windsor Castle, 1976
45.7×55.8; 25.8×35.5
Satex Ltd
DP.6663

Peter Lanyon 1918–64

The Returned Seaman, 1973
(from The Penwith Portfolio)
74.2×80.1; 63×70.3
Penwith Galleries
DP.6324

Robin Laurie

The Burning Cone, 1970
51×63.5; 19.8×11.7
Academy Editions
DP.6325

Bernard Leach b.1887

Drawing for a Pot, 1973
(from The Penwith Portfolio)
77.5×57.4; 30.1×29.6
Penwith Galleries
DP.6359

Bird Dish, 1973–74
77.4×56.7; 48.1×41.4
Curwen Prints
DP.6326

Black Jar, 1973–74
77.5×57.4; 48×40.9
Curwen Prints
DP.6327

Cornish Coast Tile, 1973–74
56.8×77.5; 37.8×46.5
Curwen Prints
DP.6328

Deer Plate, 1973–74
77.4×57.2; 48.1×41.4
Curwen Prints
DP.6329

Fish Vase, 1973–74
77.5×57.1; 50.8×29.7
Curwen Prints
DP.6330

Lion Tile, 1973–74
57.2×77.4; 43.4×52.1
Curwen Prints
DP.6331

Tree Jar, 1973–74
77.4×57.5; 44.7×36.6
Curwen Prints
DP.6332

Jan Le Witt b.1907

Axial Image, 1966
65.6×50.5; 40.5×33.2
Scamander Fine Art/Curwen
DP.6333

Alan Lowndes 1972

Dartsman and *Organ Grinder*, 1972
50.4×65.6
Crane Kalman Gallery
DP.6334

Stockport Viaduct, 1973
51.2×64.4; 40.8×50.2
Pallas Gallery
DP.6737

The Doss House, 1975
78.9×57.5; 51×41
Pallas Gallery
DP.6335

The Pawnbroker, 1975
78.7×58; 49.6×41.1
Pallas Gallery
DP.6336

Robert MacBryde 1913–66

Head, 1960
80.8×57.3; 54.3×42
St George's Gallery
DP.6342 (Cat.307)

Still Life I, 1960
80.3×57.4; 50.3×35
St George's Gallery
DP.6343 (Cat.308)

Still Life II, 1960
80.4×57.5; 61.2×50.5
St George's Gallery
DP.6344

Frances MacDonald b.1914

Iffley Church, 1970–71
59.1×78.1; 39.4×56.1
The artist
DP.6345

Alex Mackay

Two Bird Studies, 1976
59.7×76.6
The artist
DP.6738

F. E. McWilliam b.1909

Woman of Belfast, 1973
(from The Penwith Portfolio)
56.6×77.5; 46×58.2
Penwith Galleries, DP.6346

Ronald Maddox b.1930

The Mansion House/City of London, 1974
25.7×53.3; 20.3×43.5
B.B.C.
DP.6347

Royal Festival Hall/Queen Elizabeth Hall and Purcell Room, 1974
25 8×53.4; 19.3×45.4
B.B.C.
DP.6348

Royal Naval College and Queen's House/Greenwich, 1974
25.8×53.3; 21.4×45.4
B.B.C.
DP.6349

Samuel Maitin b.1928

After California, 1968
(from Set of Ten Lithographs)
63×50.2
Guggenheim Foundation
DP.6350

Again and Now, 1968
(from Set of Ten Lithographs)
62.4×50.4; 56×39.6
Guggenheim Foundation
DP.6351

Couplets, 1968
(from Set of Ten Lithographs)
62.7×50.8; 59×45
Guggenheim Foundation
DP.6352

For Ollie, 1968
(from Set of Ten Lithographs)
63.2×50.7
Guggenheim Foundation
DP.6353 (Cat.309)

Go and Be Gay, 1968
(from Set of Ten Lithographs)
63.1×50.4
Guggenheim Foundation
DP.6354

I have found it, 1968
(from Set of Ten Lithographs)
63×50.5
Guggenheim Foundation
DP.6355

Thus have the starlings, 1968
(from Set of Ten Lithographs)
63×50
Guggenheim Foundation
DP.6356

Helena Markson

Tower of London, 1968
56×76; 43.4×56.3
William Weston
DP.6357

Enid Marx b.1902

Budgerigars, 1972
57.5×77.6
The artist
DP.6358

Keith Michell b.1928

Metamorphosis, 1973
60.4×76.5
World Graphics
DP.6739

*I. What is your substance, whereof
are you made*, 1975
(from Shakespeare Sonnets)
61.2×50.1; 51×37.7
Century Galleries
DP.6664

*II. Not marble, nor the gilded
monuments*, 1975
(from Shakespeare Sonnets)
61.2×50.2; 52.6×39.5
Century Galleries
DP.6665

*III. When I consider everything that
grows*, 1975
(from Shakespeare Sonnets)
61.1×50.2; 50.9×38.4
Century Galleries
DP.6666

*IV. Mine eye hath played the
painter and hath . . .*, 1975
(from Shakespeare Sonnets)
61.4×49.8; 51.8×38.9
Century Galleries
DP.6667

*V. When in disgrace with fortune
and men's eyes*, 1975
(from Shakespeare Sonnets)
61.7×49.9; 51.7×37.8
Century Galleries
DP.6668

*VI. How heavy do I journey on the
way*, 1975
(from Shakespeare Sonnets)
61.8×50.1; 52.2×38
Century Galleries
DP.6669

*VII. Since I left you, mine eye is on
my mind*, 1975
(from Shakespeare Sonnets)
61.4×50.2; 52×37.7
Century Galleries
DP.6670

*VIII. Shall I compare thee to a
summer's day*, 1975
(from Shakespeare Sonnets)
61.7×50.3; 52×41
Century Galleries
DP.6671

*IX. Look in thy glass and tell the
face thou viewest*, 1975
(from Shakespeare Sonnets)
61.7×49.9; 54.5×40.5
Century Galleries
DP.6672

*X. My mistress eyes are nothing
like the sun*, 1975
(from Shakespeare Sonnets)
61.5×49.7; 52×38
Century Galleries
DP.6673

*XI. Two loves I have, of comfort
and despair*, 1975
(from Shakespeare Sonnets)
61.8×50.2; 53×40
Century Galleries
DP.6674

*XII. Poor soul, the centre of my
sinful earth*, 1975
61.1×50.3; 52.8×41.2
Century Galleries
DP.6675

Ioan Mirea b.1912

Moldavian Nude, 1966
63.5×51; 55.6×38.1
Curwen Prints
DP.6360

Transylvanian Nude, 1966
63.5×50.7; 55.4×38.1
Curwen Prints
DP.6361

Henry Moore b.1898

Eight Reclining Figures, 1958
58.3×40.5; 30.8×25.8
Kestner Gesellschaft, Hanover
DP.6362

Black on Red Image, 1963
(from Europaeische Graphik I)
66×50.2; 52.3×48.1
Galerie W. Ketterer, Munich
DP.6363

*Eight Reclining Figures on Rock
Background*, 1963
65.8×50.3
Hamburg Print Club
DP.6364

*Eight Reclining Figures with
Architectural Background*, 1963
(from Europaeische Graphik I)
76.4×52.1; 43×33
Galerie W. Ketterer, Munich
DP.6366

Five Reclining Figures, 1963
77×56.7
The artist
DP.6368 (Cat.310)

*Seventeen Reclining Figures with
Architectural Background*, 1963
57.1×80.4; 52×68.5
Curwen Prints
DP.6367

Single Form, 1963
65.8×50.3
Proofed only
DP.6369

Six Reclining Figures, 1963
50.1×66
Proofed only
DP.6370

Six Reclining Figures in Black, 1963
50.5×65.8
The artist
DP.6371

*Six Reclining Figures with Buff
Background*, 1963
61×73.5; 46×58.9
Gerald Cramer, Geneva
DP.6372

*Two Reclining Figures with River
Background*, 1963
50.1×82; 30.6×63.3
Gerald Cramer, Geneva
DP.6373

Two Seated Figures in Stone, 1963
(from Europaeische Graphik I)
76×52.2; 39.5×29
Galerie W. Ketterer, Munich
DP.6374 (Cat.311)

Two Standing Figures, 1963
50.3×66
Proofed only
DP.6365

Three Reclining Figures, 1971
43.3×33.4; 30×23.2
Société Internationale d'Art
XXe Siècle, Paris
DP.6375

Three Reclining Figures, 1971
30.4×25.4; 27.5×23.2
Edizioni d'Arte Fratelli Fabbri,
Milan
DP.6376

Three Reclining Figures, 1971–72
65.7×50.9; 30×22.7
Il Bisonte, Florence
DP.6377

Three Reclining Figures, 1971–73
52.2×39.6; 29.8×23.8
Gerald Cramer, Geneva
DP.6378

Three Reclining Figures, 1971–73
65.8×50.8; 29.9×23.1
Société Internationale d'Art
XXe Siècle, Paris
DP.6379

Group of Reclining Figures, 1973
(from Reclining Figures)
66×50.6; 46.4×39.8
Société Internationale d'Art
XXe Siècle, Paris
DP.6380

Pallas Heads, 1973
65.5×50.5; 34.6×28.4
Pallas Gallery
DP.6381

*Reclining and Standing Figure and
Family Group*, 1973
(from Reclining Figures)
66×50.5; 44.3×32.6
Société Internationale d'Art
XXe Siècle, Paris
DP.6382

Reclining Figure with Red Stripes,
1973
66×50.6; 22.5×20.5
Bruckmann Verlag, Munich
DP.6383

*Reclining Figure with Sea
Background*, 1973
(from Reclining Figures)
66×50.8; 46.7×37.5
Société Internationale d'Art
XXe Siècle, Paris
DP.6384

*Reclining Figure with Sky
Background*, 1973
(from Reclining Figures)
66×50.5; 44×38.3
Société Internationale d'Art
XXe Siècle, Paris
DP.6385

Reclining Figures, 1973
57.5×47.3; 29.3×21.8
Patrick Seale Prints Ltd
DP.6698

Seven Sculptural Ideas, 1973
65.4×50; 34×25.6
Galerie W. Ketterer, Munich
DP.6699

*Silhouette Figures with Border
Design*, 1973
(from The Penwith Portfolio)
77.5×57.4; 48.7×45.2
Penwith Galleries
DP.6700

Six Reclining Figures, 1973
52×66.5; 32×38.1
Los Angeles County Museum of
Art, Los Angeles
DP.6386

Two Black Forms: Metal Figures,
1973
58.8×44.6; 31.8×26.1
Gerald Cramer, Geneva
DP.6387

Two Reclining Figures, 1973
(from Reclining Figures)
66.1×50.6; 42.8×33.6
Société Internationale d'Art
XXe Siècle, Paris
DP.6388

*Two Reclining Figures on Striped
Background*, 1973
(from Reclining Figures)
66×51; 46.4×33.5
Société Internationale d'Art
XXe Siècle, Paris
DP.6389

Four Reclining Figures, 1973–74
(from Hommage à Picasso)
56×77.4; 42.2×62.7
Propylaen Verlag, W. Berlin and
Pantheon Press, Rome
DP.6390

Ideas for Wood Sculpture, 1973–74
56.5×41.2; 35×26.5
Gerald Cramer, Geneva
DP.6391

Mother and Child, 1973–74
48.8×36.5; 24.1×17.7
Gerald Cramer, Geneva
DP.6392

Three Sculptural Objects, 1973–74
56.5×43.5; 34.4×25.6
Gerald Cramer, Geneva
DP.6393

Four Reclining Figures: Caves, 1974
56.5×69.9; 45×59.9
Art Gallery of Ontario, Toronto
DP.6394

Charles Mozeley

Untitled, 1959
79.9×57.4; 60.5×42
The artist
DP.6395

Untitled, 1959
80.2×56.6; 64×44
The artist
DP.6396

Rodrigo Moynihan b.1910

Lake Shadow, 1972
57.2×77.5
The artist
DP.6397

Sarah Neckemkin

Landscape, 1960
57.3×40; 39×28.1
The artist
DP.6398

Ben Nicholson b.1894

Abstract 1936, 1973
(from The Penwith Portfolio)
66.6×80
Penwith Galleries
DP.6399

John O'Connor b.1913

Canal Lock, 1967
59×81.2
Proofed only
DP.6400

Kersey Church, 1970
58.2×77.5; 48.5×63.3
Curwen Prints
DP.6401

Yoko Ono b.1933

I Ching No.14, c.1970
51.1×76.3
Consolidated Fine Art, New York
DP.6402

Bryan Organ b.1935

Geoff Lewis, 1974
(from Six British Jockeys)
53.3×43.2; 31×18.3
Ackermanns
DP.6403

Jimmy Lindley, 1974
(from Six British Jockeys)
53.2×43.2
Ackermanns
DP.6404

Joe Mercer, 1974
(from Six British Jockeys)
53.4×43.2
Ackermanns
DP.6405

Lester Piggott, 1974
(from Six British Jockeys)
53.3×43.2
Ackermanns
DP.6406

Mike Carson, 1974
(from Six British Jockeys)
53.2×43.2; 33.5×29.2
Ackermanns
DP.6407

Monarch of the Glen After Landseer, 1974
69.2×69.3; 61×61.1
Pallas Gallery
DP.6408

Ophelia, 1974
57×77.5; 48.1×53.6
Pallas Gallery
DP.6409

Tiger, 1974
75.7×63.2; 65.1×53.8
Christie's Contemporary Art
DP.6410

Tony Murray, 1974
(from Six British Jockeys)
53.3×43.2; 31.5×19.6
Ackermanns
DP.6411

1. Tiger, 1974–75
(from Four Heads of Wild Cats)
26.9×26.7; 21×19.6
Christie's Contemporary Art
DP.6412

2. Lion, 1974–75
(from Four Heads of Wild Cats)
26.7×26.7; 19.9×19.7
Christie's Contemporary Art
DP.6413

3. Lioness, 1974–75
(from Four Heads of Wild Cats)
26.7×27; 18.5×19.4
Christie's Contemporary Art
DP.6414

4. Cheetah, 1974–75
(from Four Heads of Wild Cats)
26.9×27; 18.8×19
Christie's Contemporary Art
DP.6415

Hotel Timeo, 1975
67.6× 61.1; 56×49.7
Gadsby
DP.6677

Sicilian Window, 1975
67.5×61.1; 56×50
Gadsby
DP.6676

Alex Packham b.1914

The Kitty, 1970–71
58.5×79.2; 42.9×57.9
Curwen Prints, DP.6416

Valerie Parkinson

Title not known (2 images), 1968
Each 77×58; 24.3×32.1
Centre Hotels
DP.6417

Title not known (2 images), 1968
Each 52.5×68.2; 32×24.1
Centre Hotels
DP.6418

Victor Pasmore b.1908

Points of Contact No.3, 1965
63.4×86.2
Marlborough
DP.6419 (Cat.314)

Rafael Penagos b.1941

Boy with Mirror, 1976
77.4×57
Enrique Michelsen
DP.6741

Woman with Fur Wrap, 1976
77.5×57.3
Enrique Michelsen
DP.6740

Maurice Philips

Two Heads, 1969
64.6×51
The artist
DP.6420

Edward Piper

High Level Bridge, Newcastle, 1965
54.4×62.6; 50.9×59.8
Curwen Prints (Unicorn)
DP.6743

Telford's Pont-Cysylltaw, 1965
55.2×49.9; 50.2×45.5
Curwen Prints (Unicorn)
DP.6742

John Piper b.1903

Westminster School (a), 1961
57.4×80.5; 43× 58.5
Paul Cornwall-Jones
DP.6421

Westminster School (b), 1961
57.7×81; 45×58.7
Paul Cornwall-Jones
DP.6422

Beach in Brittany, 1961–62
57.5×81.1; 47.5×64.5
Curwen Prints
DP.6423 (Cat.315)

San Marco, Venice, 1961–62
81.1×58.6; 64.5×46.5
Curwen Prints
DP.6424 (Cat.316)

Anglesey Beach, 1962–63
(from Europaeische Graphik I)
66×50.3; 56×44.5
Galerie W. Ketterer, Munich
DP.6425

Edington, Wiltshire, 1964
57.2×80.4; 53×69.8
Proofed only
DP.6426

*1. Kilpeck, Herefordshire: the
Norman South Door*, 1964
(from A Retrospect of Churches)
81.7×59.2; 72.5×51.5
Marlborough
DP.6427

*2. Gaddesby, Leicestershire:
Medieval Stonework*, 1964
(from A Retrospect of Churches)
82×59; 67.2×47
Marlborough
DP.6428

*3. Redenhall, Norfolk: The Tower,
1964*
(from A Retrospect of Churches)
82×60; 70.6×36
Marlborough
DP.6429

*4. Warkton, Northamptonshire:
Monument by Vangelder, 1775,
1964*
(from A Retrospect of Churches)
82×59.2; 69.2×49.1
Marlborough
DP.6430

*5. Exton, Rutland: Monument by
Grinling Gibbons, 1686, 1964*
(from A Retrospect of Churches)
82.5×59.4; 74.4×51.6
Marlborough
DP.6431

*6. St Kew, Cornwall: Church in a
Hilly Landscape*, 1964
(from A Retrospect of Churches)
59.6×82.4; 50.4×70.1
Marlborough
DP.6432

*7. Llan-y-Blodwell, Shropshire: Mid
19th century Furnishing and
Painting*, 1964
(from A Retrospect of Churches)
82.4×59.9; 66×46
Marlborough
DP.6433

*8. Malmesbury, Wiltshire: the
South Porch*, 1964
(from A Retrospect of Churches)
82.5×59.5; 61.5×52
Marlborough
DP.6434 (Cat.317)

*9. Tickencote, Rutland: the Norman
Chancel Arch*, 1964
(from A Retrospect of Churches)
59.5×81.5; 42.4×67.4
Marlborough
DP.6435

*10. Rudbaxton, Pembrokeshire:
17th century Monument, 19th
century Furnishing*, 1964
(from A Retrospect of Churches)
60×82.3; 47.3×64.9
Marlborough
DP.6436

*11. Inglesham, Wiltshire: A Rustic,
Medieval Interior*, 1964
(from A Retrospect of Churches)
59.5×81.6; 50.7×71.1
Marlborough
DP.6437

*12. Lewknor, Oxfordshire:
Textured Walls, Traceried
Windows*, 1964
(from A Retrospect of Churches)
59.5×82.2; 53.1×70.9
Marlborough
DP.6438

*13. Leckhampstead, Berkshire: A
Victorian Church by S.S. Teulor,
1964*
(from A Retrospect of Churches)
82.1×59.6; 68.5×47.2
Marlborough
DP.6439

*14. Fotheringhay,
Northamptonshire: Medieval
Stone*, 1964
(from A Retrospect of Churches)
59.2×81.5; 48.6×68.7
Marlborough
DP.6440

*15. St Nicholas, Liverpool:
Smoke-black, Dockland Church,
1964*
(from A Retrospect of Churches)
82×60.3; 61.9×45.4
Marlborough
DP.6441

*16. Easton, Portland, Dorset: St
George Reforne an 18th century
Church Among the Quarries*, 1964
(from A Retrospect of Churches)
59.8×82.5; 50.1×64.2
Marlborough
DP.6442

*17. North Grimstone, Yorkshire
(East Riding): The Deposition –
Detail from the 12th century Font,
1964*

(from A Retrospect of Churches)
82.3×59.6; 73.7×53.7
Marlborough
DP.6443

18. Gedney, Lincolnshire: A Tower in the Fens, 1964
(from A Retrospect of Churches)
82.7×59.9; 77.6×51.5
Marlborough
DP.6444

19. Llangloffan, Pembrokeshire, the Baptist Chapel, 1964
(from A Retrospect of Churches)
60×82; 51.9×69.6
Marlborough
DP.6445 (Cat.318)

20. St Anne's Limehouse, London: by Nicholas Hawksmoor, 1964
(from A Retrospect of Churches)
82×59.5; 70.5×47.7
Marlborough
DP.6446

21. Christ Church, Spitalfields, London: by Nicholas Hawksmoor, 1964
(from A Retrospect of Churches)
82×60; 73.2×48.3
Marlborough
DP.6447 (Cat.319)

22. St Matthias, Stoke Newington, London: by William Butterfield, 1964
(from A Retrospect of Churches)
82.5×60; 68.6×52
Marlborough
DP.6448

23. St James the Less, Westminster: by G. E. Street, 1964
(from A Retrospect of Churches)
60.1×81.9; 49×65.3
Marlborough
DP.6449

24. St Mary's, Paddington: by G. E. Street, 1964
(from A Retrospect of Churches)
82.3×59.3; 69×48.8
Marlborough
DP.6450

Crug Glass, 1966
59.5×82; 50.4×76.8
Marlborough
DP.6451

Dylwyn Church, 1966
81.7×59.2; 77.3×54.5
Marlborough
DP.6452

Ironbridge, 1966
59.5×82.4; 48.3×64.5
Marlborough
DP.6453

Swansea Chapel, 1966
82.2×60; 68.2×51.7
Marlborough
DP.6454

Bethesda Chapel, 1966–67
59.5×81.5; 52.5×68.8
Marlborough
DP.6455 (Cat.320)

Foliate Head, 1971
64.2×45.2; 38.9×26.6
Leonard Appelbee
DP.6456

Annunciation to the Shepherds, 1973
(from The Penwith Portfolio)
58.5×79.8; 43.4×55
Penwith Galleries
DP.6457

Avoncroft Museum, 1976
56.4×76.2; 42.3×59.3
Avoncroft Museum
DP.6744

Patrick Procktor b.1936

Northern Lass, 1971
(from Europaeische Graphik VII)
65.8×50.8
Galerie W. Ketterer, Munich
DP.6458

Man Ray 1890–1976

Untitled I, 1969
(lithograph with screenprinting)
64.9×49.9; 58×44.3
Consolidated Fine Art, New York
DP.6459

Untitled II, 1969
(lithograph with screenprinting)
64.7×49.9; 58×44.4
Consolidated Fine Art, New York
DP.6460

Untitled III, 1969
(lithograph with screenprinting)
64.7×49.8; 57.9×44.5
Consolidated Fine Art
DP.6461 (Cat.321)

Mary Rennell b.1901

Aborigines, 1972
66.1×50.3
The artist
DP.6746

Forest, 1972
53.3×71.3
The artist
DP.6745

Welsh Landscape, 1973
76.6×36.8
The artist
DP.6747

The Boy Jesus and the Shepherd, 1974
63.6×80.4; 57.5×72
The artist
DP.6462

Carmelites in Choir, 1974
50×65; 25.8×30.2
The artist
DP.6463

Carmelite Nun, 1975
57.4×38.8; 24×16.5
The artist
DP.6678

Christmas Card, 1975
39.8×21.9× 31.9×16.8
The artist
DP.6679

Ceri Richards 1903–71

Trafalgar Square, 1958
57.4×80.3; 44.9×57.1
Proofed only
DP.6464

Hammerklavier (trial proof), 1959
50.3×76.7
Proofed only
DP.6465

Cathédrale Engloutie II, 1959
(from Hammerklavier Suite)
80.2 × 57.3; 77.2 × 51
St George's Gallery
DP.6467 (Cat.322)

Cathédrale Engloutie III, 1959
(from Hammerklavier Suite)
57 × 79.8; 45.3 × 66
St George's Gallery
DP.6468

. . . *Ce qu'a vu le vent d'ouest*, 1959
(from Hammerklavier Suite)
80.2 × 57.2; 59.7 × 47
St George's Gallery
DP.6469

Le Poisson d'Or, 1959
(from Hammerklavier Suite)
77.2 × 21.3
St George's Gallery
DP.6466 (Cat.323)

La Pianiste, 1959
57.5 × 80.7; 48.9 × 67.5
St George's Gallery
DP.6470

Trafalgar Square, 1961–62
57.6 × 80.6; 52 × 67.6
St George's Gallery
DP.6471 (Cat.324)

Trafalgar Square, 1962
57.9 × 81.4; 52.6 × 77.6
St George's Gallery
DP.6472

Trafalgar Square (trial proof), 1962
57 × 80.5; 51.6 × 65.8
Proofed only
DP.6473

1. Author's Prologue, 1965
(from Twelve Lithographs for Six
Poems by Dylan Thomas)
59.3 × 81.5
Marlborough
DP.6474

*2. The force that through the green
fuse drives the flower*, 1965
(from Twelve Lithographs for Six
Poems by Dylan Thomas)
59.7 × 82.1
Marlborough
DP.6475

*2. The force that through the green
fuse drives the flower* (trial proof),
1965
60.2 × 82.4
Proofed only
DP.6713 (Cat.325)

3. The Crooked Rose, 1965
(from Twelve Lithographs for Six
Poems by Dylan Thomas)
59.8 × 82.3; 53.5 × 68.8
Marlborough
DP.6476

3. The Crooked Rose (colour
variant), 1965
59.9 × 81.8; 54.3 × 69
Proofed only
DP.6714

3. The Crooked Rose (colour
variant), 1965
59.4 × 82.1; 53.6 × 69.2
Proofed only
DP.6715

4. Blossom, 1965
(from Twelve Lithographs for Six
Poems by Dylan Thomas)
60 × 82.2
Marlborough
DP.6477

4. Blossom (trial proof), 1965
59.7 × 82.1
Proofed only
DP.6716 (Cat.326)

4. Blossom (trial proof), 1965
59.9 × 82.2; 39.5 × 62
Proofed only
DP.6717

*5. The force that drives the waters
through the rocks*, 1965
(from Twelve Lithographs for Six
Poems by Dylan Thomas)
59.6 × 81.1; 43.5 × 59.1
Marlborough
DP.6478 (Cat.327)

*6. And I am dumb to tell the crooked
rose my youth is bent by the same
wintry fever*, 1965
(from Twelve Lithographs for Six
Poems by Dylan Thomas)
59.1 × 80.6; 45.7 × 63.1
Marlborough
DP.6479

7. Green Metaphor, 1965
(from Twelve Lithographs for Six
Poems by Dylan Thomas)
82 × 59.5
Marlborough
DP.6480

8. And death shall have no dominion,
1965
(from Twelve Lithographs for Six
Poems by Dylan Thomas)
59.4 × 81.8; 56.2 × 79.2
Marlborough
DP.6481

8. And death shall have no dominion
(trial proof), 1965
59.8 × 82.3
Proofed only
DP.6718

9. The Flowering Skull, 1965
(from Twelve Lithographs for Six
Poems by Dylan Thomas)
59.5 × 81.7
Marlborough
DP.6482 (Cat.328)

*10. Do not go gentle into that good
night*, 1965
(from Twelve Lithographs for Six
Poems by Dylan Thomas)
82 × 59.5; 69.2 × 59.5
Marlborough
DP.6483

11. Over Sir John's Hill, 1965
(from Twelve Lithographs for Six
Poems by Dylan Thomas)
59.2 × 81.1
Marlborough
DP.6484

12. Poem on his Birthday, 1965
(from Twelve Lithographs for Six
Poems by Dylan Thomas)
59.1 × 82; 56.9 × 79
Marlborough
DP.6485

*1. And we who wake, who saw the
swallow's wings*, 1970
(from Elegiac Sonnet by Vernon
Watkins)
56.8 × 28.5; 36.5 × 27.9
M'Arte Edizioni, Milan
DP.6486

2. This body sleeping where the dead leaves lie, 1970
(from Elegiac Sonnet by Vernon Watkins)
56.5×28.4
M'Arte Edizioni, Milan
DP.6487

Vaucluse, 1971
(from Journey Towards the North by Roberto Sanesi)
50.2×63.2; 32.2×24.2
Cerastico Editore, Milan
DP.6488

Journey Towards the North, 1971
(from Journey Towards the North by Roberto Sanesi)
44.4×63.5; 35.6×27.2
Cerastico Editore, Milan
DP.6489

From a conversation between Hermes and Menipeus on a field of snow, 1971
(from Journey Towards the North by Roberto Sanesi)
50×63.5; 36×29.1
Cerastico Editore, Milan
DP.6490

Improvisation No.9 Upon the Dawn, 1971
(from Journey Towards the North by Roberto Sanesi)
49.6×63.3; 29.7×24.5
Cerastico Editore, Milan
DP.6491

The story lost in the snow, 1971
(from Journey Towards the North by Roberto Sanesi)
50.1×63.6; 41×30.5
Cerastico Editore, Milan
DP.6492

Elegy for Vernon Watkins, 1971
(from Journey Towards the North by Roberto Sanesi)
44.6×63.2; 32.2×22.3
Cerastico Editore, Milan
DP.6493

Information Report, XVI, 1971
(from Journey Towards the North by Roberto Sanesi)
50.2×63.3; 38.6×28.2
Cerastico Editore, Milan
DP.6494

Frances Richards b.1903

Being Beauteous, 1973–75
(from Les Illuminations)
43×38.6; 18.9×16
The artist
DP.6495

Bottom, 1973–75
(from Les Illuminations)
43×38.4; 25×20.3
The artist
DP.6496

Bottom, 1973–75
(from Les Illuminations)
42.9×38.4; 23.7×18
The artist
DP.6497

Childhood II, 1973–75
(from Les Illuminations)
43×38.5; 22.5×16.6
The artist
DP.6498

Childhood II, 1973–75
(from Les Illuminations)
42.9×38.4; 20.9×17.5
The artist
DP.6499

Dawn, 1973–75
(from Les Illuminations)
43×38.4; 20×16.3
The artist
DP.6500

Dawn, 1973–75
(from Les Illuminations)
42.9×38.4; 21.4×17.3
The artist
DP.6501

Dawn, 1973–75
(from Les Illuminations)
38.3×43; 16.2×20.8
The artist
DP.6502

Devotion, 1973–75
(from Les Illuminations)
42.9×38.4; 21.3×20.6
The artist
DP.6503

Mystic, 1973–75
(from Les Illuminations)
38.3×43; 18.8×22.7
The artist
DP.6504

Title page, 1973–75
(from Les Illuminations)
43×38.4; 22.8×19.2
The artist
DP.6505

Hieratic Floral Figure, 1974
77.5×57.3; 58×51.6
Patrick Seale Prints (Observer Art)
DP.6506

Oliffe Richmond b.1919

Big Man, 1966
63.2×50.6; 47.1×27.5
Curwen Prints
DP.6507

Dance, 1966
77.8×52.1×; 42.1×32.6
Curwen Prints
DP.6508

Discus, 1966
63.3×50; 48.2×25.4
Curwen Prints
DP.6509

Four Figures, 1966
58.5×79.8
Curwen Prints
DP.6510

Marathon, 1966
65×51.3; 48.2×25.1
Curwen Prints
DP.6511

Pilot, 1966
63.1×50.5; 48×25.2
Curwen Prints
DP.6513

Standing Group, 1966
64.7×51.5; 40.9×38.1
Curwen Prints
DP.6512

Edward Ripley b.1929

Landscape, Cotswold Farm, 1975
61×76.1; 47.1×63.5
Athena
DP.6680

Brian Robb, b.1913

Southend Pier, 1956
(from Guinness Lithographs)
54.3×79.5; 48.2×73.5
Guinness
DP.6719

Donald Roberts b.1923

Osseous 68, 1968
59×83.5
The artist, DP.6514

Vair Project – Argent 68, 1968
59.7×83.5
The artist, DP.6515

Vair Project – Basalt 68, 1968
60×83.7
The artist
DP.6516

Zsuzsi Roboz b.1939

Backstage, 1975
(from Backstage at the Windmill
Theatre)
55.5×75.5; 47.5×57.5
The artist
DP.6682

Closing Day, 1975
(from Backstage at the Windmill
Theatre)
75.1×55.3; 58.5×39.2
The artist
DP.6681

Connoisseurs, 1975
(from Backstage at the Windmill
Theatre)
55.3×75.5; 50.8×57.2
The artist
DP.6683

Dear Mum, 1975
(from Backstage at the Windmill
Theatre)
74.9×55.2; 61.1×45.7
The artist
DP.6686

Dressing Room, 1975
(from Backstage at the Windmill
Theatre)
55×75.5; 44.1×56
The artist
DP.6685

Interval, 1975
(from Backstage at the Windmill
Theatre)
75.3×55.4; 49.8×38.9
The artist
DP.6684

Dancing Figure, 1976
57.4×77.5
The artist
DP.6748

Michael Roschlau b.1942

The Pillar, 1972
77.5×57.3; 66.5×49.5
Proofed only
DP.6517

Leonard Rosoman b.1913

The Gothik Temple, Stowe, 1971
(from Follies)
57.2×77.6; 51×69
Curwen Prints
DP.6518

Michael Rothenstein b.1908

Sunrise at 36,000ft, 1973
(from The Penwith Portfolio)
58.2×79; 48.3×71.4
Penwith Galleries
DP.6519

Kenneth Rowell b.1922

Two Figures in a Landscape,
1963–64
57.5×81.2; 50×71.9
Curwen Prints
DP.6749

Untitled I, 1964
57.8×80.8; 55.5×77.7
Proofed only
DP.6520

Untitled II, 1964
57.6×80.7; 55.5×76.3
Proofed only
DP.6521

Untitled III, 1964
57.1×80.8; 54.1×75.7
Proofed only
DP.6522

Untitled IV, 1964
56.9×81.2; 54.5×76.3
Proofed only
DP.6523

Ceremony, 1965
79.4×57.3; 74.5×49.6
Curwen Prints
DP.6524

Ritual Objects, 1965
80.3×57.3; 74.7×49.2
Curwen Prints
DP.6525

Edwina Sandys b.1938

Bowl of Flowers, 1972
77.5×56.7; 50.6×45.9
The artist
DP.6526

Circus, 1972
77.5×57.3; 72×54.6
The artist
DP.6527

Cardplayers, 1974
57.9×78.4; 50.9×64.1
The artist
DP.6528

Couples, 1974
77.4×57.8; 68.3×52
Patrick Seale Prints
DP.6529

Daffodils, 1974
77.6×58.1; 70×46
The artist
DP.6530

Green Nude, 1974
58×78.5; 42×58.6
The artist
DP.6531

Moonscape, 1974
58×78.5; 32.2×59.3
The artist
DP.6532

Peace, 1974
57.2×77.5; 41.5×58.7
The artist
DP.6533

Double Vision, 1974
63.4×81.2; 56.3×78.9
The artist
DP.6534

Sea Shells, 1974
57.9×77.9; 41.5×59.1
The artist
DP.6535

Gerald Scarfe b.1936

Another Successful Transplant,
1969
78.1×58.8; 76.4×55.9
Grosvenor Gallery
DP.6536

Hugh Hefner (The Playboy), 1969
77.2×58.4; 74.1×53.3
Grosvenor Gallery
DP.6537

Investiture Souvenir, 1969
77×58.3
Grosvenor Gallery
DP.6538

Jackie and the Shower of Gold, 1969
76.7×58.1; 76×56.1
Grosvenor Gallery
DP.6539

Ted Kennedy, 1969
77.5×58.8; 75.2×54
Grosvenor Gallery
DP.6540

Marquis de Gaulle, 1969
77.1×58.3
Grosvenor Gallery
DP.6541

Tricky Dick, 1969
77×58.1
Grosvenor Gallery
DP.6542

Students of the Revolution, 1969
76.8×58.2; 76.6×56
Grosvenor Gallery
DP.6543

Ian Fleming as James Bond, 1970
77.4×58.3; 73.7×54.6
The artist
DP.6544

Lennon and Ono, 1970
79.3×56.2; 74.4×56.2
The artist
DP.6545

Pope and the Pill, 1970
78×59; 75.2×56.2
The artist, DP.6546

The Queen, 1970
78×59; 74.6×52.2
The artist
DP.6547

Spiro Agnew, 1970
77.7×58.8
The artist
DP.6548

Laurence Scarfe b.1914

Apparition, Venice, 1965
76.2×50.9; 67.4×42.9
Curwen Prints (Unicorn)
DP.6750

Battersea Night, 1965
50.8×76.2; 41.6×61.9
Curwen Prints (Unicorn)
DP.6751

Quatrefoil Garden, 1965
76.1×50.8; 60.8×41.5
Curwen Prints (Unicorn)
DP.6752

Peter Schmidt b.1931

Flowing in the Right Direction, 1971
(from Europaeische Graphik VII)
61.4×41.6; 52.1×32.7
Galerie W. Ketterer, Munich
DP.6549

Flowing in the Right Direction
(1st version), 1971
66.9×53; 52×32.1
Proofed only
DP.6550

Campbell Scott

Untitled (2 images), 1969
79.4×58
The artist
DP.6551

Robert Scott

Peruvian Night, 1965
62×46
Curwen Prints (Unicorn)
DP.6753

William Scott b.1913

Arran, 1960
58.1×80.7; 52.2×64.8
Johanna Schiessel Abstracta-Verlag,
Freiburg
DP.6552 (Cat.329)

Benbecula, 1961–62
57.6×80.5; 50×62.3
Curwen Prints
DP.6553 (Cat.330)

Jura, 1961–62
57.4×80.5; 49.8×59
Curwen Prints
DP.6554

Barra, 1962
57.5×81; 50.2×60.1
Curwen Prints
DP.6555 (Cat.331)

Mingulay, 1962
57.6×80.8; 50.5×61.9
Curwen Prints
DP.6556

Scalpay, 1963
(from Europaeische Graphik I)
50.5×65.6
Galerie W. Ketterer, Munich
DP.6557 (Cat.332)

Brown Predominating, 1976
(from Summer Suite)
57.1×76.7
Editions Alecto
DP.6687

Green Predominating, 1976
(from Summer Suite)
56.9×77.2
Editions Alecto
DP.6688

Shmuel Shapiro

1. Woman Shielding Her Child,
1966–67
(from Tor des Todes)
57×79.6
Maltzahn/Curwen
DP.6558 (Cat.333)

2. Brother and Sister, 1966–67
(from Tor des Todes)
57.6×80.8
Maltzahn/Curwen
DP.6559 (Cat.334)

3. Adonai, 1966–67
(from Tor des Todes)
80×57.1
Maltzahn/Curwen
DP.6560

4. Dying Mother and Child,
1966–67
(from Tor des Todes)
80.2×57
Maltzahn/Curwen
DP.6561

5. Man Mad with Fear, 1966–67
(from Tor des Todes)
80.5×57
Maltzahn/Curwen
DP.6562

6. Gas Chamber, 1966–67
(from Tor des Todes)
57.5×80.5
Maltzahn/Curwen
DP.6563

7. Burning Woman, 1966–67
(from Tor des Todes)
80.5×57.4
Maltzahn/Curwen
DP.6564

8. Resigned Woman, 1966–67
(from Tor des Todes)
79.6×57
Maltzahn/Curwen
DP.6565

9. Dying Man, 1966–67
(from Tor des Todes)
56×79.8
Maltzahn/Curwen
DP.6566

*10. Woman Crying Over Dead
Child*, 1966–67
(from Tor des Todes)
80×57.7
Maltzahn/Curwen
DP.6567

Two Lovers, 1966–67
40.4×57.6; 34.8×44.6
Curwen Prints
DP.6720

Rosemary Simmons b.1932
Helix, 1971
77.6×58.3; 75.2×55.1
The artist, DP.6568

Birgit Skiold
Sea Image, 1968
59.1×79.3
London Graphic Arts
DP.6569

Bernard Slawik
Pre-Historic Subject, 1976
43.4×57.2; 29.2×36.2
The artist
DP.6754

Humphrey Spender b.1910
Gravel Pit, 1968
59.8×79.2; 48.5×69
Proofed only
DP.6570

Cornish Tin Mines, 1969
57.6×79.5; 42.2×66.9
Curwen Prints
DP.6571

Donegal Coastscape, 1969
57.7×79.5; 40.1×55.5
Curwen Prints
DP.6572

Donegal Landscape, 1969
58.4×79.1; 41.3×56.9
Curwen Prints
DP.6573

Reedy Pool, Essex, 1969
58.5×79; 44.2×64
Curwen Prints
DP.6574

Walled Landscape, Kerry, 1969
58.1×79.1; 43.7×57.7
Curwen Prints
DP.6575

Cornish Tin Mines, 1971
52.5×72.7; 38.3×59.5
Discovering Antiques
DP.6576

Benton Spruance
Icarus I, 1963
56.5×79.7; 42.4×54.6
The artist
DP.6577

Icarus III, 1963
56.8×80.2; 45.1×61
The artist
DP.6578

Bestiary, 1967
64.7×50.4; 60×48.3
The artist
DP.6579

Ralph Steadman b.1936
*Courtroom Scene from Alice in
Wonderland*, 1967
57×79.5
The artist
DP.6580

Norman Stevens b.1937
Spring, 1976
(from Lower Wessex Lane)
62.1×65.6; 44.5×50.7
Editions Alecto
DP.6689

Summer, 1976
(from Lower Wessex Lane)
62.1×65.8; 44.5×50.7
Editions Alecto
DP.6690

Autumn, 1976
(from Lower Wessex Lane)
62.2×65.9; 44.4×50.8
Editions Alecto
DP.6691

Winter, 1976
(from Lower Wessex Lane)
62.1×65.9; 44.5×51
Editions Alecto
DP.6692 (Cat.335)

Graham Sutherland b.1903
Portrait of Aloys Senefelder, 1971
(from Europaeische Graphik VIII)
78.3×57.1; 65.7×49.2
Galerie W. Ketterer, Munich
DP.6581 (Cat.337)

Philip Sutton b.1928
Great Australian Bight, 1966
58.8×78.8; 50.1×51
Curwen Prints
DP.6582

Hawaii, 1966
58×78.8; 51×51
Curwen Prints
DP.6583

Pacific, 1966
58.3×79; 50.5×51.1
Curwen Prints
DP.6584

Samoa, 1966
59.2×78.7; 50.8×50.8
Curwen Prints
DP.6585 (Cat.338)

San Francisco, 1966
56.2×78.8; 50.2×51.6
Curwen Prints
DP.6586 (Cat.339)

Vancouver, 1966
58.5×78.5; 51.1×51.4
Curwen Prints
DP.6587

John Thirsk

Deer House, Bishop Auckland, 1971
(from Follies)
57.2×77.5; 44.5×65
Curwen Prints
DP.6588

Wainhouse Tower, Halifax, 1971
(from Follies)
77.5×57.2; 63.3×49.8
Curwen Prints
DP.6589

Dr W. G. Grace, 1972
77.5×57.1; 57.3×38.5
Sun
DP.6590

Feliks Topolski b.1907

City, 1973
(from London Suite)
47.7×62.7; 33.4×50.7
Christie's Contemporary Art
DP.6591

Piccadilly Circus, 1973
(from London Suite)
47.6×62.7; 35.9×42.2
Christie's Contemporary Art
DP.6592

Westminster, 1973
(from London Suite)
62.7×47.6; 42.9×38.3
Christie's Contemporary Art
DP.6593

Speaker's Corner, 1973
(from London Suite)
47.6×62.7; 29.8×45.4
Christie's Contemporary Art
DP.6594

Trafalgar Square, 1973
(from London Suite)
62.7×47.4; 46×35.9
Christie's Contemporary Art
DP.6595

Trooping the Colour, 1973
(from London Suite)
47.6×62.7; 34.5×49.9
Christie's Contemporary Art
DP.6596

Ann Travis b.1931

Bloomsbury Pie, 1974
38.8×57.5; 35.7×39
Harvane Gallery
DP.6597

Julian Trevelyan b.1910

Thames Boat, 1968
77.1×58.2; 49.2×35.9
London Graphic Arts
DP.6598

Tower Bridge, 1968
77.4×58.3; 48.9×36.2
London Graphic Arts
DP.6599

Brentford, 1975
71.3×50.6; 51.1×38.5
Curwen Prints
DP.6693

Camden Lock, 1975
50.6×71.1; 38.2×51.3
Curwen Prints
DP.6694

Canal Holiday, 1975
50.9×71; 38.2×51.3
Curwen Prints
DP.6695

West Country, 1975
71.1×50.8; 51.2×38.2
Curwen Prints
DP.6696

Dee Villiers

Kyrenia Harbour, 1970
57.1×72.6; 41×62
The artist
DP.6600

William Walmsley b.1923

Ding Dong Daddy Dog Biscuits #2,
1974–75
77.7×58; 63.2×51.3
The artist
DP.6601

Michael Warren b.1938

Lapwing, 1973
65.7×40.4; 50.8×25.6
Christie's Contemporary Art
DP.6602

Crested Grebe, 1974–75
65.2×50.4; 52.2×38.3
Christie's Contemporary Art
DP.6603

Nicholas Wegner b.1948

Aerial View and *Figures with
Motorbike*, 1972
77.5×57.4
Archer Gallery
DP.6605

Aerial View of City, 1972
77.5×57.4
Archer Gallery
DP.6612

Back View of Girl and *Girl
Standing*, 1972
77.5×57.3
Archer Gallery
DP.6608

Back View of Standing Girl, 1972
77.4×57.5
Archer Gallery
DP.6611

Girl Lying Down, 1972
77.5×57.5
Archer Gallery
DP.6610

Girl Lying on Decorated Bed and
Two Men, 1972
77.5×57.3
Archer Gallery
DP.6609

Girl's Head and *Man, Head and
Shoulders*, 1972
77.5×57.5
Archer Gallery
DP.6607

Guitarist, 1972
77.5×57.4
Archer Gallery
DP.6613

Love Making and *Aerial City*, 1972
77.5×57.4
Archer Gallery
DP.6606

Map and *Girl's Head*, 1972
77.4×57.5
Archer Gallery
DP.6604

Brett Whiteley b.1939

Seated Nude, 1973
75×55.1
Ganymed
DP.6614

Martin Wiener b.1913

1. Golda Meir, 1972–73
(from The Hands of the People
Who Are Building Israel)
77.4×57.8; 69.4×49.5
Jewish National Fund
DP.6755

2. David Ben Gurion, 1972–73
(from The Hands of the People
Who Are Building Israel)
77.4×57.3; 71.4×51.5
Jewish National Fund
DP.6756

3. Kibbutz Palmach Tzuba,
1972–73
(from The Hands of the People
Who Are Building Israel)

57.6×77.5; 55.4×75.9
Jewish National Fund
DP.6616

4. Three Arabs and a Sabra,
1972–73
(from The Hands of the People
Who Are Building Israel)
57.5×77.5; 54.7×75.2
Jewish National Fund
DP.6757

5. Nahal Settlement Ein Sivan,
1972–73
(from The Hands of the People
Who Are Building Israel)
57.5×77.5; 50×70.5
Jewish National Fund
DP.6615

*6. Children in the Panto Family
Kindergarten*, 1972–73
(from The Hands of the People
Who Are Building Israel)
57.5×77.5; 49.8×70
Jewish National Fund
DP.6758

Kyffin Williams b.1918

Pontlyfni in Snow, 1974
48.8×77.6; 39.6×73.3
Christie's Contemporary Art
DP.6617

Albany Wiseman b.1930

French Engine, 1972
57.4×77.6; 41.5×58
The artist
DP.6618

Charlotte Place, 1974
50.7×63.8
Curwen Prints
DP.6619

Fitzroy Square, 1974
50.7×63.7; 42.4×58.9
Curwen Prints
DP.6620

Berwick Market, 1974
(from The Soho Suite)
63.5×50.8; 58.5×47.1
Curwen Prints
DP.6621

Meard Street, 1974
(from The Soho Suite)
50.7×63.5; 42×58.7
Curwen Prints
DP.6622

Mitchell's Yard, 1974
(from The Soho Suite)
63.4×50.8; 51.5×41.9
Curwen Prints
DP.6623

Romilly Street, 1974
(from The Soho Suite)
63.5×51; 53.1×41.4
Curwen Prints
DP.6624

Soho Shop Fronts, 1974
(from The Soho Suite)
50.8×63.5; 43.6×58.6
Curwen Prints
DP.6625

Soho Square, 1974
(from The Soho Suite)
50.7×63.5; 44.2×54.3
Curwen Prints
DP.6626

The Phoenician, 1975
76.9×60.4; 58.5×40.3
Colin Jackson
DP.6697

Ossip Zadkine 1890–1967

Acrobat, 1964
80.6×57.8; 55.9×45
Curwen Prints
DP.6627

Figure with Guitar, 1964
60.9×45.7
Curwen Prints
DP.6628

Figure with Guitar, 1964
80×57.5; 53.6×34.3
Curwen Prints
DP.6629 (Cat.340)

Tree Form, 1964
80.3×57.2; 62.4×46.1
Curwen Prints
DP.6630

Glossary
of printing terms

The first three items define the major printing processes referred to in this book; thereafter entries are in alphabetical order.

INTAGLIO Printing from an image recessed below the surface level of a metal plate. The plate is heavily inked, particular care being taken to fill all the incised channels of the image; the surrounding surfaces are then cleaned with a circular wiping action of muslin pads and a final polishing from the palm of the hand. All stages of the wiping are designed to leave the maximum amount of ink in the image lines – stiff inks assist the process. The plate is placed on the travelling bed or plank of a rolling press built rather like the old-fashioned domestic mangle. Dampened paper is placed over the plate which is then rolled slowly through the press under specially resilient woollen blankets to force the softened paper into all the ink-carrying incisions. The print thus achieved is actually a mould of the image – hence the plate mark typical of the process, and the crisp line standing proud of the paper surface. See AQUATINT, DRYPOINT, ENGRAVING, ETCHING, MEZZOTINT, PHOTO-GRAVURE.

LETTERPRESS Printing from a relief surface; which alone is inked. The principle can be observed in the everyday action of the rubber stamp. The image is transferred to paper by pressure either from a cylinder or from a platen which acts on the entire image area in one stroke. See LINE BLOCK, LINO-CUT, PARAMAT, WOODCUT and WOOD ENGRAVING.

LITHOGRAPHY Printing from a level or 'plano-graphic' surface, its fundamental principle being based on the natural antipathy of grease and water. If water is spread across the specially prepared grain of the printing surface it will be held as a thin, even film. Should there be any spots of grease present these will reject the water. If an inked roller is now taken across the surface, ink will be attracted to the grease spots, but not to the water bearing areas. Thus the use of a suitable greasy medium for the creation of the image is all that is required to ensure the separation of printing and non-printing areas. The image is trans-ferred to the paper by pressure. See AUTOLITHO-GRAPHY, CHROMOLITHOGRAPHY, 'COLLOGRAPH', DIAZO LITHOGRAPHY, OFFSET LITHOGRAPHY, PHOTOLITHOGRAPHY.

AQUATINT An intaglio print in which the image tones or 'tints' are created by etching with 'aquafortis' (nitric acid) through a finely grained acid resist of resin dust fused to the plate by heat. The minute particles of resin leave free a crazed area of bare metal not unlike the cracking of mud in a dried-up pond. Areas that are eventually to print as pure white are 'stopped-out' with varnish from the outset; intermediate tones are bitten, as in ETCHING, to varying depths: the darker the tone required, the longer and therefore deeper the biting.

AUTOGRAPHIC IMAGE Achieved when the printing surface is prepared by the artist.

AUTOLITHOGRAPHY The artist draws his image either directly onto a lithographic stone or plate, or onto TRANSFER PAPER (q.v.). The stone is a thick slab of limestone, the surface of which is polished to the degree of smoothness required by the artist; plates are made of aluminium or zinc and are lightweight and flexible, but lack the versatility of surface available from stone. The image is drawn in a greasy medium known as TUSCHE, available in stick and liquid form, and it is the grease in this to which the ink will adhere for printing. See also DIRECT PRINT and OFFSET LITHOGRAPHY.

CHINE Papier de Chine; China or India paper. A very thin, soft, unsized paper made from bamboo fibre and particularly suitable for hand printing fine-quality impressions of engravings.

CHROMOLITHOGRAPHY Hand-drawn colour work on lithographic stones or plates in which a craftsman

copies the artist's original, using a separate surface for each colour. See LITHOGRAPHY.

'COLLOGRAPH' Term used by Henry Moore, synonymous with DIAZO LITHOGRAPH (q.v.).

COLLOTYPE Process in which the image is transferred photographically to a glass or zinc plate coated with a light-sensitive gelatine. It can interpret a continuous-tone original by means of the subtle, irregularly-reticulated crazing of the gelatine, and produces a result superior to the regular pattern of the HALF-TONE's (q.v.) mechanically screened dots.

DIAZO LITHOGRAPHY Developed during the 1960s, this employs a sensitized coating on an aluminium plate. The artist draws an image on a transparent sheet (tracing paper or 'Kodatrace' for example) which is developed on the surface of the diazo plate by ultraviolet light. This is not a method employing any kind of mechanical screen (see HALF-TONE); every nuance of texture in the artist's original is imparted directly to the plate. It is a method regarded by Stanley Jones of the Curwen Studio as a more sensitive and faithful means of transferring an artist's idea than the traditionally used TRANSFER PAPER (q.v.). Henry Moore has made particularly inventive use of it. (See *Henry Moore: graphics in the making*, Tate Gallery 1975.)

DIRECT PRINT One which is taken directly off the printing surface. A disadvantage of the method is that the artist must work in reverse, or else accept the fact that his drawing will be reversed when printed.

DRYPOINT An intaglio print basically linear in character. The image is torn into the surface of a metal plate by the dragging action of a sharp round point held like a pencil. A v-shaped trench is created with a parapet of displaced metal ('burr') on either side. The burr, which holds ink rather as a hedgerow will collect drifting snow, provides a particularly full and soft-edged line, but it wears rapidly in printing.

EM The square of any size of type. The 12 point em or pica (a little over 4mm) is the printer's standard unit of measure in typographical work.

ENGRAVING The term is often used very loosely in relation to all intaglio and relief work. Most specifically it applies to recess line engraving: v-shaped lines are cut into the surface of a metal plate with a special tool called a graver or burin. Its pointed end, v-shaped in cross section, is pushed along to scoop out a shaving of metal. With short stabbing strokes the tool can achieve a variety of dotted or stippled effects. See WOODCUT and WOOD ENGRAVING.

ETCHING An intaglio print in which the image is created by the controlled erosion of the surface of a metal plate. First covered with a specially prepared acid-resistant ground of wax, the plate is blackened with smoke. The design is then drawn through the blackened ground with a sharp point or 'etching needle'; the drawing is finally revealed as bright metal cleared of ground. The subsequent application of nitric acid to the surface bites into the bared metal; the length of time during which the acid remains on the metal governs the depth of the line bitten. Those parts of the design that have been sufficiently worked can be 'stopped out' with varnish to allow for further biting of remaining areas.

FOUNT A complete set of type characters of a particular size and design, made up to a specified weight or number of characters.

FROTTAGE A rubbing made by placing a sheet over a relief surface, parts of which stand proud, and taking an impression. Stone and brass rubbings are also frottage. It is possible to make the frottage on TRANSFER PAPER and put it down onto a plate or stone for lithographic printing.

HALF-TONE By photographing a continuous-tone original (e.g. a photograph, watercolour drawing or oil painting) through a cross-line screen, it is broken down into a mass of individual dots of varying size. These when printed in a single colour, usually black, create the illusion of a full range of tone from black, dark and lighter grey to white. Colour half-tone work involves, in addition, the preliminary separation of the original into the three primary colours and black by means of filters. If a fine screen is used, 175 to 200 lines to the inch, the process is almost subliminal; the coarser the screen (e.g. as used for newsprint) the more mechanical and obvious the process becomes.

LINE BLOCK Letterpress block used to reproduce images from black-and-white originals without intermediate tones. The image is transferred, usually to a zinc block, by hardening a sensitive emulsion or

gelatine by light through a photographic negative. The hardened gelatine is used as an acid-resist which protects the wanted parts of the image when the rest of the metal is etched away. It therefore resembles a mechanically made WOODCUT (q.v.).

LINOCUT Autographic relief process in which the artist carves away from a soft medium, traditionally lino, the areas not required to form the image. See also WOODCUT and WOOD ENGRAVING and PARAMAT for similar techniques.

MEZZOTINT An intaglio print made from a metal plate first treated by pitting the entire surface with a toothed rocker to produce an even field of tiny indentations for the holding of ink. Without further treatment the plate would print a solid black. The image required is subsequently realized by scraping and burnishing the plate in those areas intended to print in intermediate tones of grey or white. This black-to-white process can be paralleled in autolithography by painting or crayoning a solid all over the stone or plate for subsequent scraping.

MONOTYPE CORPORATION Company which developed the Monotype system of single-type composition – mechanized typecasting and setting (used for the text of this book).

OFFSET LITHOGRAPHY The image on the lithographic plate or stone is first printed onto an intermediate rubber 'blanket' roller, and from this roller onto the paper. An incidental effect of this technique is that the final printed image is not reversed, but appears as originally drawn. Though used for the printing of AUTOGRAPHIC work (leading to intense debate about what constitutes an 'original' or 'artist's proof') the term is generally associated with modern PHOTOLITHOGRAPHY (q.v.).

ORIGINAL PRINT Traditionally defined as 'a print made directly from a master image on wood, stone, metal, etc. which is executed by the artist himself, printed by him or under his supervision and, in recent times, usually signed by him' (Oxford English Dictionary). However, since the photographic image has infiltrated creative print procedures 'originality' has become more difficult to define (see under OFFSET LITHOGRAPHY).

PARAMAT Composition rubber about one-tenth of an inch thick which can easily be cut and mounted for letterpress printing. John Piper used this medium for his illustration in *Axis*.

PHOTOGRAVURE The commercial application of the intaglio process. The image is photographically transferred onto a cellular structure, creating hollows of regular area (usually 150 or 175 to the inch) but of varying depth. The depth of the hollow dictates the amount of ink carried and printed. The hollows are filled and the surface is scraped clean of ink as the printing cylinder revolves, thus automating the process of hand-inking and wiping an intaglio plate.

PHOTOLITHOGRAPHY The modern commercial printing process generally known as 'offset litho' in which the printing plates are prepared by photo-mechanical means.

PRELIMS The pages of a book, such as title page, preface, acknowledgements, etc. which precede the body of the text.

PRESSWORK A term which embraces all the niceties of adjustment in paper preparation, inking and press action which ensure the best possible transfer of image to paper.

SANS SERIF Letterforms designed without serifs and generally with uniform weight of line; compare SERIF/SERIF. Serifs are the fine lines at the ends of a letter's terminating strokes.

STENCIL A thin sheet of metal or oiled card through which colour is brushed onto the paper or other surface through holes previously cut in the stencil. Harold Curwen's innovation was the introduction of the use of transparent celluloid as the masking sheet.

TRANSFER PAPER Chemically treated 'release' paper for use in AUTOLITHOGRAPHY (q.v.). The artist draws in TUSCHE (q.v.) on the transfer paper; the drawn image is then released from the paper onto a lithographic stone or plate. If a DIRECT PRINT is then taken, the final printed image reads the same way as the image on the transfer paper. A print made with a different medium, e.g. LINOCUT, may be

printed with special ink onto transfer paper for lithographic printing.

TUSCHE See under AUTOLITHOGRAPHY.

TYPOGRAPHY General term concerned with the aesthetic and technical aspects of presenting and reproducing the printed word and image.

WOODCUT and WOOD ENGRAVING Relief processes which differ only in degree of coarseness (cut) and fineness (engraving). Plank wood cut along the grain with knives and gouges is usually called woodcut; end-grain wood, cut with the fine tools of the metal engraver and yielding much more detailed work is usually called wood engraving.

Index